THE EXPRESSIONIST LANDSCAPE

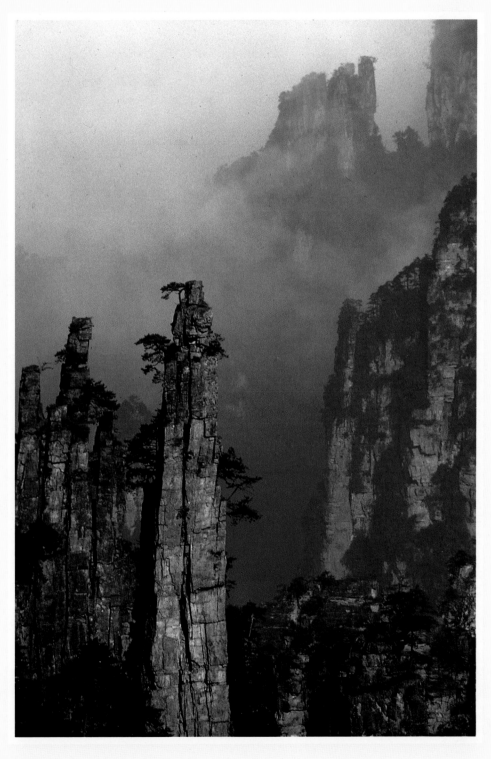

YUAN LI

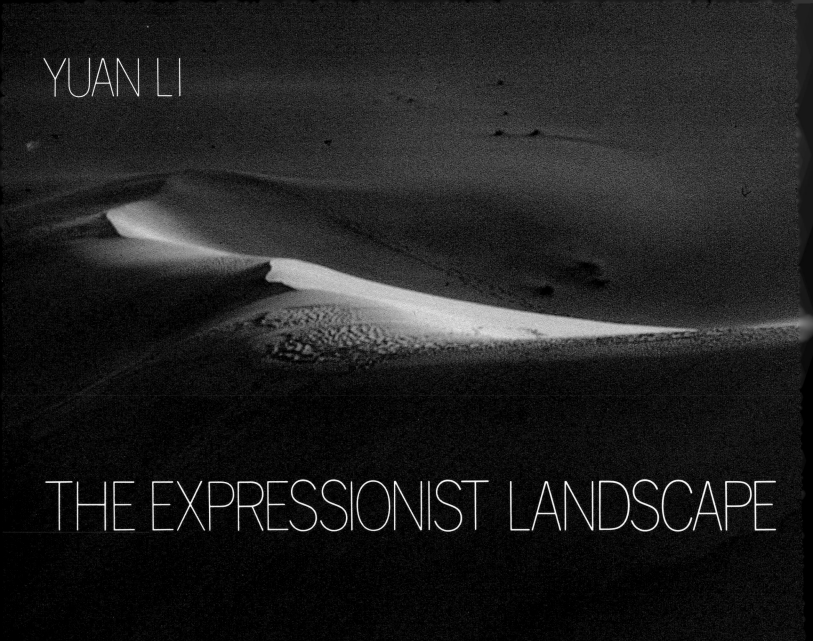

THE EXPRESSIONIST LANDSCAPE

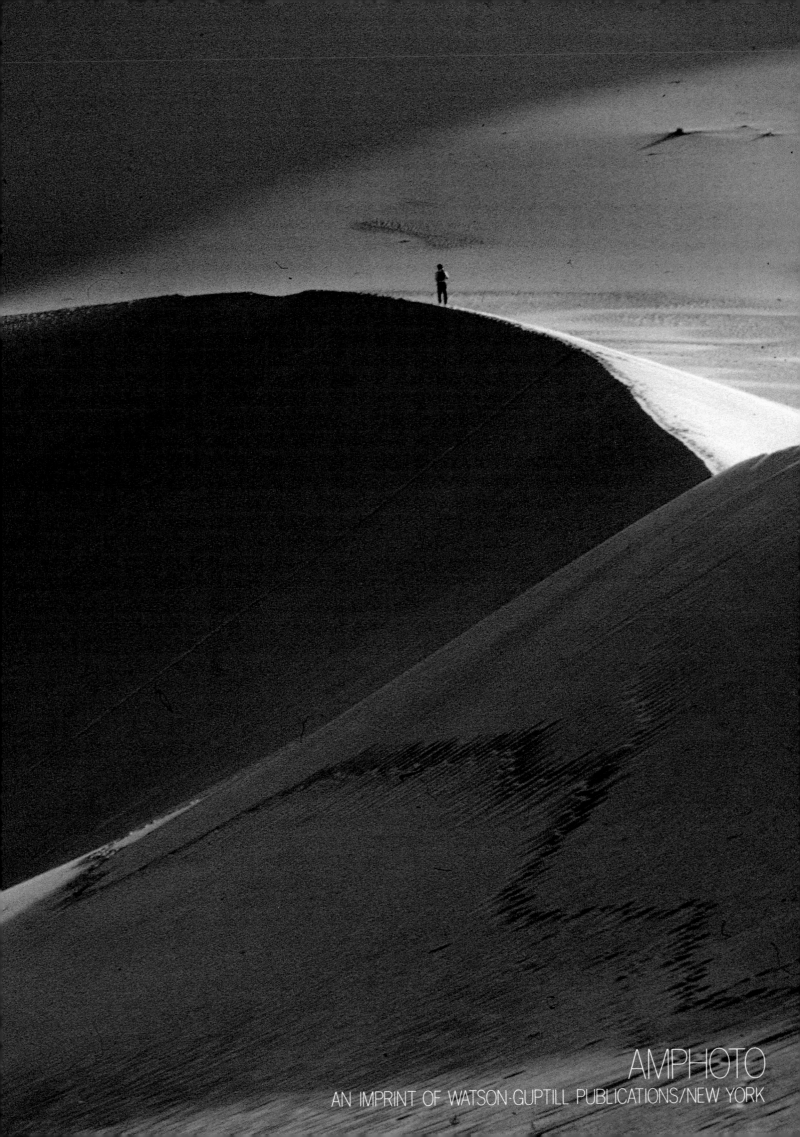

AMPHOTO
AN IMPRINT OF WATSON-GUPTILL PUBLICATIONS/NEW YORK

My thanks to Susan Hall for making this book a reality, to Liz Harvey for her invaluable editorial assistance, and to Grace Marmor Spruch for her steady encouragement. My thanks also go to Shen Jinguang, Lin Shaozhong, and Deng Ligen, who help to put my work into focus.

Edited by Liz Harvey
Designed by Jay Anning
Graphic production by Hector Campbell

First published 1989 in New York by AMPHOTO,
an imprint of Watson-Guptill Publications,
a division of Billboard Publications, Inc.,
1515 Broadway, New York, NY 10036

Library of Congress Cataloging-in-Publication Data

Li, Yuan.
 The expressionist landscape / Li, Yuan.
 Includes index.
 ISBN 0-8174-3834-3 ISBN 0-8174-3835-1 (pbk.)
 1. Photography—Landscapes. I. Title.
TR660.L7 1988
778.9'36—dc19
 88-26784
 CIP

Manufactured in Japan

1 2 3 4 5 6 7 8 9 / 97 96 95 94 93 92 91 90 89

To those who have shaped and expanded my vision.

CONTENTS

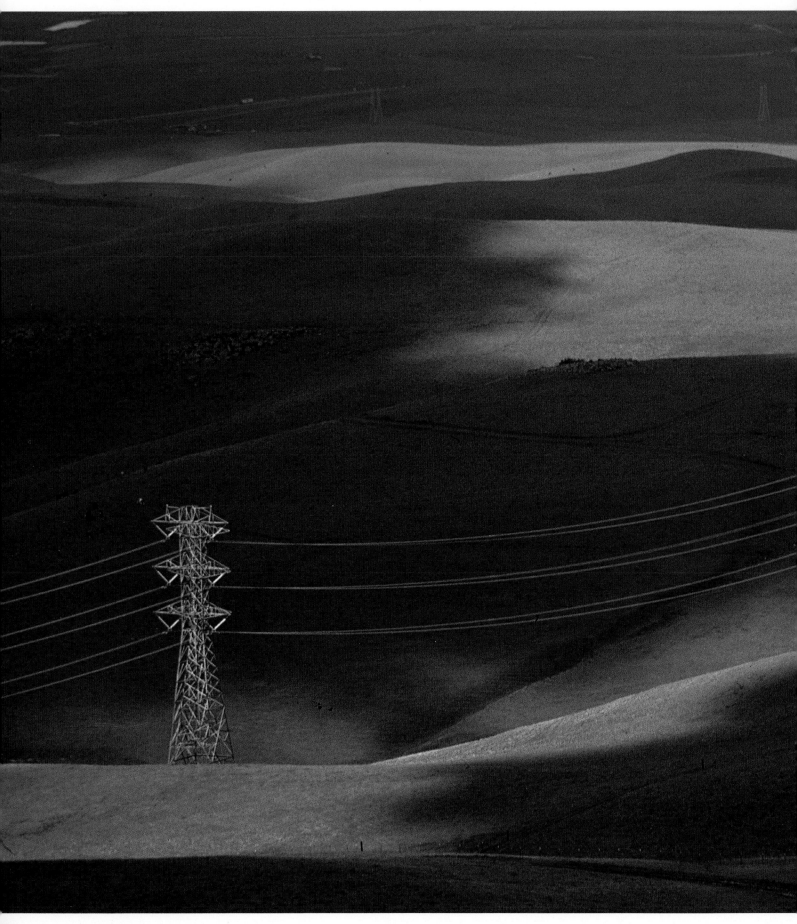

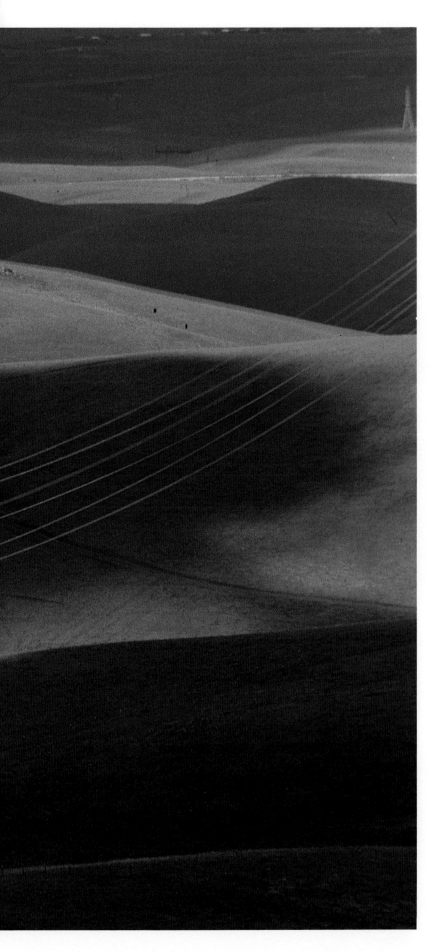

INTRODUCTION

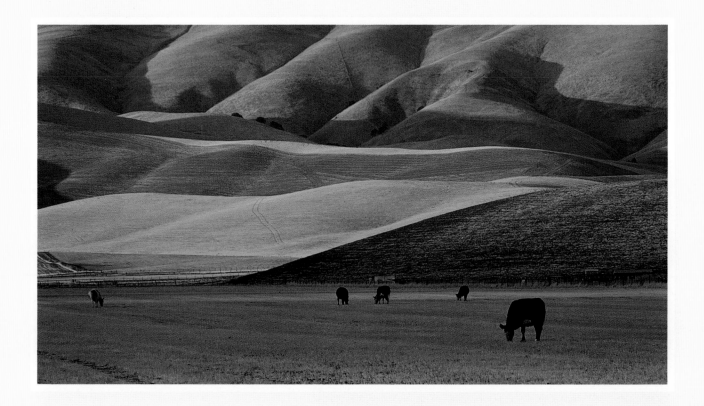

*Dotted only occasionally with shacks, this hillside in Livermore, California, looked
barren until the setting sun created a lively interplay of light and shadow. I viewed this
scene as a multilayered contrast. The tranquillity of the pasture seemed incongruous with
the uncertainty the fault suggested. To bring the cattle up against the hill, without
trespassing, I used a Canon FD 80–200mm lens near the long end, which was mounted
on my Canon FT. Metered on the far hill still in the sun, the exposure was f/22 for 1/8
sec. on Kodachrome 64.*

During the summer of 1976 in Livermore, California, I faced a photographic challenge on a trip that I now regard as one of my favorite explorations into landscape photography. During the long evening hours, I drove along country roads, with my camera at my side. It was quite a pleasure to see vast panoramas without having the view blocked or interrupted by any obtrusive visual obstacles. I found myself drawn to the Livermore Valley's fault-fractured hills. Dotted with rundown shacks and apparently unmaintained, the hillside was desolate. I then noticed that the contour looked as if it had been sketched in the twilight; the earth, covered with dry, brown grass, seemed alive. The still landscape was transformed into a dynamic abstraction of light, rhythm, and movement. This powerful scene, created by a restless earth, made quite an impression on me.

Landscape photography calls to mind panoramas of the American West as captured by Ansel Adams. These powerful images have defined in large measure the tradition of landscape photography in this century.

At the time of the birth of photography in 1838, people looked to the camera as the ideal means to record, accurately and objectively, the world around them. In America, Timothy O'Sullivan shot stark, almost abstract images of the West as chronicles of government expeditions to new territories. Even today, most viewers respond to a picture of a natural setting by asking, "Where was this taken?" The essence of the photograph is subjugated to the location of the landscape.

I doubt that such a utilitarian view of landscape photography was what Adams had in mind when he took his view camera to the hills. But the technological developments in photography provided the foundation for Adams' virtuoso performances in the field and in the darkroom and led him to place the technical precision of his photographs ahead of the emotional response such landscapes might evoke.

The work of other landscape photographers elicits strong reaction without the sacrifice of technical excellence. Carleton E. Watkins and Eadweard Muybridge's photographs are appealing because they capture the religious and utopian qualities of the American West. Images taken by such Sierra Club photographers as Eliot Porter and Philip Hyde inspire a reverence and a deeper appreciation of nature; they also heighten awareness about the urgent need for additional environmental protection measures. Landscape photography makes natural vistas accessible to the masses and helps them realize their responsibility to the land.

CREATING A LASTING IMPRESSION

Ever present and seemingly eternal, the natural landscape is one of the first subjects most photographers shoot. Still, few landscape photographs leave a lasting impression. Even some of the truly spectacular scenes, such as the Half Dome in Yosemite, photographed so often that their locations are now clearly marked on maps and listed in travel guides, lose their novelty and

no longer generate excitement. Also, unlike "human interest" pictures, a large number of landscape images appear to lack a connection between the subject and the viewers. What is in such pictures seems too far removed from the daily lives of most people to be able to produce either an emotional or intellectual response.

Landscape photography, however, can and should reveal the bond viewers have with their natural surroundings. People respond to the countryside various ways. They see in effective landscape images a respite from urban life and a reflection of their concern for the environment; they react emotionally to landscape images just as they do to an Impressionist painting by van Gogh, with its bold colors and strokes, providing a strong sense of movement. It is up to photographers to elicit these responses and to explore their personal vision and the potential of landscape photography.

THE ELEMENTS IN A LANDSCAPE PHOTOGRAPH

As in all visual media, the impression an image leaves is based on only two elements: subject and design. The subject (or subjects) helps to focus the viewers' attention, brings out the allegories, serves as a symbol for human experience, and prompts associations. The design provides the overall visual impact and evokes a response to the intangibles. But the dividing line between what to present and how to present it is not always clearcut. The design can influence the interpretation of the subject while the selection of a specific subject can alter the design.

Ordinarily, the power of a photographic impression lies in the realistic depiction of what takes place in a split second. Landscape photographers, on the other hand, must include a careful, deliberate element of design in their pictures to emphasize the distinctive nature of the subject. Rather than create a setting that is to their liking, they have to be sensitive enough to perceive an image based on what lies before their eyes. But, at the same time, a satisfactory picture must also give the impression that the photographer was in full command of the situation while making the image. This often means searching, contemplating, and having a bit of luck on a well-planned journey because the landscape—unlike a studio set—is basically beyond the photographer's control.

It is this bit of "manipulation" that helps to establish the photographer's individual approach to reaching deeper into the conscience of viewers. Usually I begin by seeking out a place I can relate to and deciding which specific aspect of the area looks best under the existing weather and lighting conditions. When I discover a place that appeals to me, I try to go back to it several times under various conditions. In doing this, however, I am not suggesting that I anticipate and wait for "the right moment" to take a picture. Because different conditions produce drastically different results, it is difficult to preconceive exactly how they will affect an area's appearance. I simply let what is in front of me determine the image. What is captured on film is more important

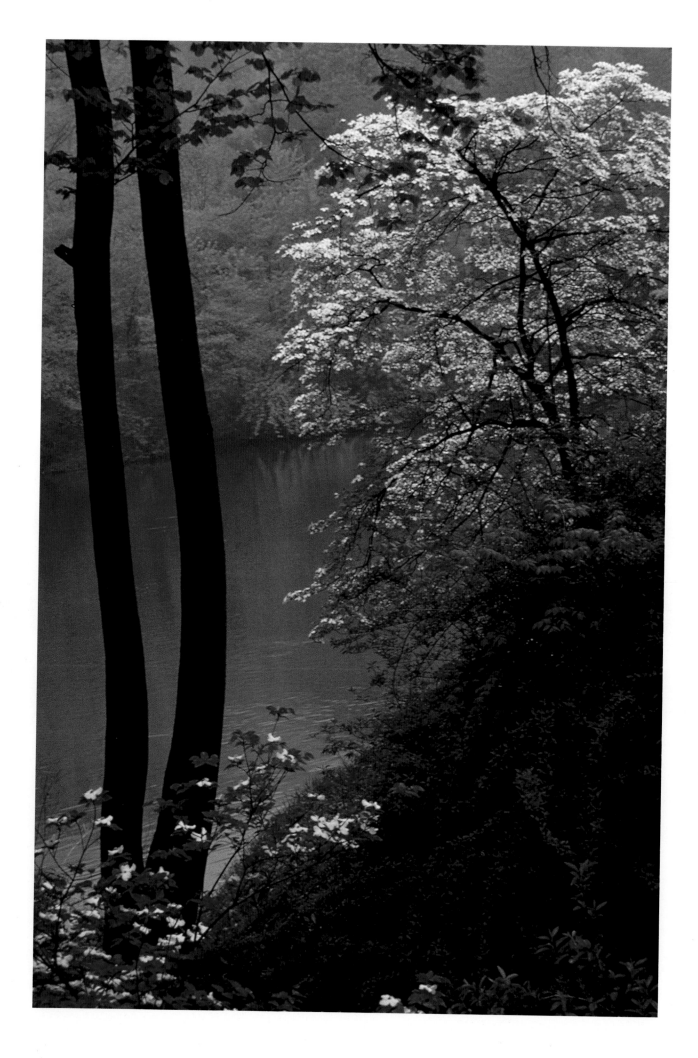

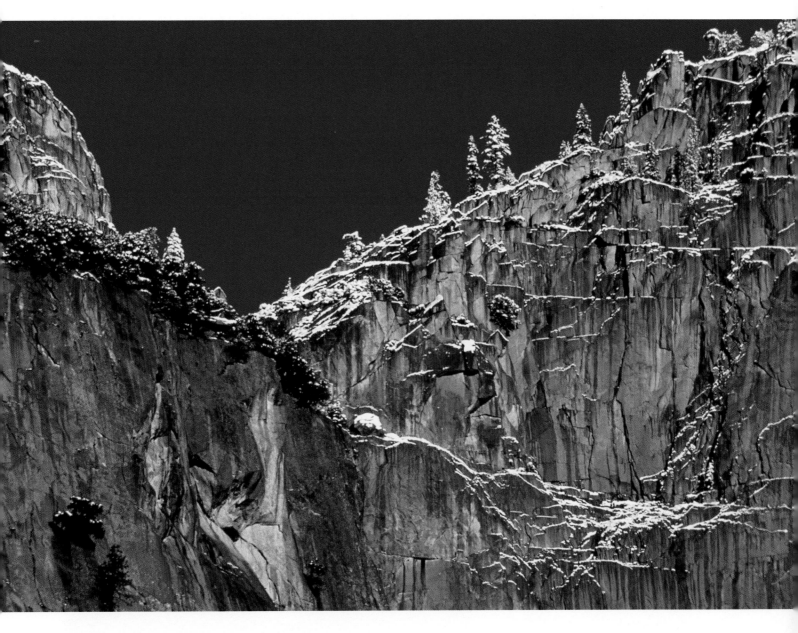

Although Yosemite has been photographed countless times, the beauty of the landscape can still be captured on film in a memorable way. In the picture above, an evening drizzle turned into snow, and, as the morning sun shone on the powdery cliff, the valley looked like a mosaic. I composed the image so that the blue sky would appear triangular and that the entire picture would contain three triangles. Using a Canon FD 80–200mm lens set at 200mm on my Canon A1 and Kodachrome 64, I metered on the concentration of snow on the cliff. The exposure was f/22 for ⅟₁₅ sec.

The towpaths along many rivers in New Jersey are easily accessible and allow photographers to capture quaint scenes near the canals. When the trees on the slope along the paths are placed against a clear background of sky or open water, the resulting image is a simple abstraction. In the photograph on the opposite page, a light rain darkened the trees and added detail to the banks of a brook. With a Canon FD 135mm lens mounted on my Canon FT, I metered on the river in the subdued light; the exposure was f/22 for ⅛ sec. on Kodachrome 25.

than the subject's identity. Not only does my approach preserve spontaneity, it also enables me to make a personal statement about what I see rather than to merely record what is there.

All photographers—and most viewers—are aware of this difference between reality and an image. Whether or not such a discrepancy is desirable or acceptable, few photographers can precisely pinpoint the reasons for it. Although some of these causes are obvious, such as the inability of any type of film to reproduce exactly what can be seen with the naked eye, most are not. But, in landscape photography, several specific factors help to explain the difference: the existence of carefully composed but artificial boundaries in a picture contrasts directly with human vision, which is limited only by the obstacles present on the land (and the photographer's imagination). A photograph's boundaries limit what can be included in it, force viewers to focus on the elements in the picture, and, occasionally, create tension in the image that is not present in reality.

The relative sizes of the subjects within a photograph also distinguish between an actual image and the photographer's perception of it. Because photographers can focus on one particular, discernible object at a time on land, no matter how small it is, viewers can usually ignore potentially distracting elements. If photographers aren't selective when they compose their images, a random cluster of various-sized objects will compete for the viewers' attention; camera lenses do not discriminate. So, unless photographers want to convey a sense of chaos, the absence of an emphasis will weaken an image's essence and visual impact. Perhaps this word of advice from my first photography teacher, the late Helen Manzer, will clarify this point: "Before releasing the shutter, ask yourself what excites you in the viewfinder." Once photographers answer this question, they should make sure that they give the source of their inspiration the prominence it deserves.

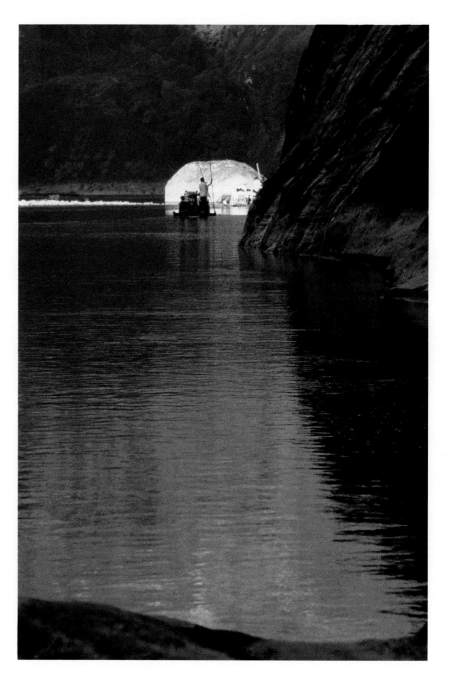

Riding in a bamboo raft on the Brook of Nine Bends in the Fujian Province in China on a hot July morning, I noticed another raft spotlighted at a bend in the water. This section of the brook was still in shadow. Using my Canon T90, a Canon FD 80–200mm lens set at 200mm, and Fujichrome 400, I spot-metered on the light area of the image. The camera was in the program mode.

During the spring, the river in Lockwood Gorge, New Jersey, flows rapidly, and each year I find that the reflection of the white birch on the cascade forms different patterns. Exposing for the white reflection in the image on the opposite page, I set my Canon F1 at f/16 for 1/30 sec. and used a Canon FD 80–200mm lens.

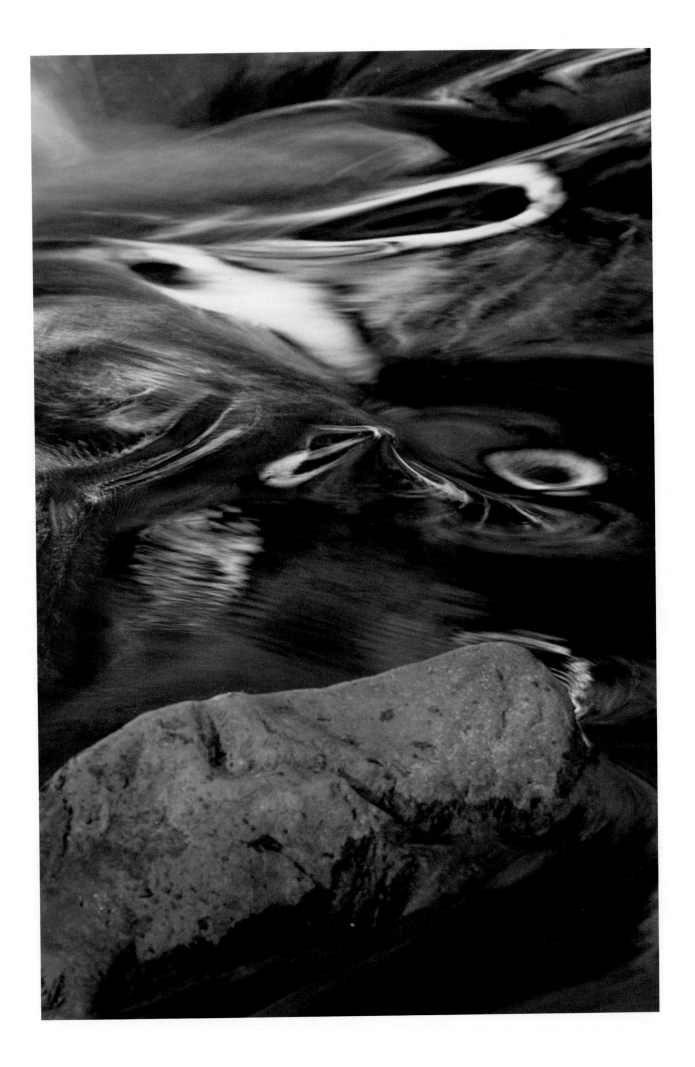

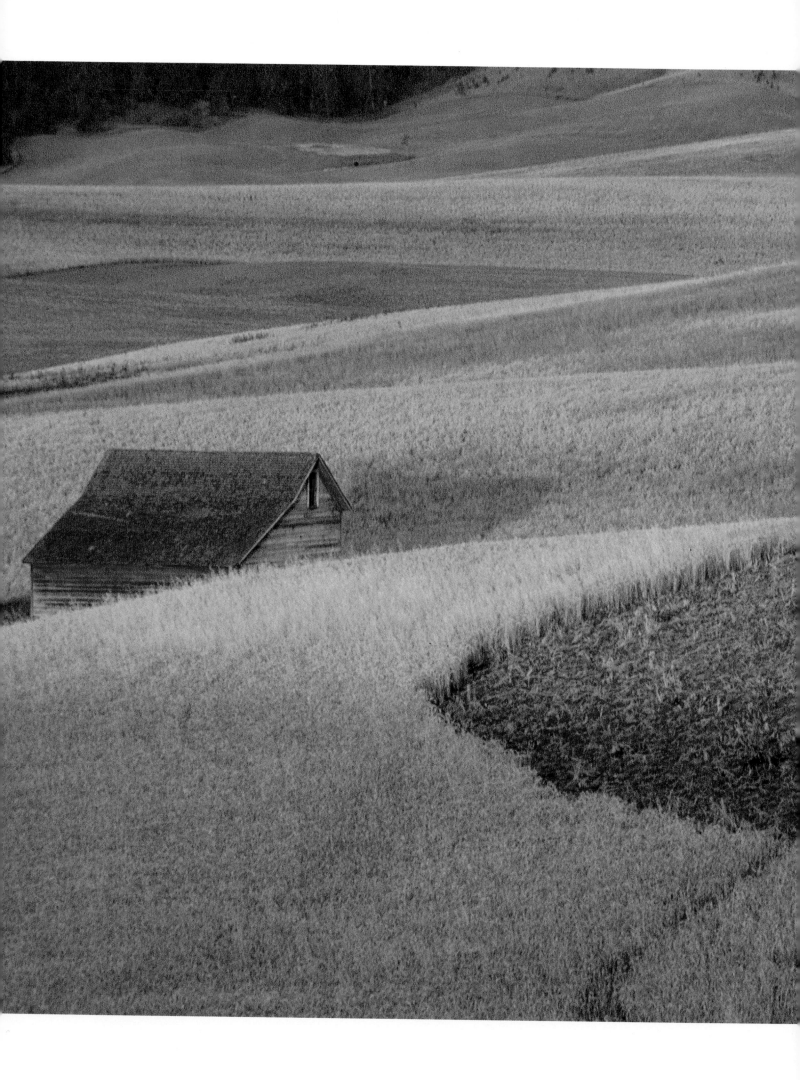

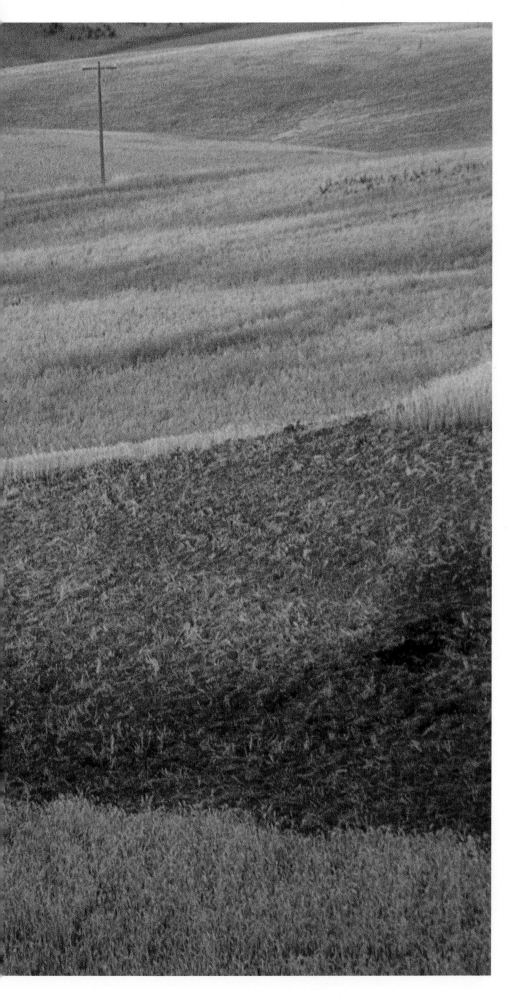

At different stages of harvesting, wheat fields display a variety of forms and colors. But neither the color nor the form in this picture is strong enough to carry it. The shack provides a much-needed center of focus. Working with a Canon FD 80–200mm lens and my Canon FT, I exposed for ¹⁄₁₅ sec. at ƒ/22 on Kodachrome 64.

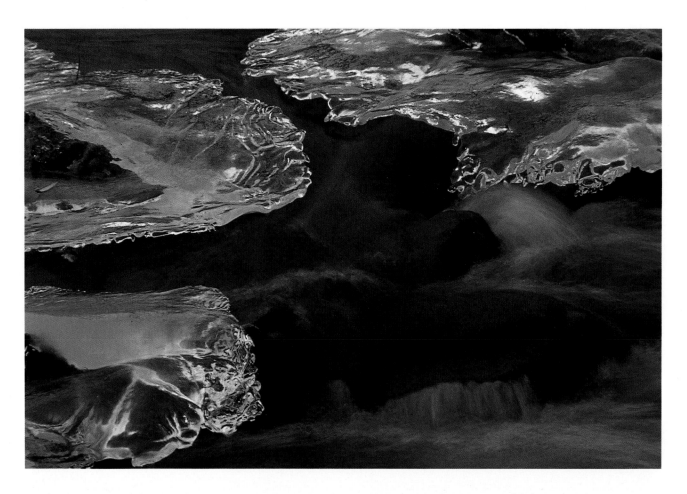

The ice on this brook in New Jersey's Hacklebarney State Park formed an almost abstract pattern. Taken on a bright winter afternoon when the leaf-covered bank was in the sun and the brook in the shade, this image shows that the reflection from the bank made the ice sparkle and added color to the water. I mounted a Canon FD 80–200mm lens on my Canon FT and set it at 200mm. Metering on the ice, I exposed at f/22 for ½ sec. on Kodachrome 64. The slow shutter speed prevented the water in the background from competing with the glistening ice.

The last factor that separates actual images from perceived ones is light. Unless a photographer shoots near midday or under flat lighting conditions, shadows will be present in the pictures. Shadows can be deceptive: although they can appear less noticeable in the field and, so, be easily overlooked, they become as prominent as the subject in the final picture. In some photographs, shadows seem even more dominant and powerful than the subject because they show up as the darkest areas within the frame. Also, shadows can appear to be randomly placed, producing a chaotic effect, or orderly arranged, providing a sense of control. Although pictures with stark contrasts can be powerful, the omission of detail usually leaves viewers wanting. As such, effectively integrating shadows and subjects are a challenge to photographers.

Finally, landscape photographers must think about the question of communication between the artist and the audience. An effectively designed image can sometimes make a dull subject interesting, appealing, or perhaps, even thought-provoking. Within natural surroundings, the interplay of subject and design in photographs can lead to almost endless visual statements. The sensitivity of landscape photographers to this relationship awakens their imagination to the possibilities and enriches their work, their viewers, and themselves.

THE PROFOUND POWER
OF NATURAL LIGHT

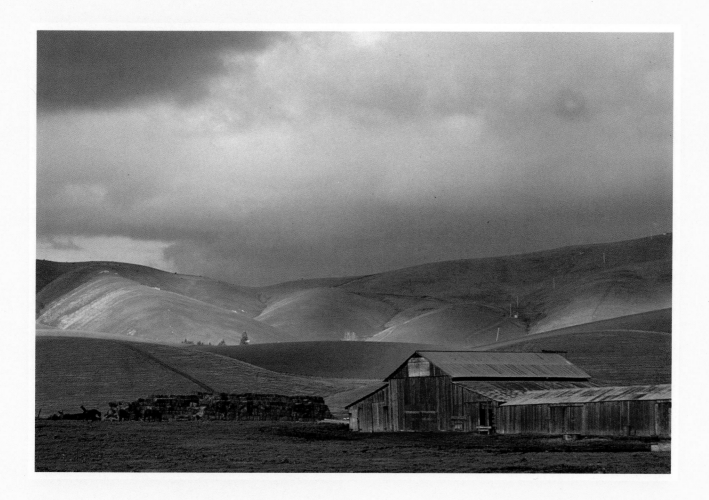

As the sun penetrated these clouds, it spotlighted the green hills. It seemed that something mysterious created the glow in the valley. Because I decided not to wait for the sunlight to spread to the barn, the glow on the hill is the center of interest in this picture, rather than the buildings. I used a Canon FD 80–200mm lens on my Canon A1 and exposed at f/22 for ⅟₁₅ sec. on Kodachrome 64.

Combining "photo" (light) and "graphic" (to draw), photography means literally "to draw with light." Not only is an image formed on film through the interaction of light and the chemicals in the emulsion, different light conditions can actually produce a range of shades, all with different visual effects, from the same subject. Yet, unlike other types of photographs, landscape images are illuminated by only one source of natural light: the sun. The moon and the stars can adorn a landscape, but they cannot illuminate it adequately. With the exception of closeups, in which artificial-light sources or reflectors can be used as fill-ins, landscape photographers must work with what is given. Sensitivity to the amount of natural light on a subject is essential.

CAPTURING THE BEST LIGHT

In the early days of photography, film manufacturers recommended that pictures be taken only during the period from two hours after sunrise to two hours before sunset. Positioning the camera with its back to the sun was also suggested. Such advice is still valid if a photographer wants to produce a picture representative of the scene. Unfortunately, such pictures are frequently referred to as record shots. They appear bland and "flat"—lacking a three-dimensional quality—and they have no dramatic impact. The full range of tones (aided by the zone system) seen under different light conditions in Ansel Adams' work prompted John Szarkowski, photography curator of New York's Museum of Modern Art, to remark that, just as a portrait photographer waits for the right expression on a subject's face, a landscape photographer tries to capture the proper lighting condition for a given scene.

In recent years, however, obtaining vivid colors has been emphasized. Cibachrome enhances color rendition and produces the best results without any manipulation in the darkroom when a picture is taken under flat lighting conditions. This technical innovation helps to produce good pictures much more easily, but it also gives some photographers even more reason to use adverse lighting conditions to produce something out of the ordinary.

The strong sidelighting in this photograph accentuates the seemingly fluid movement of the dunes of California's Death Valley. I exposed for ⅛ sec. at f/22 on Kodachrome 64. I used my Canon FT and a Canon FD 80–200mm lens.

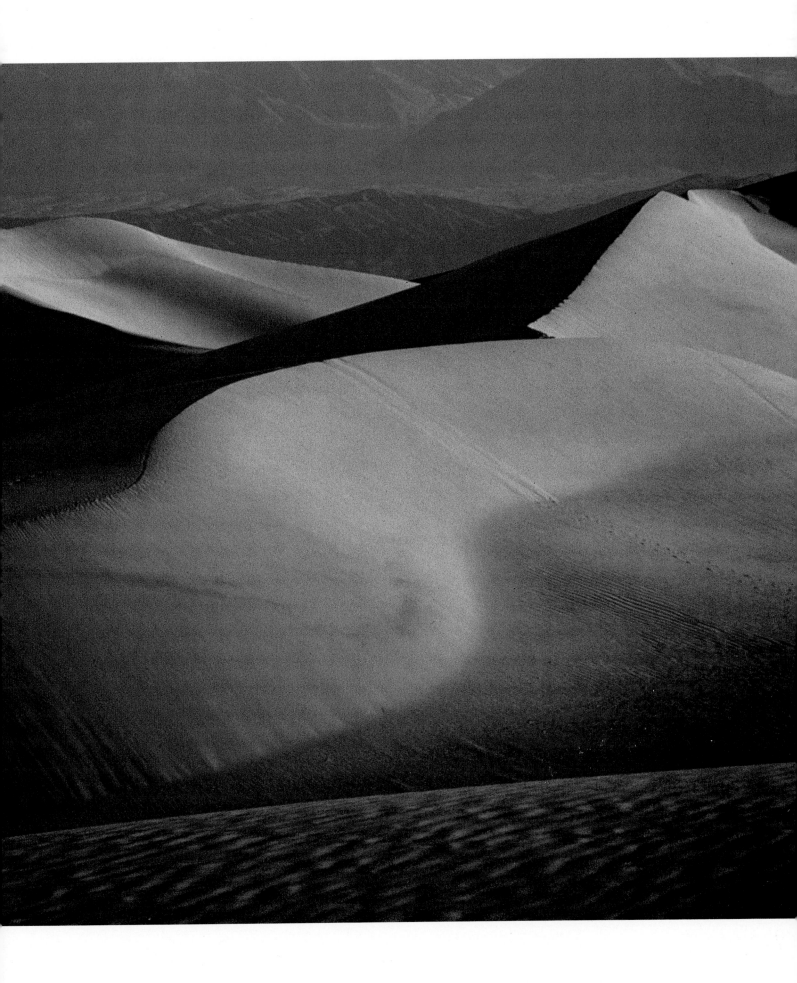

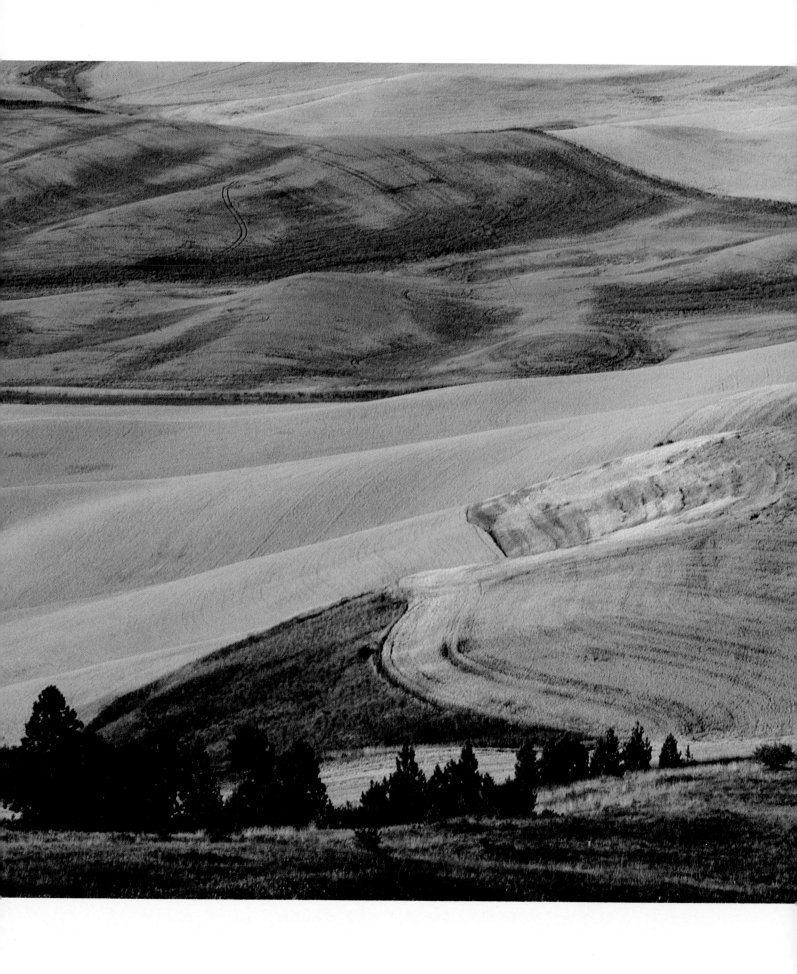

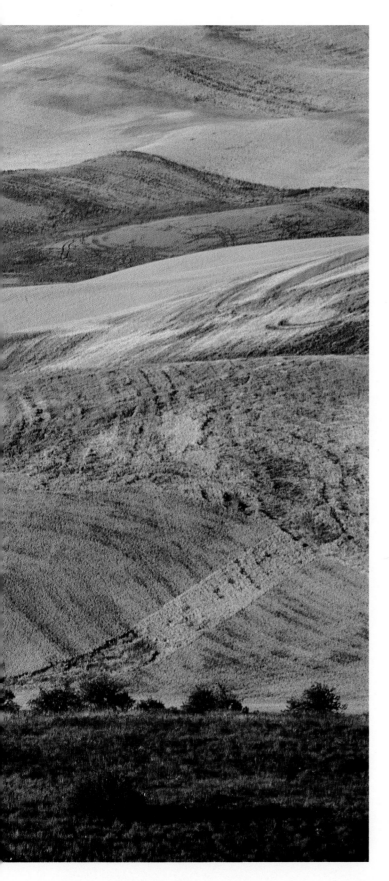

THE POSITION OF THE SUN

For a given scene, the sun's position can cause different effects. When the sun is behind the camera, the illumination is called *frontlighting*. Here, shadows are minimized, and the picture usually looks flat. Unless the subject is a vibrant hue, the overall color tone of the image tends to be muted. Frontlighting minimizes the deficiencies of the photographic medium, while other lighting conditions reveal the limited latitude of various types of film.

Tracing the movement of the sun will help to demonstrate the direct effect its position has on natural settings. Using the convention of a clock dial will simplify this analysis. Imagine a photographer standing on the center of the dial, facing the number twelve. As such, the sun is directly behind the photographer when it is at the six o'clock position; the landscape is frontlit in this situation.

At the four (or eight) o'clock position, the sun provides less illumination. This type of sidelighting produces noticeable but unobtrusive shadows and makes photographs somewhat three-dimensional. For example, tree trunks cast diagonal shadows in the foreground, and dark sections on buildings are separated clearly from light ones. A gradation of hues is also apparent depending on how much light reflected off a surface reaches the camera.

When the sun is at the three (or nine) o'clock position, contours are distinct and overlap very little. They separate objects in the foreground from those in the background. This lighting condition, called *sidelighting*, creates a striking three-dimensional effect. Shadows, which are prominent—and, on occasion, obtrusive—frequently cut across the image and turn it into a collage of isolated areas. Composition is critical here; the relationships among subjects must be clearly defined to avoid a "busy" image.

In this photograph, taken near Moscow, Idaho, the base is defined by a dark strip of land and a row of trees. Against this static foreground, the wheat field seems dynamic. Also, the swirling lines suggest intensity. To compensate for the frontlighting, I exposed at f/22 for ⅓₀ sec. on Kodachrome 64. I used a Canon FD 80–200mm lens mounted on my Canon FT for this image.

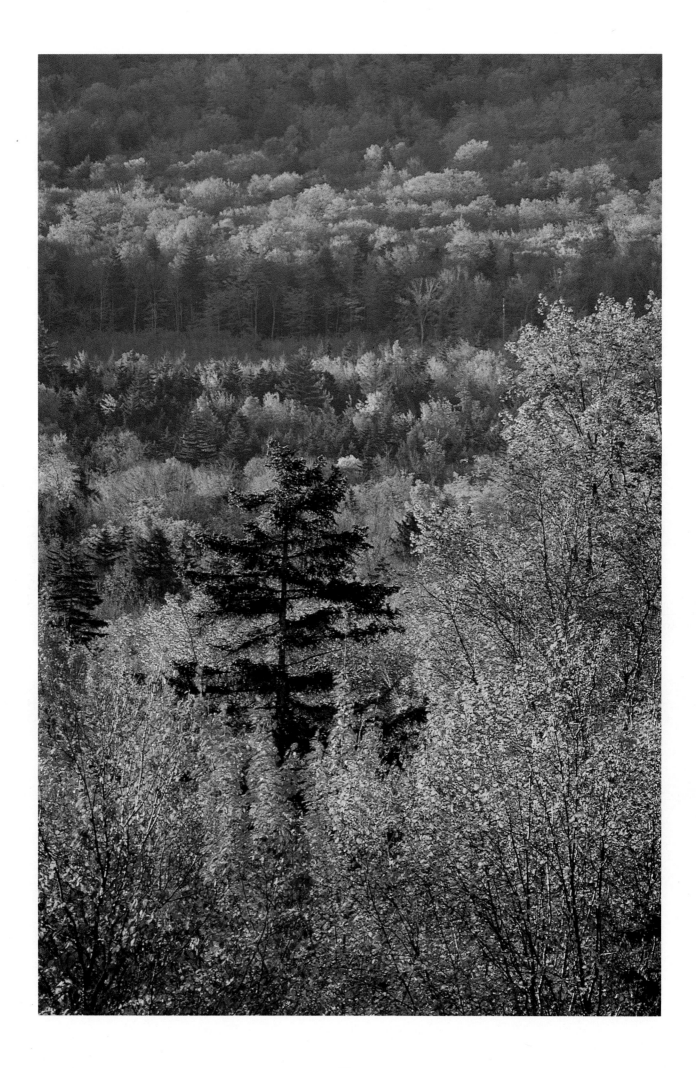

At the two (or ten) o'clock position, the sun can make snow or sand sparkle. This lighting condition, known as *backlighting*, can also make leaves and flower petals appear translucent. In addition, shadows are quite important, sometimes dominating an image. Rather than having the subject stand out against a background, it might be silhouetted against a bright background. With the sun at the two o'clock position, light might otherwise act like a brush sketching contours, darkening the background until no details are discernible. Backlighting necessitates a lens shade to avoid flare: it shields the lens from direct sun and extraneous light.

When the sun reaches the twelve o'clock position, shadows are even more pronounced than they are when the sun is at the two (or ten) o'clock position. Because the sun is behind the subject, this type of illumination is also called backlighting. Here, the middle gray tone is usually nonexistent. Only translucent subjects acting like tiny light sources provide relief. Excessive sunlight can be eliminated by using a lens shade. It is necessary, however, to look through the viewfinder to make sure that the protective cover will not show up in the picture. Placing the camera so that the lens is in the shadow of a pole or a tree trunk is a better solution.

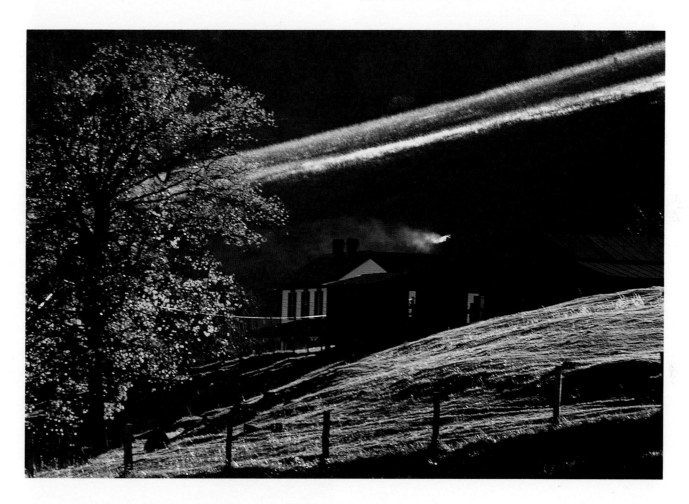

In the photograph above of the Shenandoah Valley, the contour of the backlit hillside was echoed by the color of the translucent leaves. Smoke caught the sunlight and called attention to the distant but inviting farmhouse in the otherwise empty, dark center. For this image, I mounted a Canon FD 80–200mm lens on my Canon F1 and used Kodachrome 64. Exposing for the sunlit hill, I photographed at f/22 for 1/15 sec.

In the picture at left, the morning sun provided sidelighting along New Hampshire's Kancamangus Highway in the fall. This separated the evergreen tree from the color on the hillside, which served as the background. The evergreen dominated the image, standing above the other trees in terms of both its position and its defiance against the seasonal change. I mounted a Canon FD 300mm lens on my Canon F1. The exposure was f/22 for 1/8 sec. on Kodachrome 64.

THE MAGIC HOURS AT DAWN AND DUSK

Landscape photographs taken early in the morning and shortly before sunset on clear days are frequently among the most breathtaking—and the most satisfying. The sun infuses them with warm tones that have a special appeal, all day long, but it does much more during these hours. The rays of the sun highlight ridges, sketch contours, and create long shadows. And, on gentle slopes, the sun's rays can produce a shimmering effect or generate vibrant movement. Shadows that appear at dawn and dusk can form lines and shapes, filling empty picture areas with various elements of design. Early morning and early evening shadows can improve composition by providing a direct contrast to sunlit subjects.

Although the quality of natural light at dawn and dusk differs very little, certain conditions can influence a photographer's decision about when to go out in the field. Pollution, which is more visible on the morning horizon, might prevent some photographers from working at dawn, while others might be unwilling to miss shooting in the early morning mist. The late afternoon, on the other hand, often harbors the threat of a thunderstorm, but the rich colors of a twilight sky might prove irresistible.

What actually differs most about photographing early or late in the day is the ease of preparation. In the morning, the best moment to shoot is sunrise. From that point on, the quality of natural light becomes progressively less attractive. From nine o'clock in the morning to four o'clock in the afternoon, the landscape looks flat and dull. Colors tend to be washed out during this time span. Without the use of accessories, such as a polarizing filter, color saturation cannot be achieved. As a result, it is imperative that a photographer succeed on the first try. For this reason, at dawn I prefer to shoot a landscape I am familiar with. During the afternoon, I can walk around an area and explore its potential as the lighting condition improves as sunset approaches. In short, I have time to set up and "rehearse" in the afternoon; dawn does not allow me this luxury.

The bright morning light on the lake was softened by the thin mist hovering over the water, and the lily pads, shining in the sun, filled much of the empty space in the lake. But it was the tree that provided a feeling of movement in the picture. With a Canon FD 80–200mm lens mounted on my Canon F1, I exposed for 1/60 sec. at f/22 on Kodachrome 64.

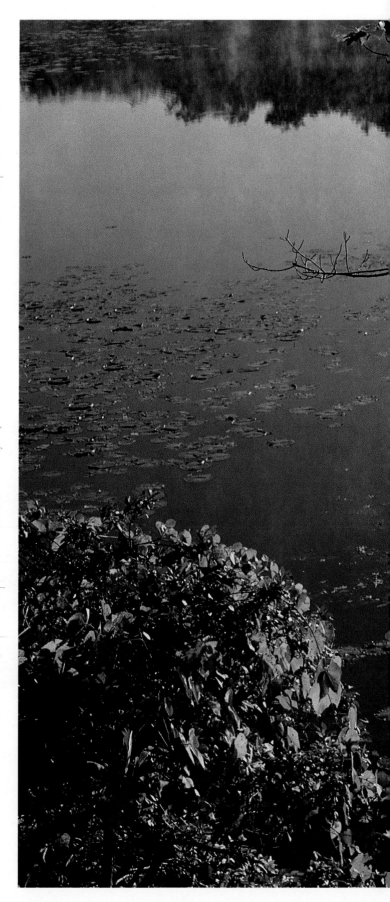

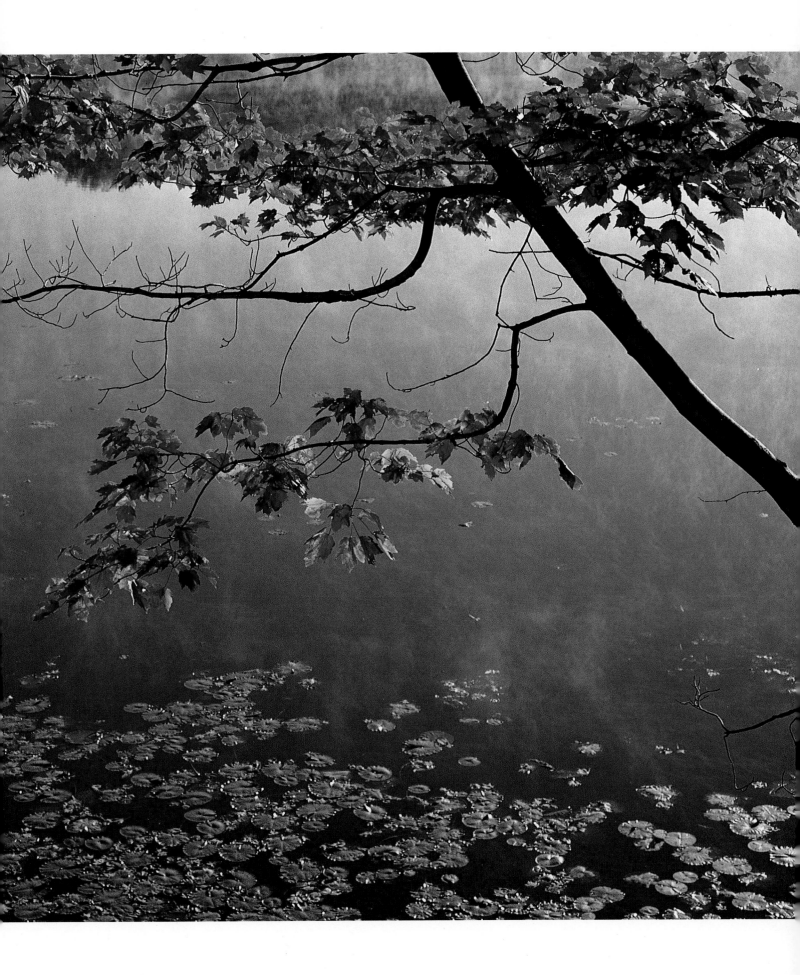

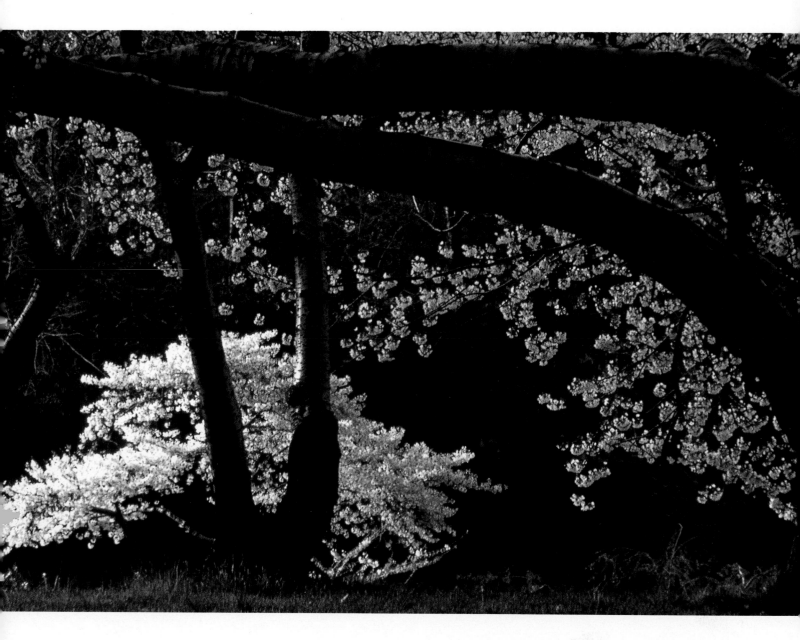

Early on a spring morning in Branch Brook Park in Newark, New Jersey, the cherry blossoms in the photograph above looked delicate in the golden sunlight. The dark branches of the tree provided a sharp contrast, suggesting power and movement. I used a Canon FD 300mm lens on my Canon F1. Metered on the blossoms, the exposure was f/32 for ¼ sec. on Kodachrome 64.

In the photograph at right the last rays of the sun, filtering through the trees, brightened the golden leaves on the near shore of a pond; the red leaves on the distant shore had already fallen under the shadow. The Canon FD 300mm lens I used compressed the leaves on the trees in the distance. With my Canon F1 and Kodachrome 64, I exposed for ¼ sec. at f/32.

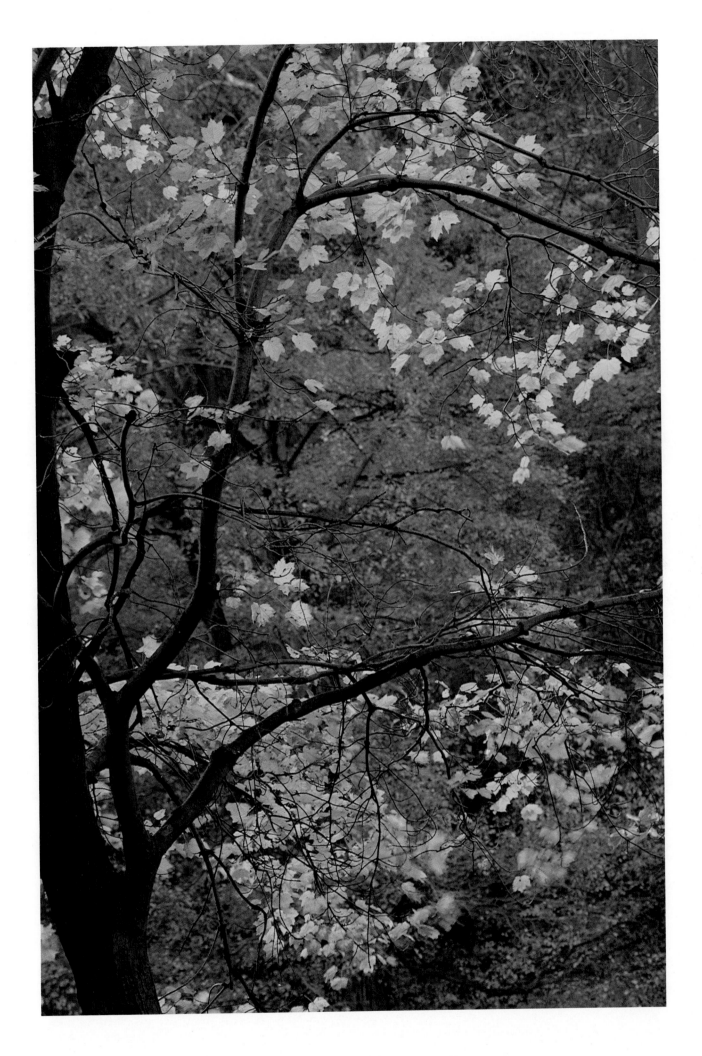

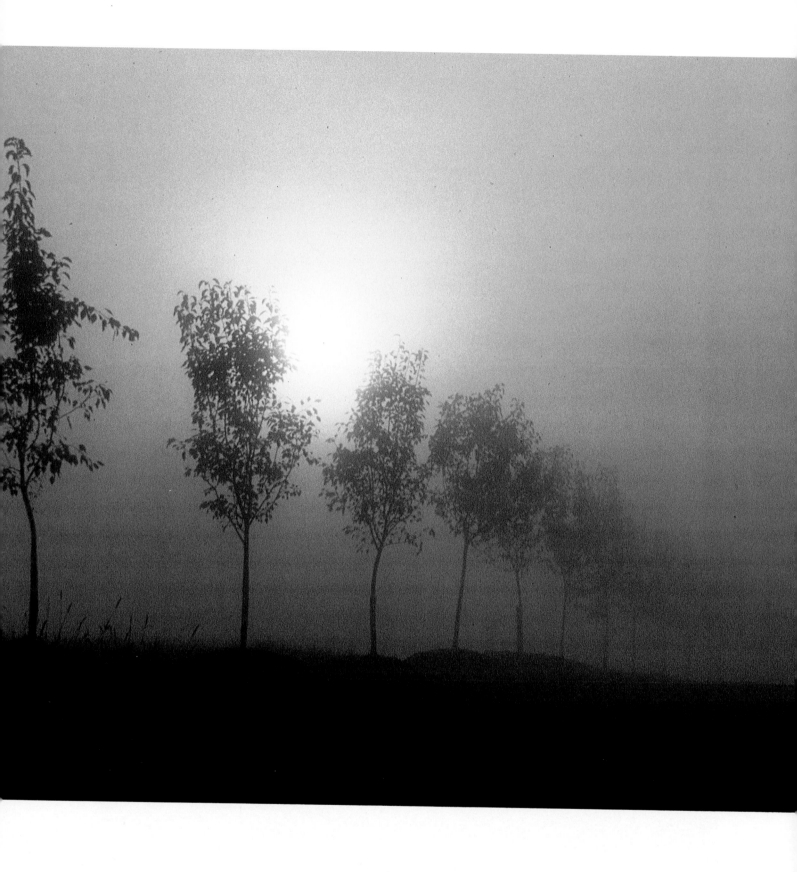

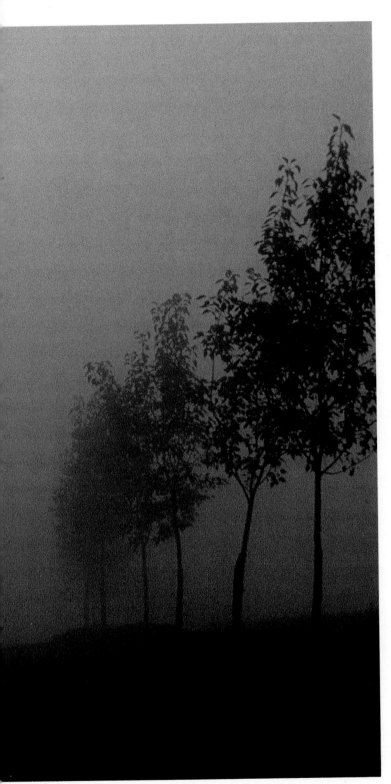

HOW THE WEATHER TRANSFORMS LIGHT

Because of technical limitations, early photography was an exercise in fair weather. Although many photographers still believe that this is the best—and safest—weather for producing an acceptable image and protecting photographic equipment, recent advances in photographic technology have made taking pictures of the landscape more than just a fair weather venture. The lighting conditions in different types of weather can add new excitement to a scene and can present a subject more effectively. Weather is the variable in the otherwise fixed equation of landscape photography and allows for some spontaneity. Since the weather alters the quality of light, as well as color (see Chapter 2), it poses a challenge to photographers. They must be sensitive to its effects and be able to determine when the weather and a particular landscape will combine to produce an evocative image.

My thoughts about integrating the weather into the creation of landscape photography differ from those of other photographers. Rather than imagining a picture of a specific area and waiting for "the right moment," I photograph subjects that look best under the prevailing weather conditions. I adapt to nature; I don't expect nature to adapt to me. Admittedly, this approach does not work for photographers working on an assignment. But knowing how various weather conditions can affect images is essential to exploring landscape photography's possibilities.

When I backed away from these trees and used a horizontal format, the scene looked less forceful but more mysterious. The trees disappeared into the fog, leading me to wonder what lay beyond. With a Canon FD 80–200mm lens set at the lower end of the focal length range, I metered on the part of the sky away from the sun and underexposed by a stop. The exposure was f/22 for ¹⁄₆₀ sec. on Kodachrome 64.

Cloudy Conditions

Overcast skies enable photographers to get deeper and more saturated colors, which is ideal for some subjects. The vibrant reds, yellows, and oranges of fall foliage look most spectacular when the sky is cloudy. Random hot spots, which are overexposed areas caused by the sun as it filters through the trees, do not pose a problem. Similarly, the rich colors of spring blossoms and summer flowers can be best captured under a cloud cover. Photographers also find that the interesting textures of tree branches and rocks are more prominent in pictures taken on cloudy days. And, during the winter, intricate patterns on ice, which is quite a reflective surface, appear most striking when photographed under the subdued lighting of overcast skies.

Hazy Conditions

While bright sunlight is necessary to capture the beauty of some areas, other landscapes can benefit from different weather conditions. Haze—the accumulation of fine, widely scattered particles of dust and moisture—reduces contrast and sharpness and dilutes color. Even under cloudless skies, harsh shadows can be avoided in this type of light.

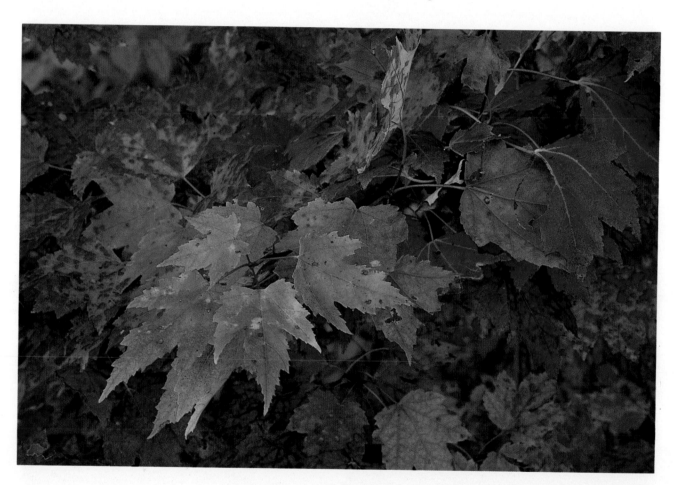

In the closeup above of the autumn leaves, taken under an overcast sky, the saturated colors suggested a sense of movement. The effect is similar to zooming. Using Kodachrome 64, a Canon FD 135mm lens, and my Canon FT, I exposed at f/22 for ¼ sec.

Driving through New Jersey's Hunterdon County on a cloudless autumn day, with only just a bit of haze enhancing the colors of the sunset, I was somewhat frustrated. The treetops frequently blocked the view, and the countryside was cluttered with developments. Capturing a grand vista seemed impossible. My frustration increased as the colors of the landscape deepened under the setting sun. I came upon the scene on the opposite page just before the sun went behind the ridge. The rich shades were intensified by the glow of the late afternoon sun, and the white steeple and dark shack added to the range of tones. Using a Canon FD 300mm lens mounted on my Canon F1, I exposed for the steeple at f/32 for ¼ sec. on Kodachrome 64.

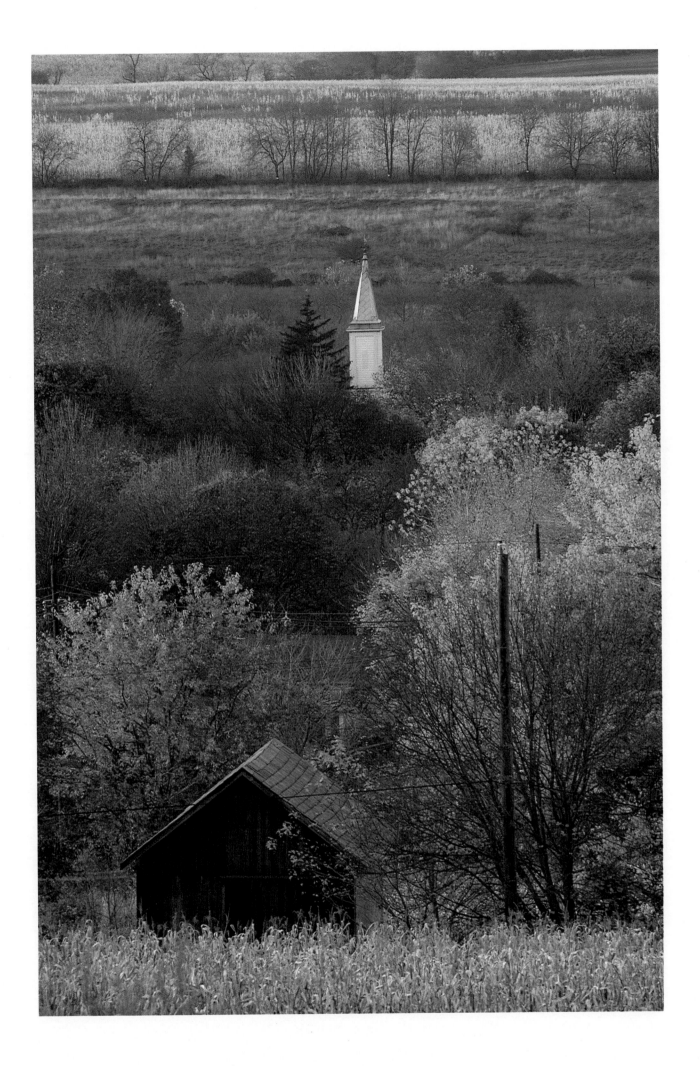

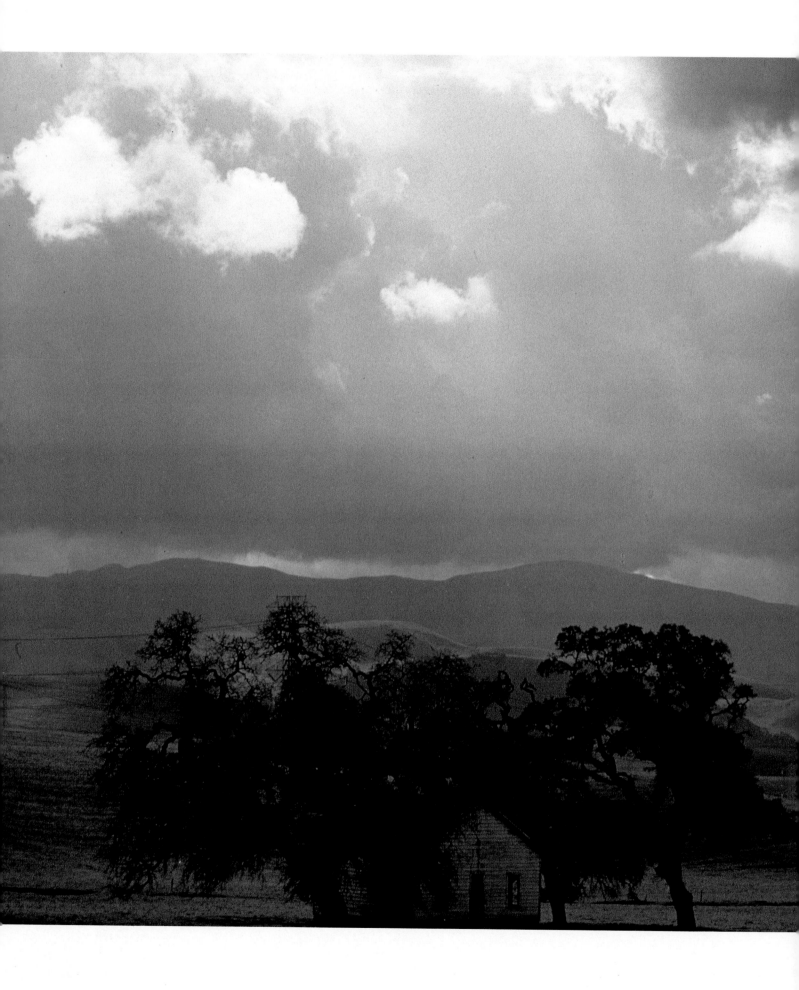

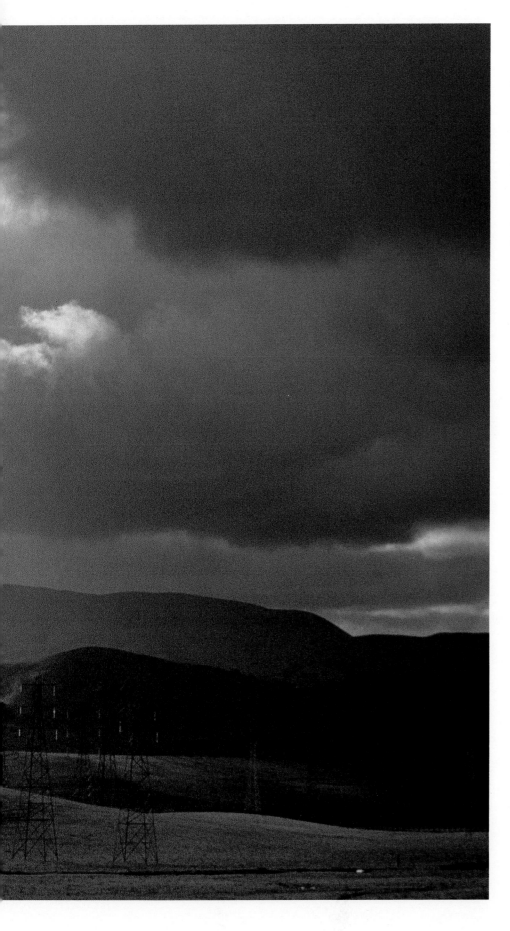

Pictures taken in hazy conditions often lack much contrast and color. But they can be dramatic. In this photograph of a winter storm in California, the clouds look ominous and remind me of nature's power. The trees seem to be trying to shield the small building from the impending storm. I used a Canon FD 80–200mm lens mounted on my Canon A1 to capture this image, and to compensate for my camera's averaging-metering system, I underexposed by one full stop at f/22 for 1/30 sec. on Kodachrome 64.

Windy Conditions

While pure white, fluffy clouds tend to grace the sky on windy days, the clouds' reflective nature helps to intensify the colors of the subject, creating quite an impact. But, as the afternoon proceeds, bright sunlight lessens in both quantity and intensity. The shadows cast by the clouds also divide the entire area below into an array of light and dark, enabling a small area to stand out. I call this "the stage effect": the shadows cover a nonessential part of the subject and spotlight the center of interest. The movement of the clouds also produces a continuously changing landscape.

Calm Conditions

The weather influences air quality. This can have an important effect on pictures requiring a long focal length. Sharp, crisp images can result only when the air is clear and free from smog and humidity. The weather also affects air movement. On clear, sunny mornings, the air is usually still. A large body of water can look like a mirror and can provide stunning reflections. During the rest of the day, there always seems to be a gentle breeze that creates ripples in the water. As the sun begins to set, calm returns and reflections appear in the lake once more.

The jet blue sky and puffy white clouds in the photograph on the right, which was taken on a windy day, complement the juniper tree that reaches toward the sky. The sense of motion is enhanced by the distortion resulting from the use of a 20mm lens held at a low angle. With my Canon FT, I exposed at f/16 for 1/125 sec. on Kodachrome 64.

For the image on the opposite page, using a 20mm wide-angle lens helped to create a pattern radiating from the falling leaves in the foreground to the reflecting trees in the water. And, because the reflecting treetop is actually farther away from the lens than the roots of the trees were, the tree lines merged toward the center of the water rather than at the top of the picture frame, which is what usually happens. Working with my Canon F1 and Kodachrome 64, I exposed at f/16 for 1/15 sec.

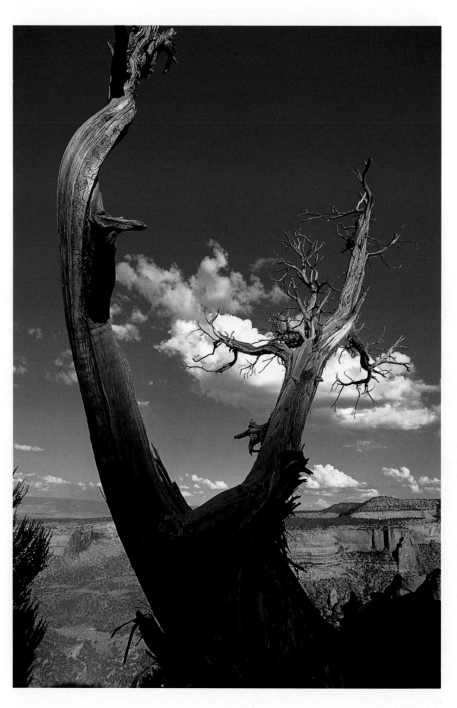

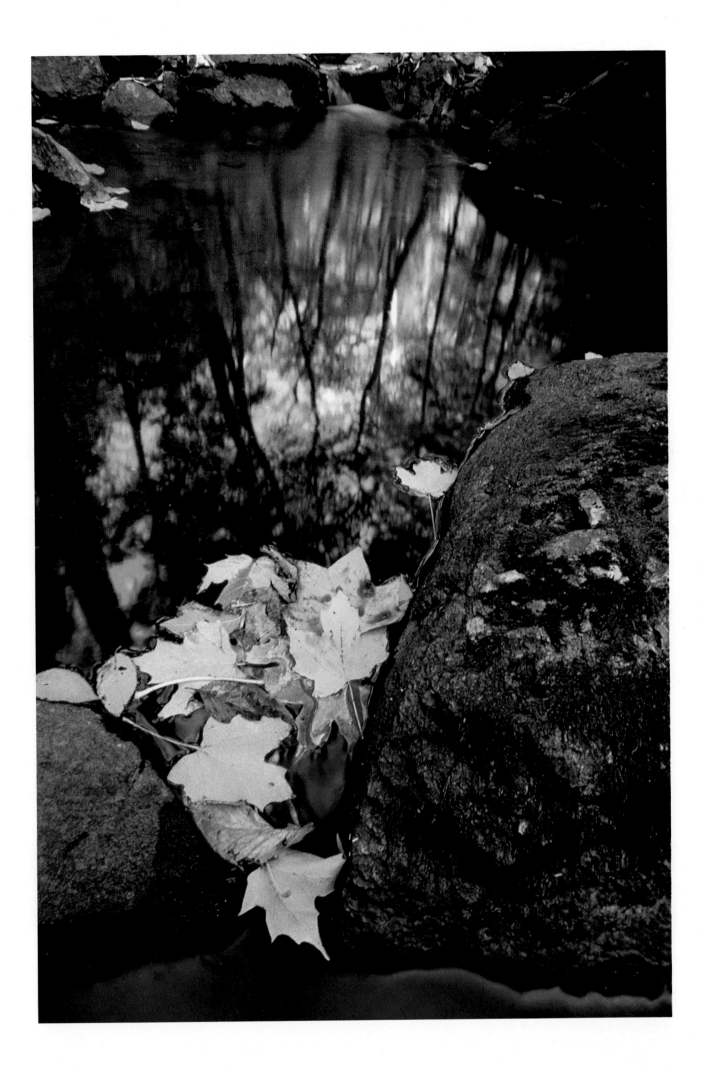

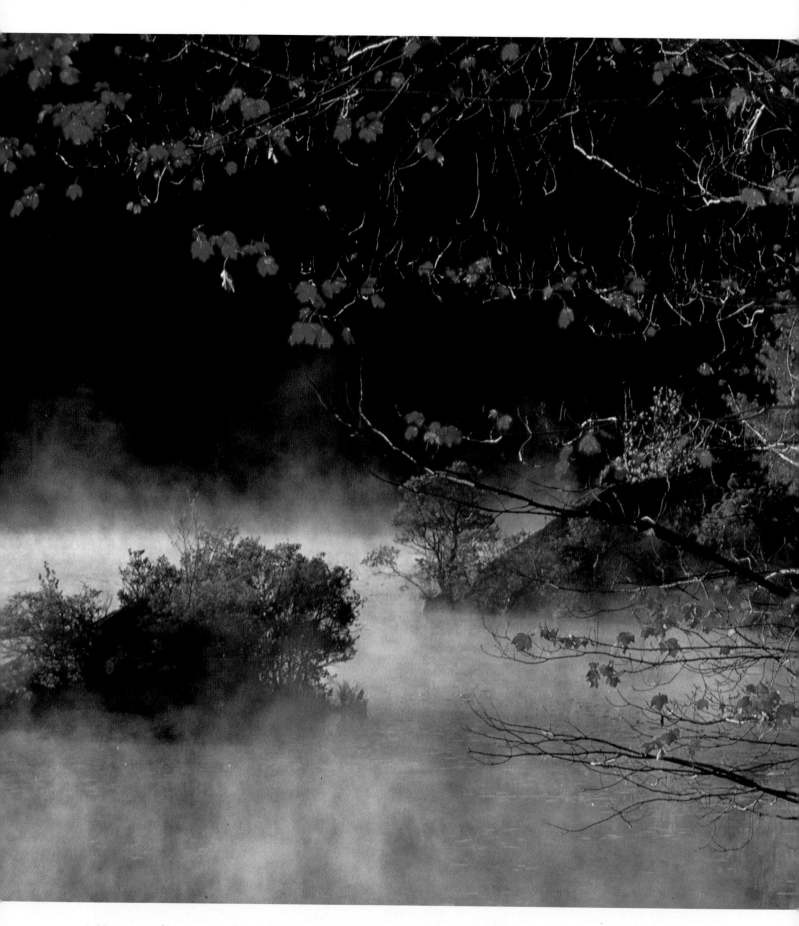

Morning sunshine can turn the mist covering the surface of a lake golden. In the image above, sidelighting reversed the usual positions of light and dark areas. The ground, which is ordinarily dark and in the lower part of a picture, was covered with mist, while the hills on the shore of the lake were in shadow. Metering on the darker portion of the mist, I exposed at f/22 for ⅛ sec. on Kodachrome 64 and used a Canon FD 80–200mm lens on my Canon F1.

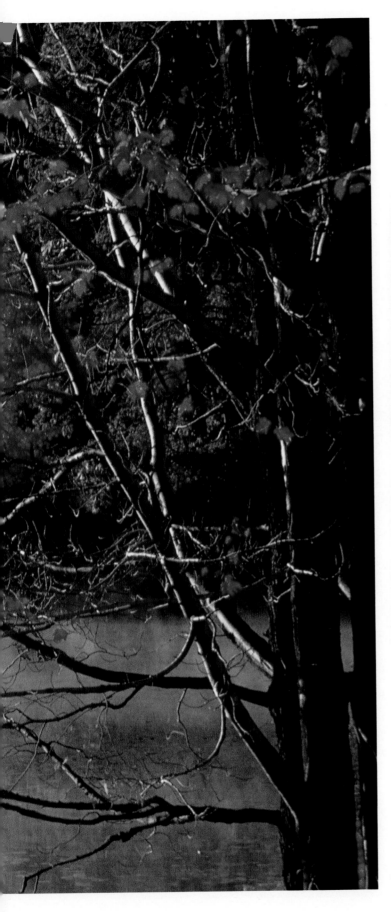

Misty Conditions

Early morning and early evening mist can soften the appearance of a landscape, creating an ethereal and sometimes melancholy feeling. Pictures taken in misty weather are not crisp or sharp; they are usually reminiscent of Impressionist paintings. Frequently, the mist makes colors look like pastels. And, when combined with the sun's first rays, the mist becomes golden and images more exciting and appealing.

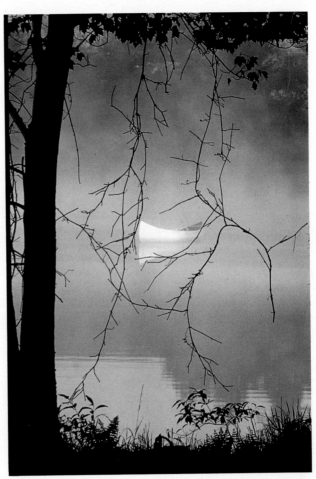

In the Pocono Mountains in Pennsylvania in late August, the cool air helped to condense the moisture rising from this lake. Framed by the tree and branches, the canoe in the photograph above was illuminated by the morning sun and seemed to float on the lake, much like a phantom. With a Canon FD 80–200mm lens mounted on my Canon F1, I metered on the canoe and overexposed by half a stop. The exposure was f/32, for maximum depth of field, for ⅛ sec. on Kodachrome 64.

Rainy Conditions

While few photographers venture out into the rain and many are frustrated by it, they should not hesitate to go out and shoot when the weather is poor—as long as they protect their equipment. In fact, I regard rainy days as some of the most exciting times to photograph. The weather dominates the landscape. The gathering storm and the light penetrating thick clouds make pictures of natural surroundings dramatic. Even the most ordinary scenes are transformed. When the rain ends, tree trunks darken and raindrops lingering on branches sparkle; the contrast can be quite striking. After a summer thunderstorm, the rapidly changing cloud patterns can enhance the beauty of any landscape. Rainy weather provides photographers with a challenge: no image can be repeated exactly the same way.

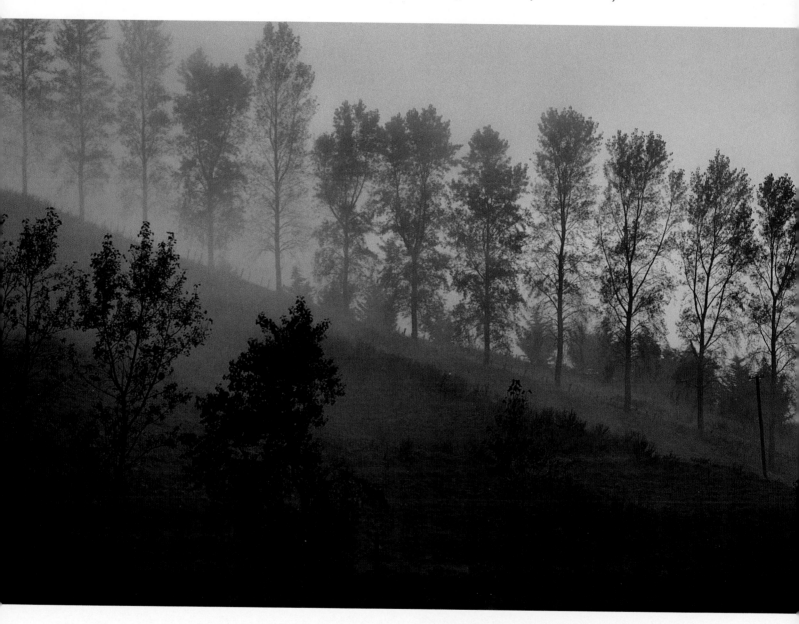

As this rain cloud ascended a hillside upon the end of a sudden shower, the slope was unveiled layer by layer. For this image, I used a Canon FD 80–200mm lens and my Canon F1. The exposure was f/16 for ⅛ sec. on Kodachrome 64.

THE ROLE SHADOWS PLAY

While for most beginners, photographing landscapes is usually the result of an afternoon outing when the weather is fair, some subjects in natural surroundings can be better presented under a different lighting condition. It is critical to understand the role shadows can play. Although illusory and unsubstantial, the shadows in a picture are just as important as the subject and should be an integral part of the scene.

Because their eyes have the ability to distinguish details in most shadows, many photographers never pay serious attention to them. But, unobtrusive to the naked eye, shadows become quite apparent on film. When in the field, photographers must train their eyes to see the way films see: with limited exposure latitudes. This is, however, easier to say than to do. And, to make the task even more difficult, negative and reversal (slide) films view shadows differently. Also, the images on negative films are printed on paper, which can be manipulated in the darkroom; this is an additional element photographers must consider when working with shadows.

The simplest way to become more sensitive to the presence—and the effects—of shadows is to squint. What people see when they squint is similar to what they see when the camera is in the stopped-down mode with the diaphragm closed down to the minimum: the contrast in the image is usually quite apparent. With a closed diaphragm or through squinting eyes, shadows become more noticeable. Photographers should regard shadows as an element in the selective process of picture-taking. They can establish chaos or order.

Walking along the shore of California's Mono Lake, I was fascinated by the delicate colors of the grass. Then I noticed how light and shadow isolated individual blades of grass. Suddenly, the image became a modern ballet in which one dancer posed and waited to receive another who was gliding across the stage. For this picture, I mounted a Canon FD 80–200mm lens on my Canon F1. The exposure was f/22 for 1/30 sec. on Kodachrome 64.

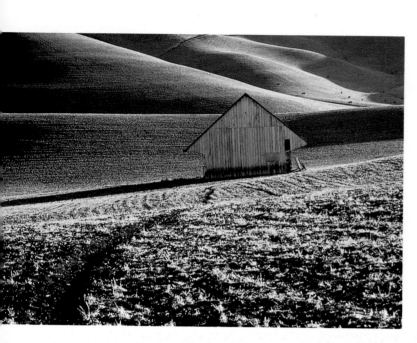

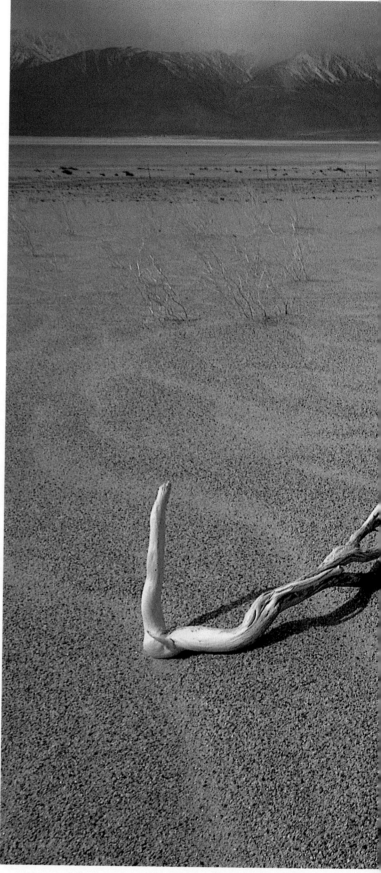

Just before sunset, the countryside near Livermore, California, comes to life through an exciting interplay of light and shadow. The small shack in the image above was not important; the real subjects were the lines of the roof and the wood, as well as the contours of the landscape surrounding the shack. Also, the dark track left by a tractor in the lower left corner invited me to approach the view. The various textures in the scene, which ranged from the very smooth to the very coarse, were accentuated by the light and shadow. This heightened the impact and visual interest of the photograph. Using a Canon FD 135mm lens on my Canon FT, I exposed at f/22 for 1/15 sec. on Kodachrome 25.

On a drive to California's Death Valley, I was afraid that a spring storm might wash away the possibility of a dazzling display of light and shadow on the sand. But the photograph of the parched landscape is dramatic. The twig in the foreground seems like a weary, thirsty traveler crawling across a desert as an ominous storm in the distance threatens—but, at the same time, promises relief. The shadow underneath the twig emphasizes its vulnerability. With a Canon FD 20mm lens mounted on my Canon A1, I exposed the scene at f/22 for 1/30 sec. on Kodachrome 64.

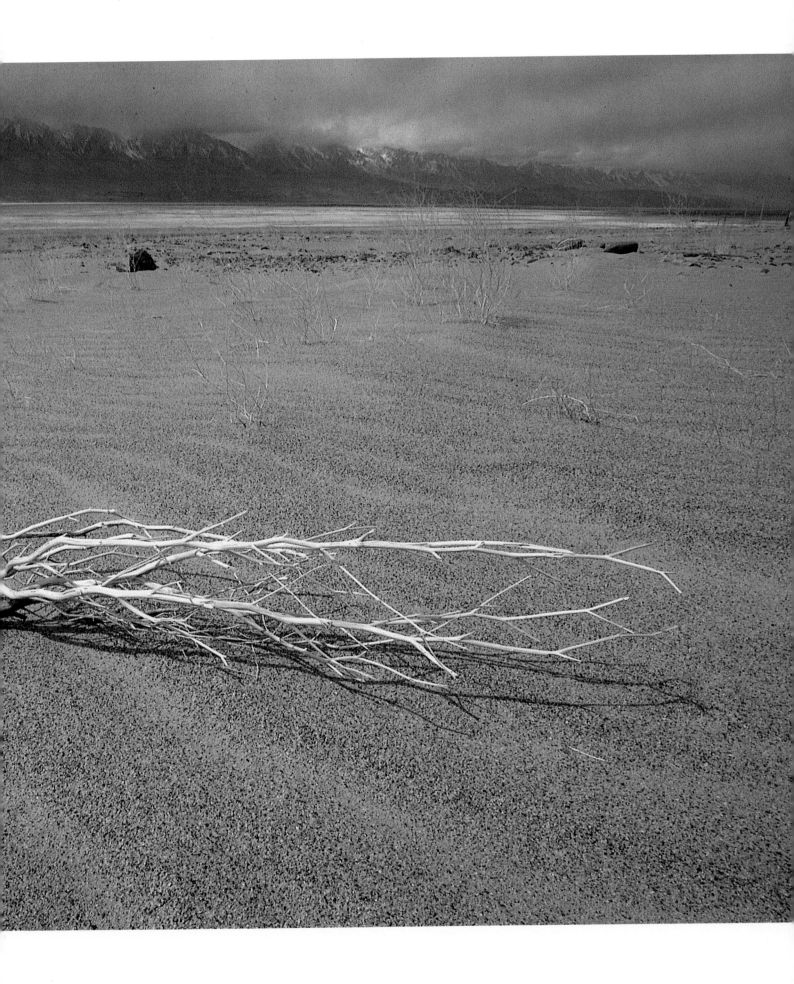

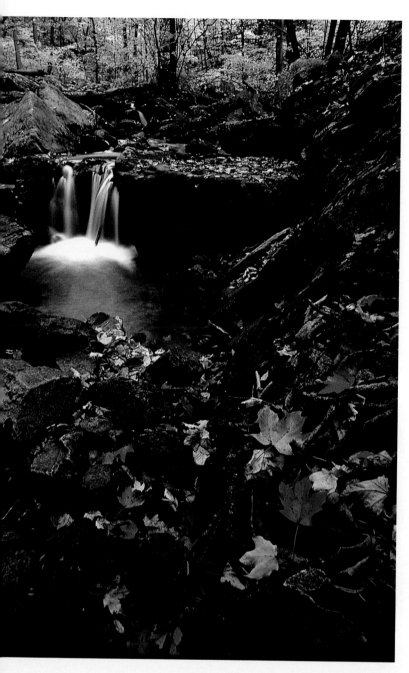

In this quiet corner of a nature preserve, autumn seemed to have arrived early: the red leaves contrasted with the distant trees that were still green. The small waterfall and the soft shadows added to the feeling of serenity in this landscape. Photographing with a Canon FD 20mm lens on my Canon F1, I exposed at f/16 for ¼ sec. on Kodachrome 64.

Shadows on Flowers and Foliage

For most pictures, shadows must be handled carefully. In closeups of flowers, it's best to display their soft, smooth petals without harsh and obtrusive shadows. Using a reflector, which can be simply a piece of household aluminum foil, minimizes shadows. While using a small aperture keeps everything in the picture reasonably focused, sunshine and shadows can make it much too contrasty. Although a larger aperture reduces contrast, it frequently causes glare in the background, overpowering the subject in the foreground.

Shadows on Running Water

When shooting water, photographers again find that the interplay of light and shadow differs greatly in various situations. Because of the uneven terrain of the riverbed and the speed of the flow, the surface of a rapidly running brook is far from smooth. It reflects sunlight randomly, producing contrasty, chaotic images. This happens with waterfalls as well. And, unless a neutral-density filter is used with them, most films available today partially stop the motion of a waterfall on sunny days. Photographers who wish to capture the rhythmic flow of a waterfall prefer soft lighting.

At the seashore, shooting in bright sunshine is essential if photographers want to freeze the motion of the tide and show the drops in the spray. While the turquoise water and white, sandy beaches might look inviting, the power and unpredictable nature of the ocean can best be captured under a partly cloudy sky at twilight.

Shadows on Ice and Snow

In the winter, snow can be made to sparkle under the sun, particularly when the sun is at the two (or ten) o'clock position. Patterns on ice, on the other hand, require diffused lighting conditions. Like a mirror, ice reflects sunlight and creates glaring, contrasty images.

Calculating Exposures

The most critical technical element when working with shadows is determining exposure. Overexposed areas can look like gaping holes, while severely underexposed areas can lack any detail. When the photographers shoot at midday with the sun behind them, they find that the lighting is more even, and the sophisticated averaging-meter systems in many 35mm single-lens-reflex (SLR) cameras work reasonably well. But once the sun moves to another position, many photographers notice that the averaging-meter system is inaccurate. To overcome this, some rate the film at a higher ISO than the one established by the manufacturer; this prevents overexposure. Others carry an extra light meter. Additional manipulation in the darkroom is another solution.

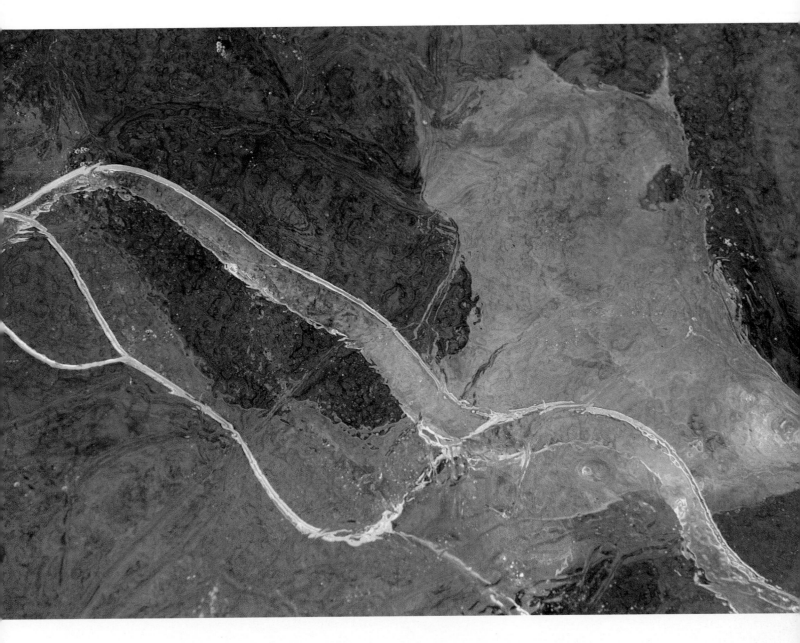

A fallen leaf that had been locked in ice created a compelling design. The edge of the leaf echoed the crack on the ice; this similarity established rhythm and a sense of movement. Because the entire scene was in the shade under a hazy sky, I was able to avoid glaring reflections. I mounted a Canon FD 80–200mm lens with a 25mm extension tube on my Canon F1, which I had loaded with Kodachrome 64. The exposure was f/22 for ¼ sec.

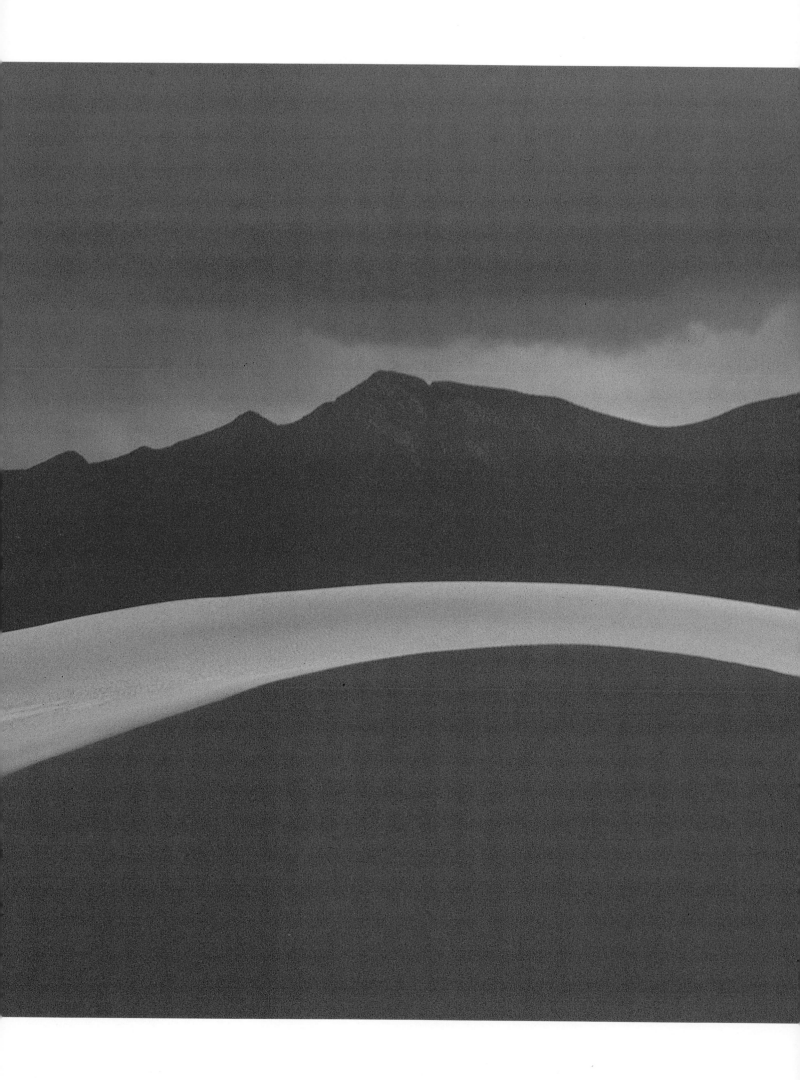

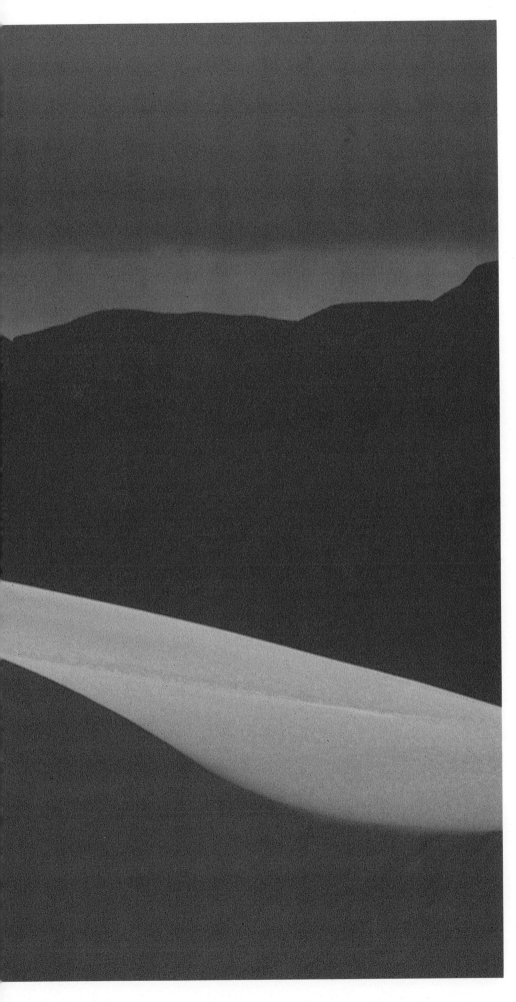

At the White Sands National Monument in New Mexico, a huge storm cloud darkened the distant hills and contrasted with the sand dune. A Canon FD 400mm lens compressed the distance between the cloud and the sky, and positioned the cloud directly over the dune. As a result, the image became a study of light and dark. With my Canon F1 and Kodachrome 64, I metered on the sand dune and exposed at ƒ/22 for ¹⁄₆₀ sec.

When I come upon an attractive scene, I first decide if the subjects within the scene will fall within the limited latitude range of the film. Next, using my camera's 12 percent metering system, I take a reading of the highlight. Depending on whether the highlight falls on a subject that is essentially gray (the 18 percent on the gray card) or on a brighter subject, such as snow, white sand, or fog, I expose according to the meter reading or give one-half to one stop overexposure. When photographing a sunrise or sunset, I find that taking a meter reading off the sun is not only unadvisable but also extremely inaccurate. It tends to throw the meter way off the scale. I usually try to take the meter reading off a part of the sky that is somewhat distant from the sun. To improve color saturation and to avoid having the sun appear to be an exploding bomb, I then underexpose

one or more stops according to this reading. (I prefer to take pictures immediately after sunrise or a couple of hours before sunset because the natural light is softer and subjects are more compatible with the limited latitude of the film. When in doubt, I bracket.)

When I use a camera with an averaging-meter system and negative film, properly determining the exposure is more difficult. Ordinarily, I take a meter reading with the center pointing toward the region under the highlight (whether or not I intend to place that at the center of the image) and underexpose the picture depending on the size of the space under the shadow. With negative film, I must calculate the exposure so that areas of interest in the shadow are distinguishable. The highlighted area is corrected during printing. But it is true that such a practice is far from precise.

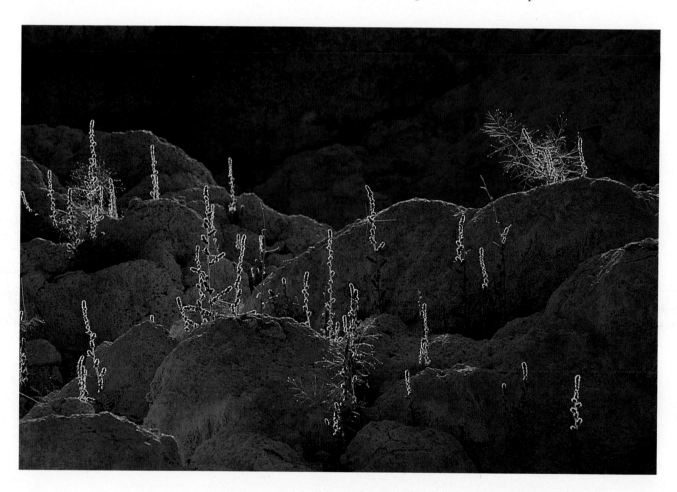

Half an hour after sunrise, Mono Lake in California looked breathtaking but offered few possibilities for originality. However, I soon noticed these tiny plants growing between the rocks. Backlighting made each one stand out. Using a Canon FD 80–200mm lens on my Canon FT, I metered on the plants. The exposure was f/22 for ⅟₆₀ sec. on Kodachrome 64.

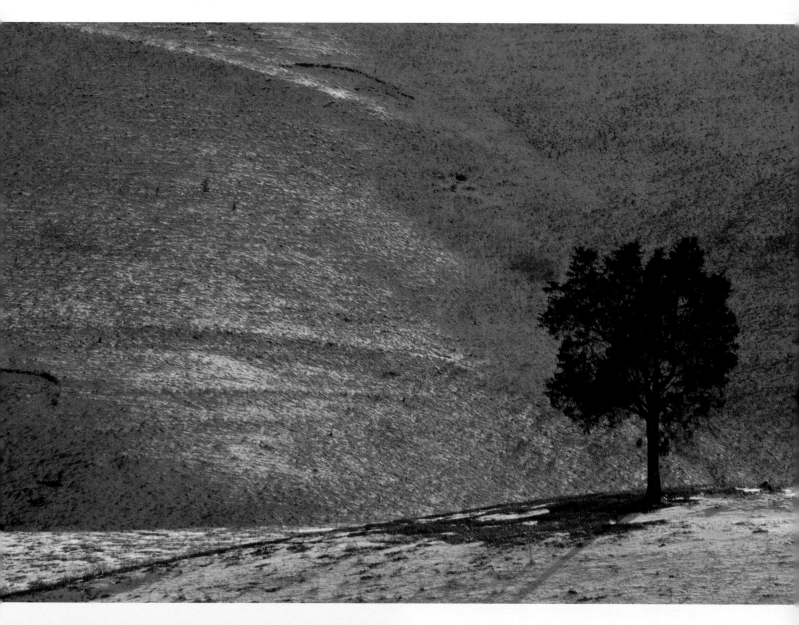

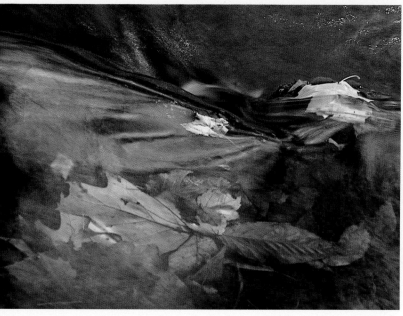

During a sudden February cold spell, several inches of snow fell in Virginia's Shenandoah Valley. But snow does not last long in this part of the United States. As I hurried toward the mountain several days afterward, I saw traces of brown earth, which added texture to the ground. Under the light from the afternoon sun, the snow-covered hillside seemed to almost radiate, and the lone tree to practically leap toward the camera. For the photograph above, I used my Canon F1 and a Canon FD 300mm lens. Metering on the snow, I exposed at f/22 for ⅛ sec. on Kodachrome 64.

To capture the colors of the autumn scene on the left, I needed to use a long lens. With a Canon FD 300mm lens on my Canon F1, the colors of the foliage reflected off the surface of the water and entered the camera. With a shorter lens closer to the edge of the water, the colors in the image would have been lost. The exposure was f/16 for ⅛ sec. on Kodachrome 64.

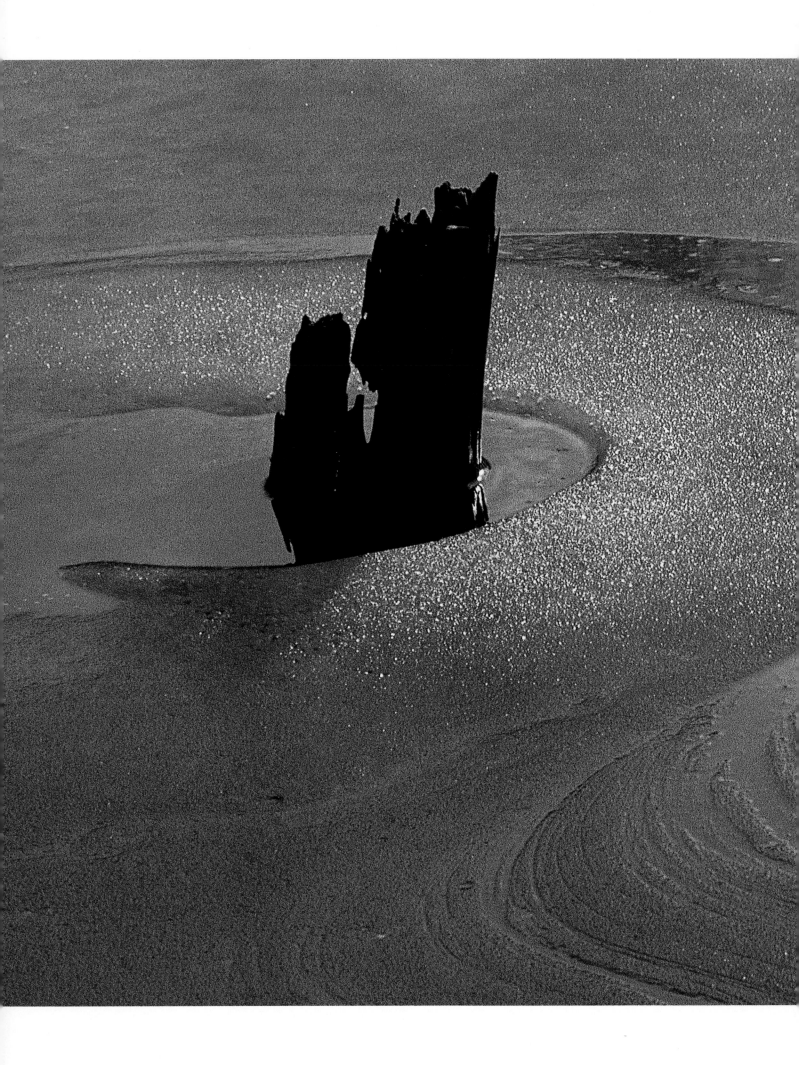

Driving through Cheesequake State Park in New Jersey on a sunny morning, I doubted that I would find an interesting subject to photograph. Most of the snow had melted, leaving dirty gray patches on the dead grass. Then I came upon this scene in one of the ponds in the park. Melting snow and ice, gleaming under the sun, swirled around this decayed stump. The contrast between light and dark and the motion of the ice created a beautiful image. With my Canon FT, mounted with a Canon FL 200mm lens, I exposed for the sparkling snow and ice at f/22 for 1/30 sec. on Agfachrome 50.

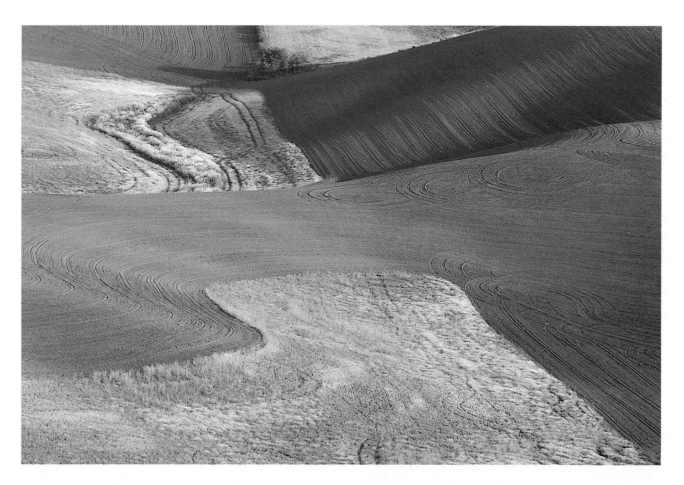

Although I did not understand why farmers had divided the field in this photograph this way, I found the view aesthetically exciting. The color and shape of this rolling wheat field, which I came across near Moscow, Idaho, formed a pattern that reminded me of an abstract Expressionist painting. With a Canon FD 80–200mm lens mounted on my Canon FT, I exposed for 1/15 sec. at f/22 on Kodachrome 64 to best capture the areas of light and dark.

Whichever technique for determining exposure is preferred, photographers must always remember that the presence of shadows reduces the accuracy of the meter reading. Whether this is a single reading taken off the light meter or an intricate calculation based on metering different areas included in the frame, using one setting to solve this complex problem—which involves the transformation of a full range of light into a medium with limited range—can be a challenge.

Mastering the nuances of calculating exposure, however, is as much an art as it is a science. Although properly adjusted cameras perform many of the same functions and operate in similar ways, different photographers achieve different, and often distinctive, results with them. And, photographers who shoot using the same camera and the same type of film for some time and bracket exposures the first few times they use the camera, come to learn how that particular camera responds in various situations. I believe that a camera and film are to a photographer what an instrument is to a musician. Both must practice until they develop a feeling for their tool, understand it intimately, and know its capabilities and limitations.

THE SPECTACULAR COLORS OF NATURE

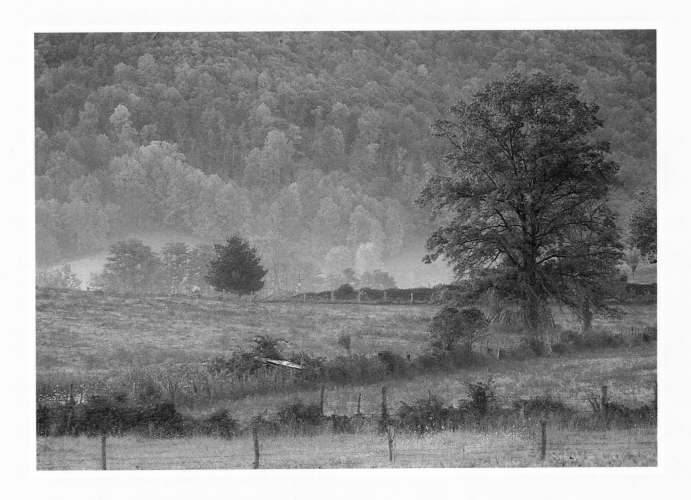

Softened by the morning mist, the autumn landscape in Virginia's Shenandoah National Park is reminiscent of an early Impressionist painting. I photographed this view of the foliage at its peak with a Canon FD 80–200mm lens set at 200mm. The morning glow of the sun before dawn blended with the blue sky, blanketing the countryside in deep magenta and purple. I was particularly struck by the ground mist separating the field from the hill in the background and the dark bushes dividing the field into patches. Using a Canon FT and Kodachrome 64, I exposed at f/16 for 1/15 sec.

Although modern color photography began with the introduction of Kodachrome in 1936, regarding it as an art form remains a somewhat controversial view. Explaining his decision to display and sell only black-and-white prints, a gallery owner remarked that the nonarchival quality of color prints makes them the ideal choice for interior decorators redesigning the offices of executives. "After all, these executives will stay on a job for only a few years," he said wryly.

While the quality and durability of color prints continue to improve, more serious problems associated with color remain: the restricted control of color that photographers have in relation to other visual artists—because of the limitations of and variations in film, the psychological assault of intense colors, and the resistance to the use of color in a medium established in black and white. Still, color is an integral part of our natural surroundings and cannot be ignored. I find that black-and-white work sometimes distances viewers; more specifically, I believe that black-and-white landscape photography tends to intellectualize images, making them seem impersonal and devoid of emotion.

HOW WEATHER AND LIGHT AFFECT COLOR

As all photographers know, sunshine tends to wash out colors. In fact, color saturation in landscape photography is directly related to both the weather and the quality of light. An overcast sky can introduce a blue cast to the landscape. Also, overcast conditions are usually accompanied by higher humidity, so to make panoramas sparkle, the moisture in the air must be properly illuminated. Unless an area is colorful, such as one filled with spring blossoms or autumn leaves, moisture can render the area gray and uninteresting. For the same reason, hazy weather doesn't ordinarily result in pictures with vivid color. In general, overcast days produce vibrant colors in closeups of natural surroundings.

Dramatic lighting—and dramatic photographs—occur when the sun is low or when weather patterns change. When it rains, the raindrops and high humidity reduce contrast and dilute color much the same way hazy weather conditions do. But, immediately after the rain, the colors of the landscape are much richer, especially those of subjects taken at close range. Also, the brightest colors can be captured when a cooler weather front pushes through an area. The winds that accompany the cool front blow away moisture and pollutants. Free of dust, most surfaces exhibit their true colors.

While changes in weather patterns frequently bring out dramatic lighting, preserving color saturation during, for example, a cloudburst can be tricky. The variation in light usually exceeds the limited latitude of the film. Unless the meter reading taken from the highlight is correct, the picture can look washed out.

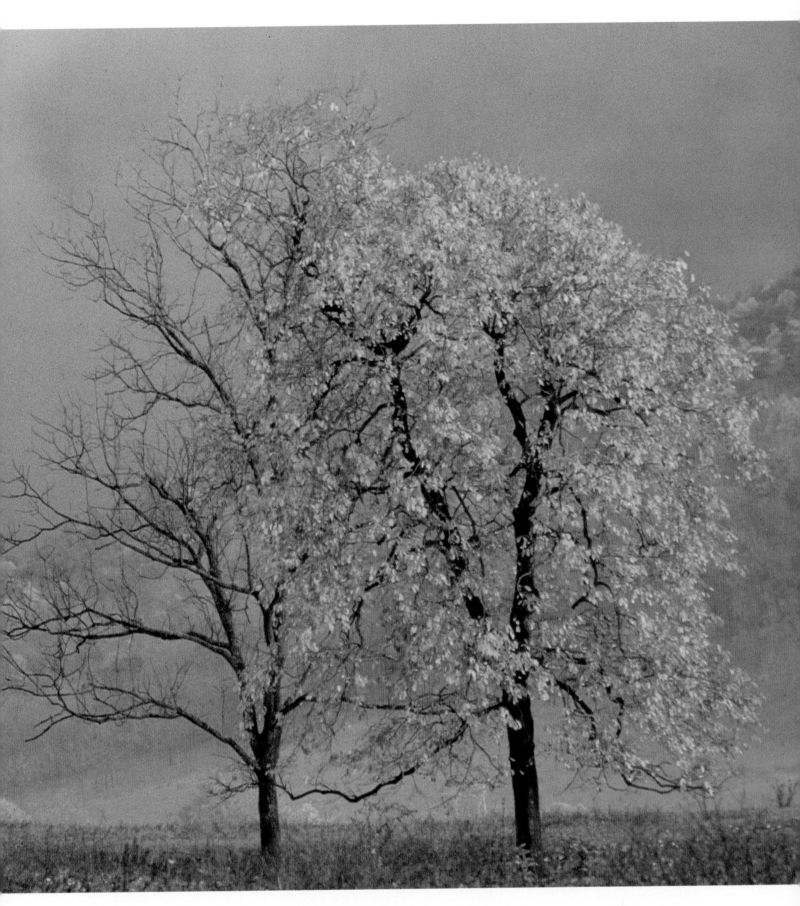

Early in the morning in the Shenandoah Valley, a dark cloud expanded into thick fog and moved rapidly. The pale sunshine on the autumn leaves provided a contrast between the background and the trees. With a Canon FD 300mm lens on my Canon F1, I metered on the mist. The exposure was f/22 for ⅛ sec. on Kodachrome 64.

53

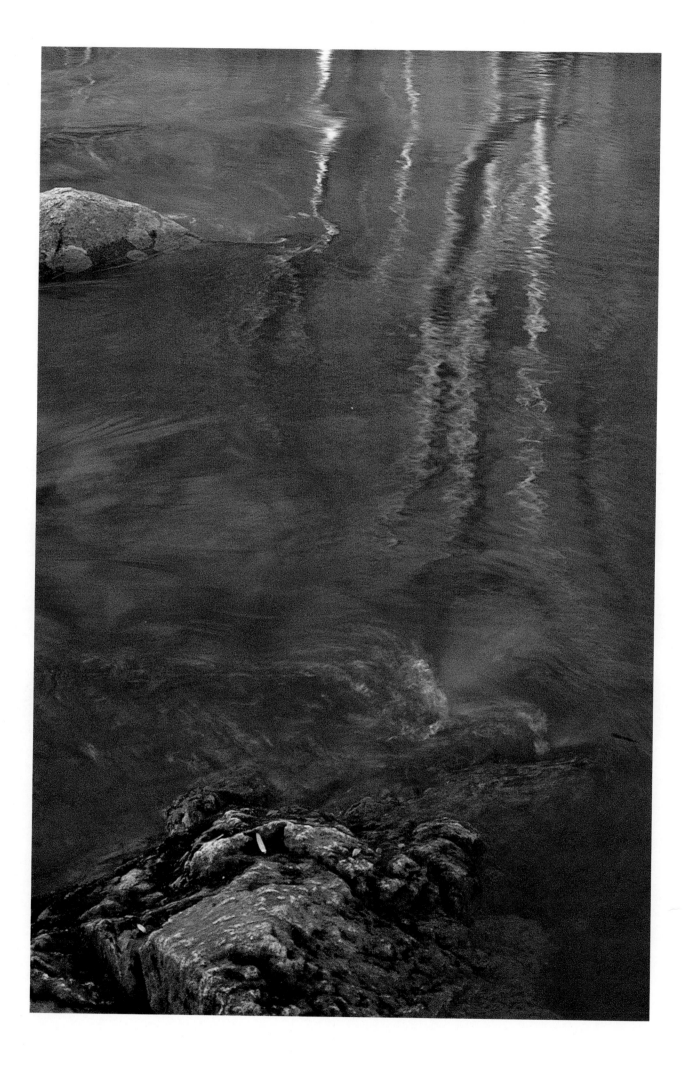

Although the sun is the primary light source for landscape images, reflected light provides a range of hues that are not ordinarily captured on film. Any reflective surface can act as a secondary source of light—but it is insignificant when the sun shines brightly. However, when the light from the sun is less intense, the light reflecting off a surface takes on the color of the surface. With a surface neutral in color, though, the reflected light is usually the color of the sky. Examples of this can be seen in photographs of ice and open water. And, although any excess blue can be eliminated through the use of a warming filter, I prefer to shoot areas in which the light reflecting off objects of different colors blends with that resulting from the blue sky.

Including hues of a variety of colors helps to enliven images of such common subjects as brooks and cascades. If, for example, in a particular location the water is in the shade and the trees in the background are bathed in sunlight, their primary color will be reflected in the water. This effect can be particularly striking when photographers try to capture the brilliant colors of autumn foliage.

Another way to add color to an image is to shoot a scene just before sunrise or in the very early evening. The morning sun gives off a golden hue; at twilight, the sun produces a pinkish or purplish cast, which results from the reddish glow of the sun and the dark blue of the sky. While the light reflected off a surface under a clear predawn sky or the afterglow at dusk is quite appealing, shooting the light directly at either of these times is tricky. The luminosity of the sky differs greatly from that of the ground. Using a graduated neutral-density filter can reduce the contrast.

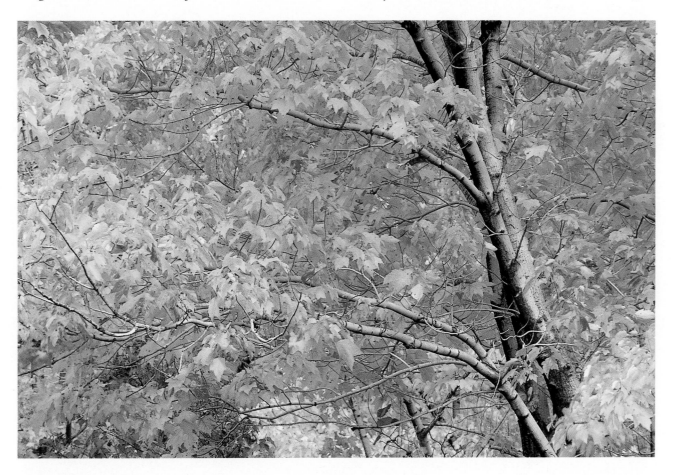

Although many trees and plants change color in the fall, trees near lakes and streams, which have a more abundant supply of moisture, seem more vibrant in color. In the closeup above, the silvery tree branch relieved the excessive warm tone and provided a structure. I used a Canon FD 80–200mm lens near the upper range to focus on the rich hues of the foliage rather than showing the entire tree in a more descriptive manner. With my Canon FT loaded with Kodachrome 64, I metered on the silvery branch and exposed at f/22 for ⅟₁₅ sec.

At Lockwood Gorge in New Jersey, with one side of the Raritan River always in sunshine and the other frequently in shadow, especially in the afternoon, the reflections in the river can be quite colorful and varied. In the image opposite, the reflection of the birch tree united illusion and reality. Using a Canon FD 135mm lens, my Canon FT, and Agfachrome 50, I metered on the reflection. The exposure was f/22 for ¼ sec.

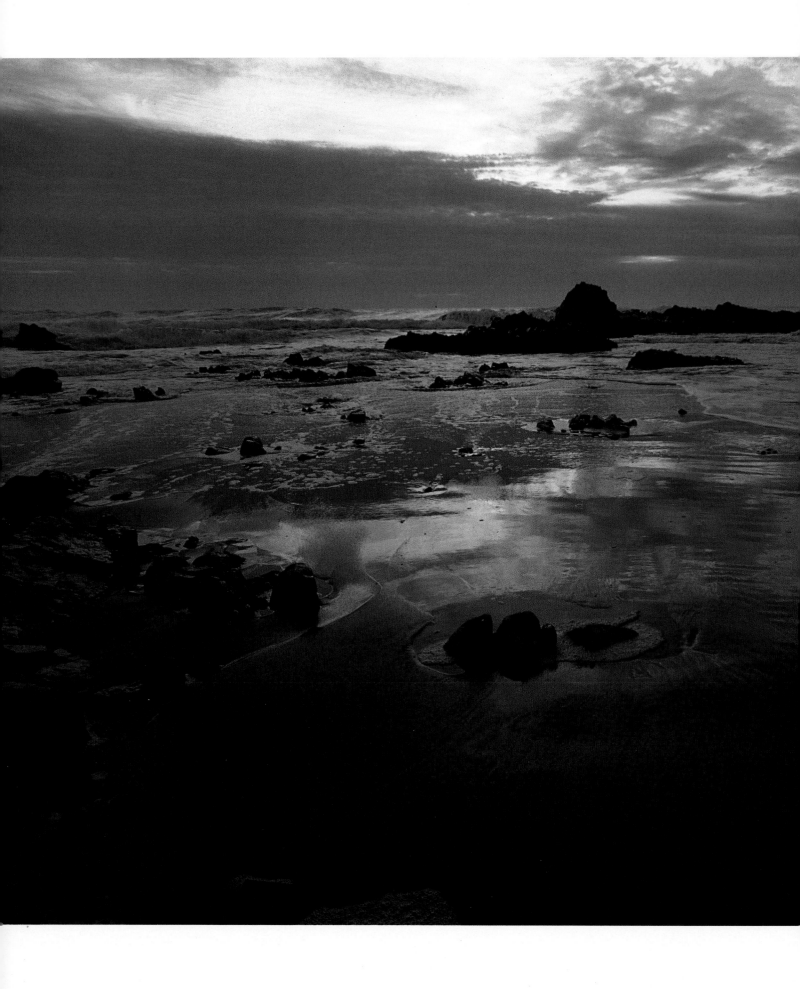

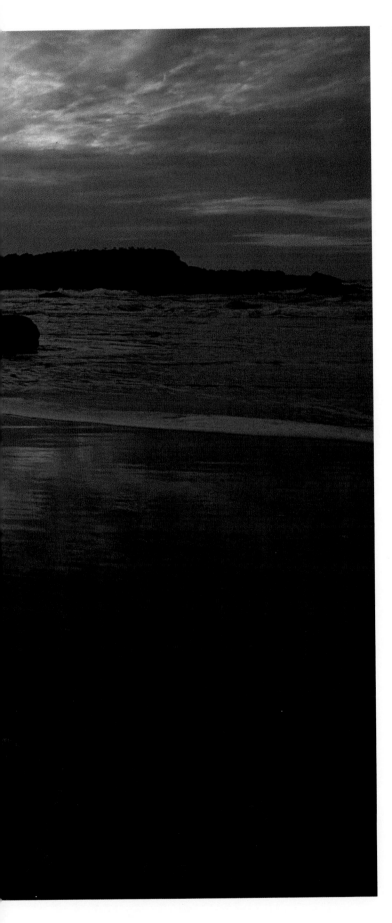

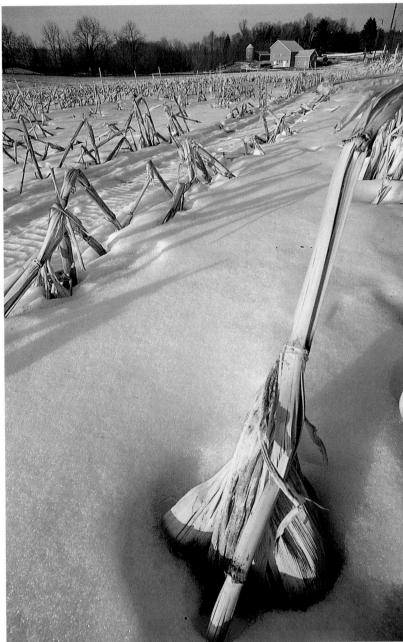

By using a Canon 20mm wide-angle lens with my Canon FT and moving close to the primary subject, I was able to emphasize the harvested cornstalks in the picture above. The photograph becomes a portrait of the golden stalks: everything else is relegated to the background. The exposure was f/22 for 1/15 sec. on Kodachrome 64.

Photographing a stormy sky with a wide-angle lens, I was struck by the muted colors of the landscape in the photograph at the left. I wanted to convey the power and unpredictable nature of the sea. For this image, I used a Canon FD 20mm lens on my Canon FT. Metering for the reflection on the sand, I exposed at f/16 for 1/30 sec. on Kodachrome 64.

PRESENTING COLORS REALISTICALLY

Nature offers color variations that no chemical can reproduce fully. The stylized, bold colors favored by commercial photographers are sneered at by some purists who think of them as exaggerated and inharmonious. Colorists regard color as the primary component of a photographic image. Unless a photographer wishes to create a fantasy world, using color elaborately in a picture makes it difficult for viewers to relate the image to an actual scene. An excess of vibrant colors can also prevent viewers from enjoying the peaceful quality found in natural surroundings.

While I accept that film cannot adequately reproduce the almost infinite number of hues in nature, I find that I can integrate color into my photography, creating a "stylized realism" (see Chapter 6). The colors in an image do not, however, have to produce a realistic rendition of a scene in the purest sense. Even an overall monochromatic color can elicit responses from viewers. But the colors in a landscape photograph do have to provide viewers with a sense of a close connection to a recognizable landscape.

THE IMPACT OF A SOLITARY TONE

Because landscape photographers have so little control of their subject, they often have to search for pleasing colors. In the field, then, the choice of one prominent color or color family is decided not by design but by chance. As such, the color affects the photographer who, in turn, incorporates this response into the final image. In this way, the photographer's perception affects viewers, and the use of color is another avenue of interpretation. A prominent color often helps to convey the photographer's impression of and reaction to a particular scene, while a color family shows off the rich diversity of the landscape.

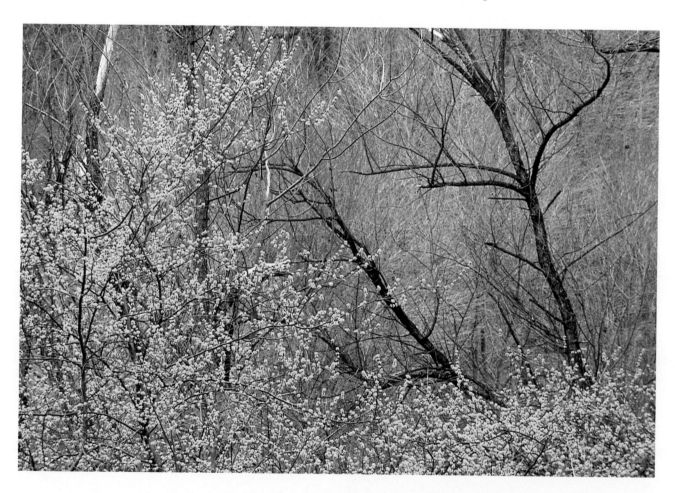

In the early spring, the subtle color changes taking place in the woods are most noticeable under the subdued light. For the photograph above, I used a Canon FD 300mm lens stopped down for maximum depth of field. This flattened the field, while the flat light enhanced the pastels in the landscape. Metering on both the bare trees and the forsythia, I exposed at f/32 for ¼ sec. on Kodachrome 64 with my Canon T90.

One late autumn morning, I looked out the window and found the surrounding area engulfed in dense fog. Remembering that some color still remained in the woods north of Oldwick, New Jersey, I drove there quickly. The mist helped create a gradation of gray tones, and the red leaves enlivened the image. I used an FD 80–200mm lens on my Canon F1, and Kodachrome 64. Metering on the fog and allowing half a stop more, I exposed at f/22 for ⅛ sec.

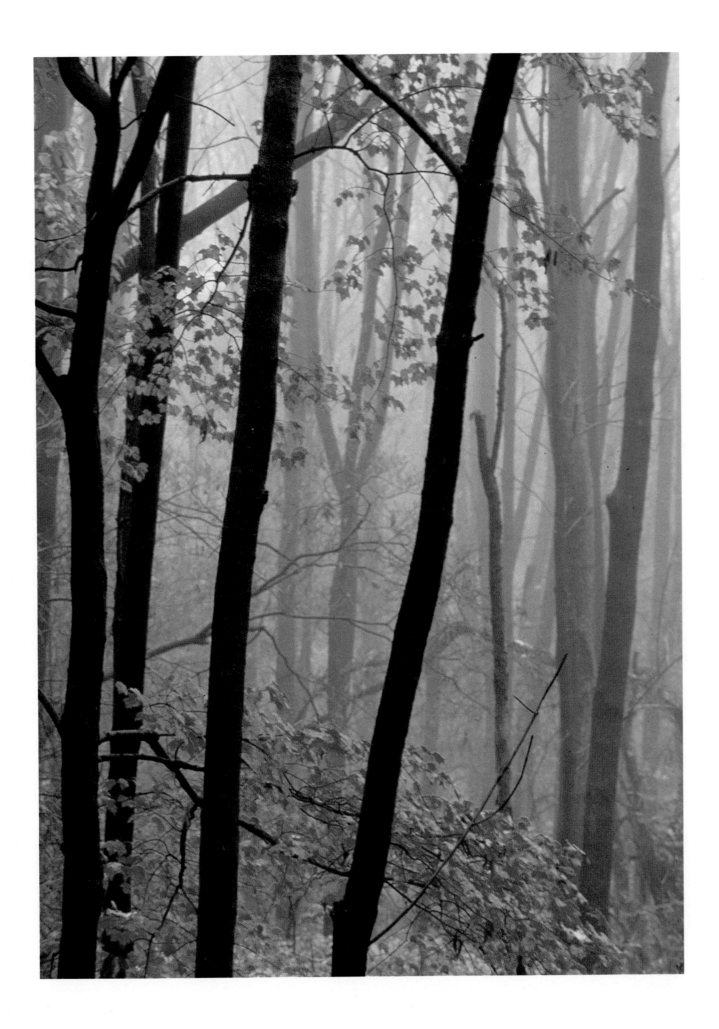

Enhancing Colors Naturally
Unlike the colors of manufactured objects, those found in nature are never stylized. Still, the saturation of natural colors can be enhanced when the sun appears near the horizon early in the day or late in the afternoon. Morning sunshine can add a touch of gold to a snow-covered terrain, which essentially looks black and white. In the late afternoon, the last rays of the sun can turn a snowy field pink. The colors seen at these times give viewers a sense of magic and a feeling of warmth.

Enhancing Colors Artificially
Although I try to avoid using filters, I often find that they are the most convenient way to improve nature's colors. The subtle shifts in color among different types of films can sometimes be corrected through the use of filters, usually a warming or cooling filter.

In addition, using an 81-series warming filter can increase the sense of intimacy present in photographs taken at midday; many people respond emotionally and favorably to warm images with red and orange hues. This type of filter is also quite effective in the winter: it reduces the bluish cast created by the clear sky on the reflective surfaces of ice and snow.

For scenes in which the sky is brighter than the land and the sun is behind the camera, a polarizing filter, or polarizer, works well. This filter diminishes glaring reflections, darkens the sky, and increases color saturation. But I dislike working with polarizers because of their tendency to produce unnatural hues; I think this commercializes a picture. Although most filters today, such as the skylight and UV (ultraviolet) filters can cut down the amount of haze frequently found in the atmosphere, they also seem to reduce nature's soft pastels.

THE INTRUSIVE ADDITION OF COLOR
Some photographers add color to landscape images through the inclusion of manufactured objects. But this makes color balance more difficult to achieve. Occasionally, such manipulated pictures can look artificial. While I have no objection to including a red barn in an image of a field at harvest time, the presence of a human model in bright, fashionable clothing always seems somewhat contrived. It also breaks up the natural harmony and composition of a landscape, which constitutes the essence of landscape photography.

THE IMPORTANCE OF COMPOSITION

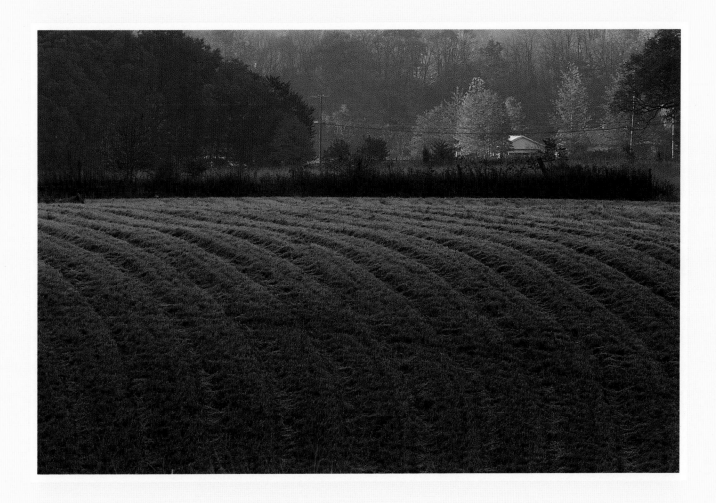

The morning sunshine accentuated the spot of red in this otherwise empty green field. I used a Canon FD 400mm lens to compress the field; I also wanted to contrast the foreground, which now looks massive, with the red tree tucked away in the background. With my Canon F1, I metered on the distant tree. The exposure was f/22 for ¼ sec. on Kodachrome 64.

To some photographers, discussing composition seems old-fashioned and too traditional. Other photographers equate composition with formalism. It truly is a matter of semantics to argue that a disregard of composition creates a style of composition. To compose a landscape photograph does not mean to "fit the shoe by trimming the foot," as a Chinese proverb goes. Rather than let a formal design dictate an image, photographers can compose a picture to effectively convey their feelings about a particular scene.

Composition is quite important in landscape photography for two reasons. Unlike natural surroundings, pictures have only a limited area in which subjects can be placed. As such, the position of subjects with respect to the border and to each other produces different effects. For example, the placement of the horizon can alter the meaning of a photograph. Positioning the horizon in the center of an image is frequently advised against: not only can the picture look static, but also strong tonal differences between the sky and the land can generate tension. But when tonal values above and below the horizon are compatible, centering it might suggest tranquility and serenity. Having the horizon in the lower part of a picture usually creates a feeling of wide open space, while moving the horizon to the upper region of a photograph suggests remoteness. Eliminating the horizon completely from a picture produces an abstract design.

The second reason why composing photographs is important is basically the invalidity of the argument that composing implies "staging." The "snapshot" style street photographers use to suggest spontaneity does not apply to the stillness and constancy of the natural landscape. The essence of landscape photography is to perceive and capture the natural world. Landscape photographers are observers, not designers, of their surroundings. It is through the thoughtful composition of images, not the manipulation of subjects, that landscape photographers attach meaning to their work. Composition is such an integral part of this type of photography that John Szarkowski, photography curator of New York's Museum of Modern Art, commenting on the work of Ansel Adams in a lecture given at Princeton University, declared that a landscape photographer must move around to achieve the best composition for a picture.

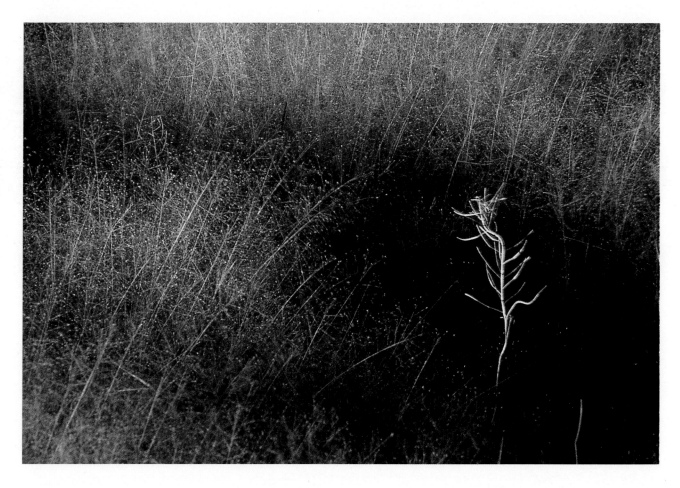

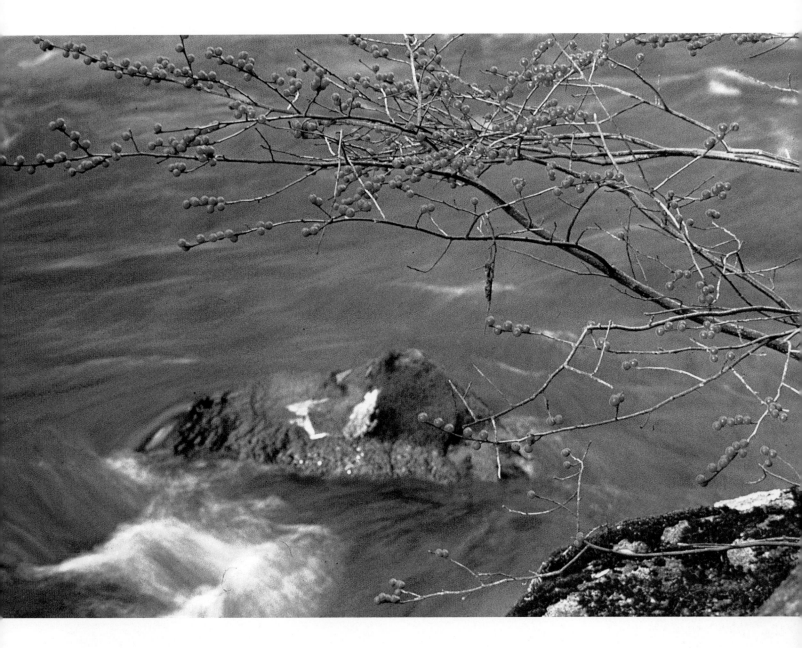

Photography is an art of selectivity. As such, unless photographers are in a studio, where they have complete control over what is included in an image, they should try to exclude any irrelevant or distracting elements. For the photograph above, I composed carefully so that the reflection of the foliage serves as the background and turns the water golden. Also, the berries add an important touch of red, and the rock near the center of the picture provides a base and balances the image. Using my Canon FT mounted with a Canon FD 135mm lens, I exposed for ⅛ sec. at ƒ/16 on Agfachrome 50.

I came upon the single blade of grass in the picture at left while photographing at Mono Lake in California. The shadow in this subtle but striking image isolates the blade of grass, spotlighting its solo performance. I mounted a Canon FD 80–200mm lens on my Canon FT and exposed at ƒ/22 for ⅓₀ sec. on Kodachrome 64.

THE ELEMENTS OF COMPOSITION

Understanding the basic elements of composition enables photographers to make their images visually effective. However, handling composition well requires artistry more than a rigid adherence to certain "rules." The following elements are arbitrarily arranged, but each one is important in terms of composition.

Balance

When landscape photographers shoot outdoors in an open space that has no frame of reference, such terms as "center" and "balance" have no meaning. When they include a limited section of the natural surroundings in a picture, however, a center is created and the space is automatically divided, albeit invisibly. Although a symmetric arrangement implies balance, balance goes well beyond symmetry. Symmetry can produce a beautiful design, creating an abstract pattern. But unless it is used in images of imposing edifices, symmetry tends to make realistic renditions of landscapes appear visually static.

Usually, balance within an image is the result of filling both sides with something discernible, establishing a relationship among patterns around the center, or simply avoiding unused—but not necessarily empty—space on one side. The art of achieving balance involves subtlety. A massive structure on one side of a picture can be balanced by a flying bird, for example, in the otherwise empty sky on the other side or a long tree at the edge of a frame. While a scene in which objects are balanced can create an impression of rivalry, thus generating tension, it can also make the image dull.

Clearly, the ways to create a sense of balance are far from rigid. Widely separated lines on one side of a picture can converge on the other side, and can be balanced by a motif at their intersection. Balance can also be achieved through the use of the S-shaped curve, which connects the different segments of a photograph, or through the use of color or tone alone. Images that are similar in tone throughout can appear balanced, as can those in which light and dark tones share relatively the same amount of space. A picture of the coast in which the land is on one side of the frame and the reflective ocean is on the other seems unbalanced when there is no boat or rock in the water. Unless huge waves are pounding toward the shore, open water is viewed as empty, unused space.

The warm climate of California's Yosemite Valley melts the fallen snow as the morning sunshine gives a touch of golden color to the rising mist. I set my Canon FD 80–200mm lens at its upper range so that the contour of the cliff and the sky would not show. By concentrating on the tree and the surrounding mist, I hoped to create a sense of mystery, as if a thick fog shrouded the area. With my Canon A1, I exposed at f/22 for 1/8 sec. on Kodachrome 64.

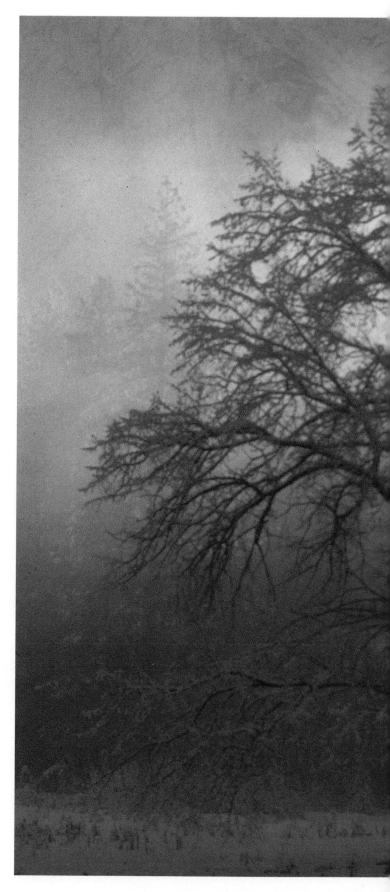

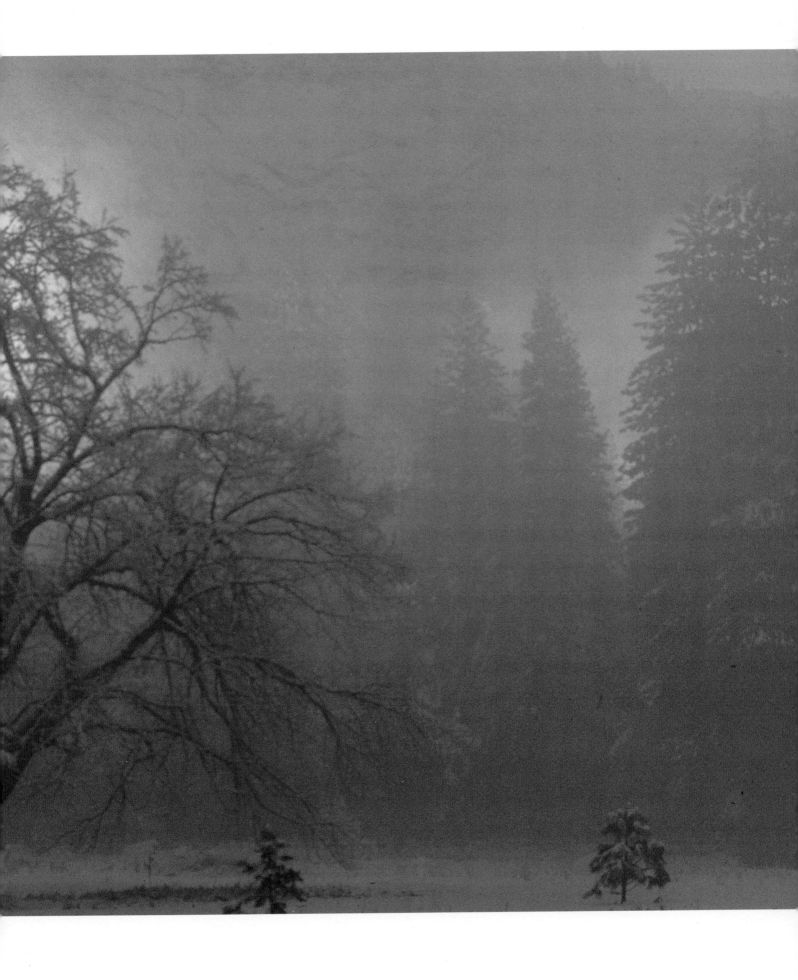

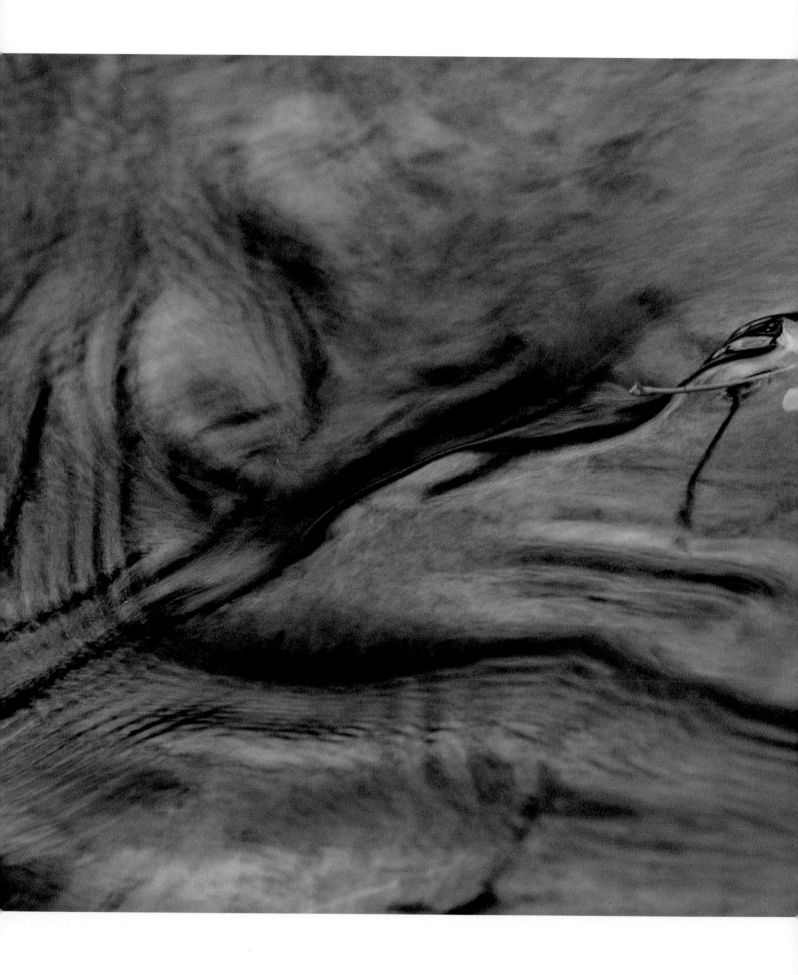

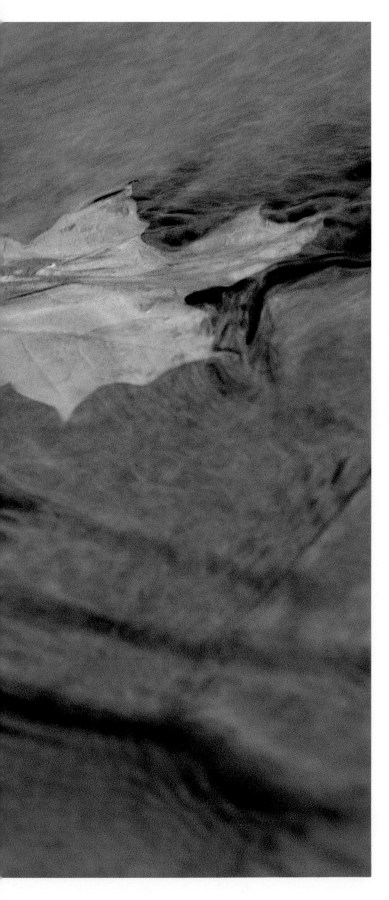

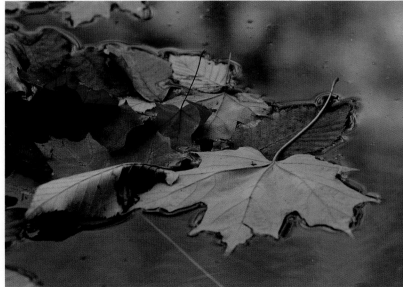

To capture the reflection of the leaves in the gold-colored water above, I needed to use a long lens. To balance the composition, I found it helpful to concentrate on one small part of the colorful reflection. Having mounted a Canon FD 80–200mm lens on my Canon F1, I metered on the water. The exposure was f/22 for ¼ sec. on Kodachrome 64.

The closeup on the left of a fallen leaf swirling in a body of water seems melancholy. The ripples in the brook, which are a primary element of this balanced composition, enhance the sense of sadness and of passing. With my Canon F1 and a Canon FD 80–200mm lens, I exposed at f/16 for ¹⁄₁₅ sec. on Kodachrome 64.

Taking pictures along the coast, or the banks of a widening river, can also produce sloping horizons. Such uneven lines usually appear whenever the edge of the terrain recedes from the camera. When there is no upright subject, such as a person, a pole, a building, or a peak, to balance the image, this can be done by slanting the camera slightly to compensate for the sloping horizontal line. The reverse is also possible if there is a massive, upright object to anchor the picture so that the slight tilt of the horizon becomes unnoticeable.

A lack of vertical balance can also be seen in pictures with a number of subjects toward the top of the frame. A picture of a shoreline in which the land is in the upper part of the image and the water is in the lower part appears top-heavy. When this happens, I usually include a strip of land at the bottom edge. This not only provides balance but also gives viewers a vantage point from which the scene unfolds.

The triangular rule of composition also produces vertical balance. When the image has a broad base, it is literally built from the bottom up. But an inverted triangle can also be striking. This type of balance creates imposing and awe-inspiring photographs, especially if a small yet distinct motif is visible near the bottom edge. On occasion, it can also suggest the precarious nature of the subject.

This is not to say that unbalanced, or asymmetric, designs are always objectionable to or unfulfilling for viewers. The boldness of such images can be arresting. The landscape determines whether or not this approach is appropriate.

Although the center of interest in this photograph is the sunlight on the ocean, the strip of land and the waves in the foreground balance the clouds in the upper edge of the frame. Here, I used a Canon FD 80–200mm lens with my Canon FT. I metered on the sunburst and exposed for ¹⁄₁₅ sec. at ƒ/16 on Kodachrome 64.

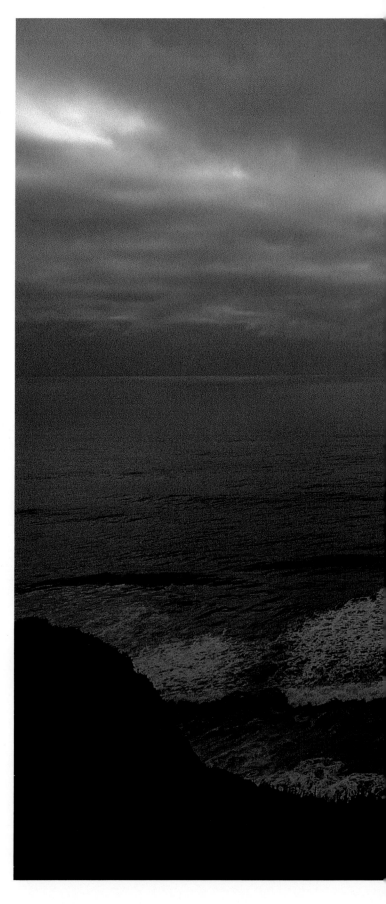

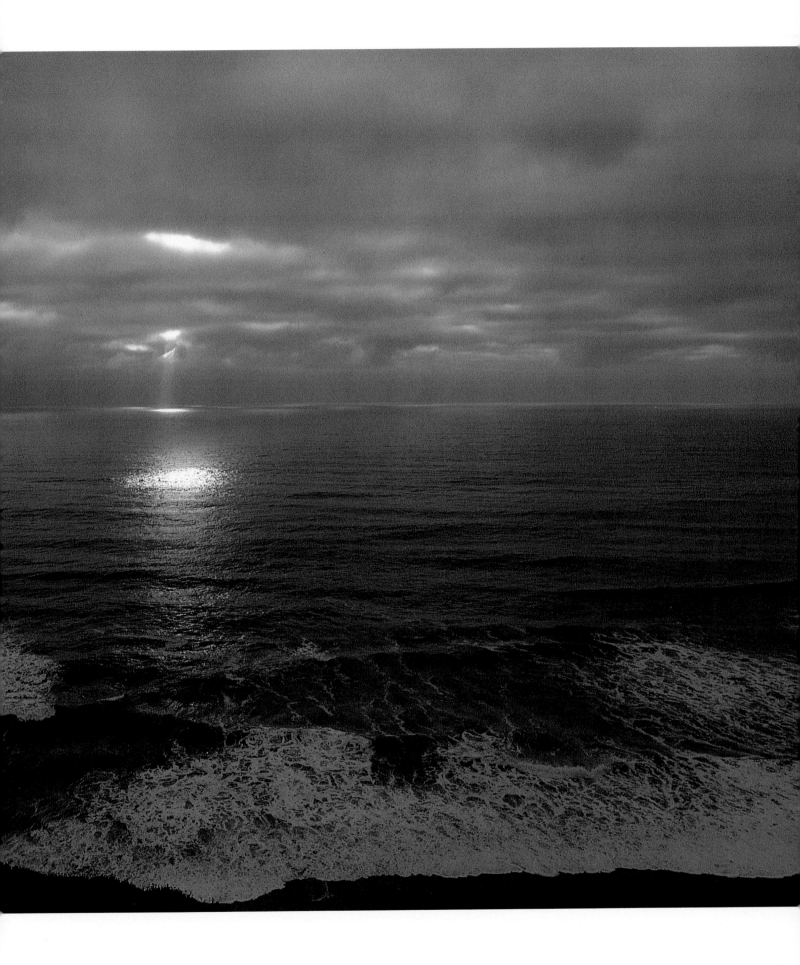

Proportion

In the limited area bound by the frame of a picture, subjects and colors cut the space into different shapes and forms. The way the space is divided makes quite an impression on viewers. An arrangement of similar shapes and sizes usually seems orderly but, at the same time, somewhat monotonous. The result is similar to that of cutting the picture area into halves or placing a subject at the center of the image. Dividing the picture space into areas of unequal sizes produces a more dynamic and interesting arrangement.

When photographers consider negative space in an image, proportion is particularly important. Negative space is any area in a picture that is not occupied by a physical object. The most obvious example of negative space is the open sky. The amount of sky included in a photograph and the contours at the edge of the horizon that define the shape of the sky are determined by the photographer. Negative space can complement the shapes of the subjects and become equally important to the image. Occasionally, because of its brightness, negative space can dominate the photograph.

Although proportion deals essentially with the arrangement of forms, the contours of these forms lead landscape photographers to consider the effect of lines on composition. Areas bounded by curves and wavy lines suggest movement, particularly if they differ slightly in size. Radiating patterns emanating from the center suggest power, while a shift of its center suggests liveliness.

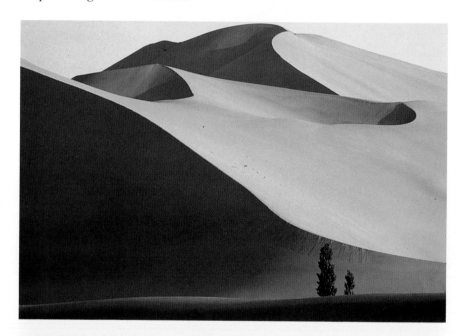

The contour and the looming presence of this dune suggest movement. More specifically, the curve of the dune in the upper part of this image seems like a winding river. Also, the poplars, which look small and fragile in comparison, but defiant, serve as a counterpoint to the imposing dune. Once again, I used a Canon FD 80–200mm lens and my Canon F1 but exposed at ƒ/22 for ¹⁄₁₅ sec. on Kodachrome 64.

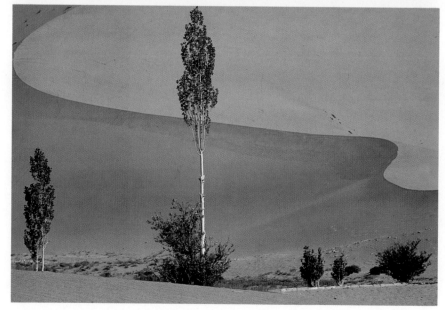

In this photograph, the vertical lines cut the dune in half and limit the sense of movement. The resulting image is less scenic but more intimate than the picture above. I used my Canon F1, a Canon FD 80–200mm lens, and Kodachrome 64, and exposed at ƒ/22 for ¹⁄₈ sec.

Using the poplar trees as a frame for the dune, I composed the image on the opposite page with one poplar on the left and three on the right. I felt that this division of the picture space worked well. I mounted a Canon FD 80–200mm lens on my Canon F1. The exposure was ƒ/22 for ¹⁄₁₅ sec. on Kodachrome 64.

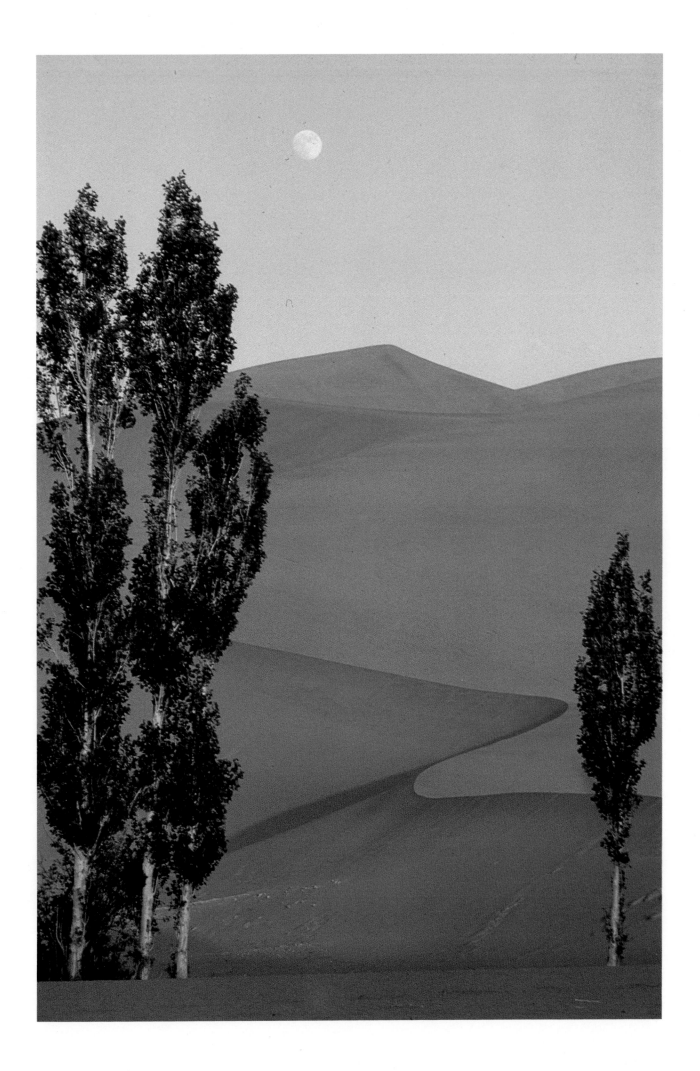

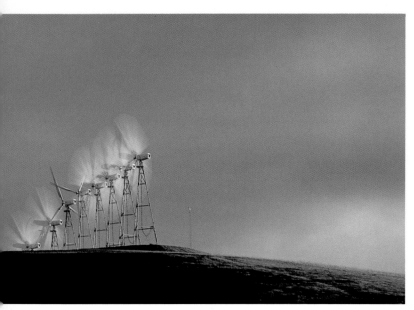

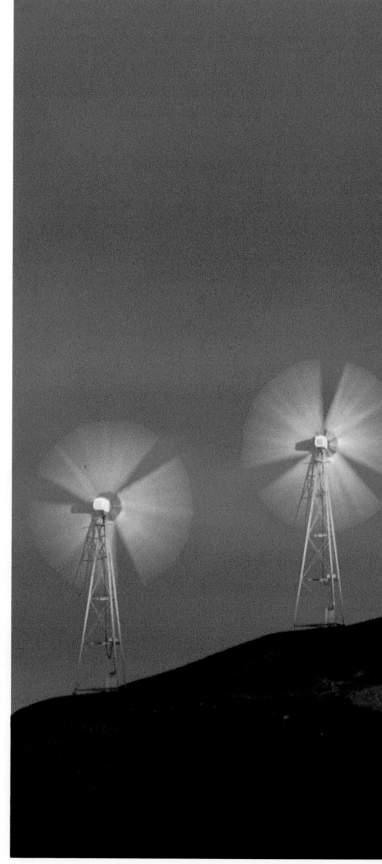

In these two photographs, the late afternoon sun highlights both the wind generators and the hillside. The picture above is an "airy" composition: the open space on the right side of the image allows the breeze to enter and to turn the generators. For this shot, I used my Canon F1 and a Canon FD 80–200mm lens and exposed for the sky at $f/16$ for $1/30$ sec. on Kodachrome 64. The picture to the right is less realistic. With the darkened sky serving as a backdrop, the generator blades fill much of the picture area as they reflect the sunlight. Here, I exposed for the reflected light at $f/22$ for $1/8$ sec. on Kodachrome 64 and used a Canon FD 300mm lens on my Canon F1.

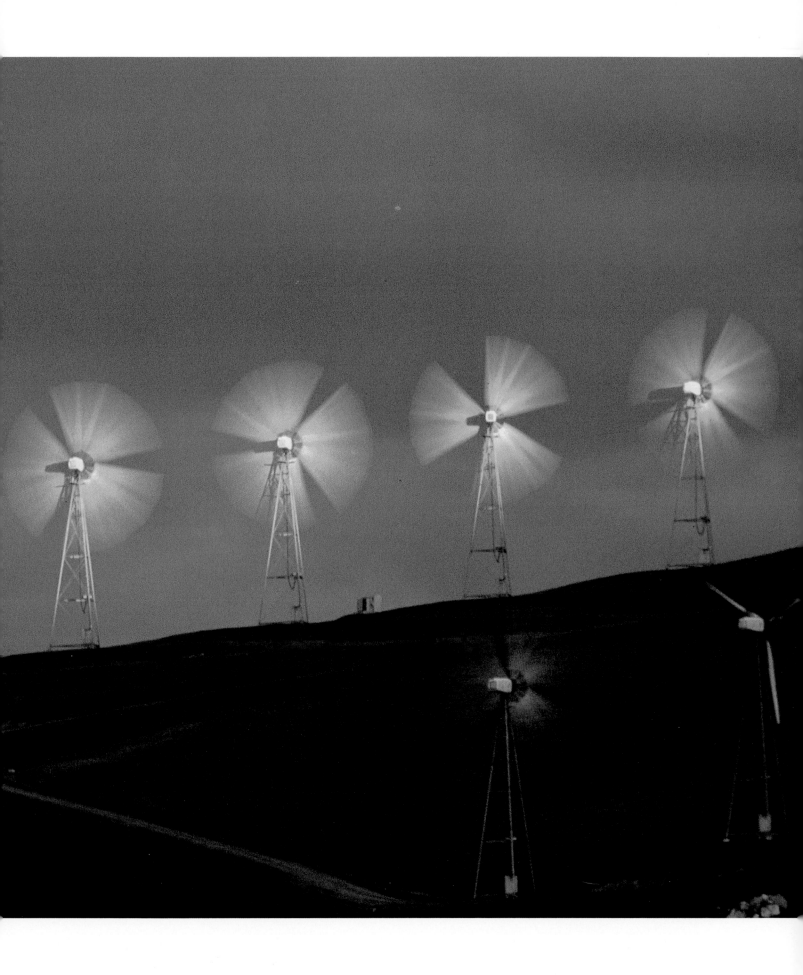

Emphasis

While this element of composition often suggests the center of interest in an image, photographers can effectively make a point without a center of interest. Landscape photographers must first decide which part of a scene best conveys their feelings about it and, as such, should be emphasized in the picture. I find the wheat fields on the rolling hills of western Idaho interesting: the abstract graphic design of these multicolored strips is usually quite strong. When the design isn't striking, I include a shack or a tree to carry the picture.

For any given landscape, a slight shift of the camera angle can change the emphasis completely. A perfectly symmetrical building, for example, cut in half either horizontally or vertically at the edge of the picture frame can lead viewers to think that the photographer composed the image this way to hide something. Similarly, an object positioned in the center of a picture can suggest its prominence and its harmonious relationship to its surroundings. But shifting the object to the edge of the picture frame gives a sense of movement.

If photographers wish to emphasize a center of interest, they can either zoom in on it or use natural light to single it out. Although a zoom lens can isolate the object

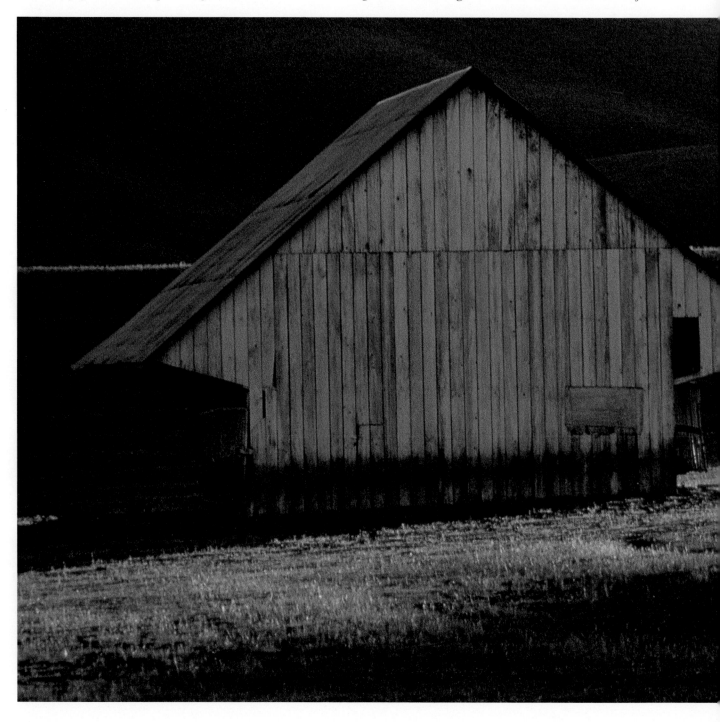

readily, photographers find that light can sometimes produce this effect, too. If the weather cooperates, the rays of the sun filtering through the clouds can draw viewers directly to the object.

I want to point out, however, that I find that including a person as the center of interest in a landscape photograph usually detracts from the scene. Most viewers would, naturally, be immediately drawn to the model, regardless of the person's position or function. Every other aspect of the landscape becomes less important. Photographers must have a clear understanding and vision of what they wish to emphasize.

This hillside in Livermore Valley, California, seemed desolate until the interplay of light and shadow enlivened it. As the last ray of the sun skimmed the rolling field, the emphasis shifted from the subject itself to the design created by the light and dark areas. I used a Canon FD 135mm lens on my Canon FT. Metering on the ridge still in the sun, I exposed at f/22, to maximize the contrast, for 1/15 sec. on Kodachrome 64.

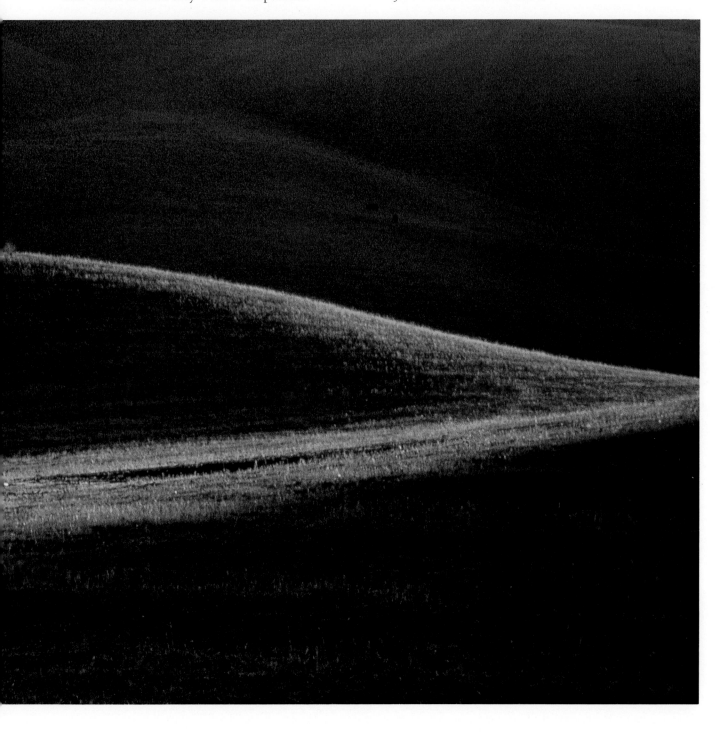

Contrast

Both color images and black-and-white photographs that include a full range of tones can have quite a visual impact. A monochromatic print with only the medium gray tone usually fails to generate much excitement. Light, which helps to produce the tonal range, plays an important part in determining an image's contrast.

One of the advantages of working with color is the subtle but pleasing contrast generated by colors of the same value. In a black-and-white photograph, these colors can look like barely distinguishable shades of gray. But in a color picture, photographers can produce sufficient color contrast and texture, even under subdued lighting. The result is reminiscent of an oil painting.

But this very advantage of having color also creates the need for color harmony, an issue that photographers working in black and white do not have to be concerned

about. Still, since the colors found in nature are seldom slick and loud, clashing colors pose less of a problem in landscape photography than in any other type. More important is the way severe contrasts in tone can turn a picture into a disjointed collage of colors, with dark regions looking like gaping black holes or cracks in the image. This potential problem can be even more serious when photographers want to use subdued lighting to enhance color saturation. Here again, the fundamental issue of sensitively handling shadows becomes critical.

Although misty air reduces the chances of creating effective contrasts, an extensive tonal range can be produced if the photographer places a silhouetted subject in the foreground of an image. But including a colorful subject can brighten the picture and increase its impact. In addition, mist can help to turn colors in the receding background into soft, pleasing pastels and to create a range of grays in black-and-white images.

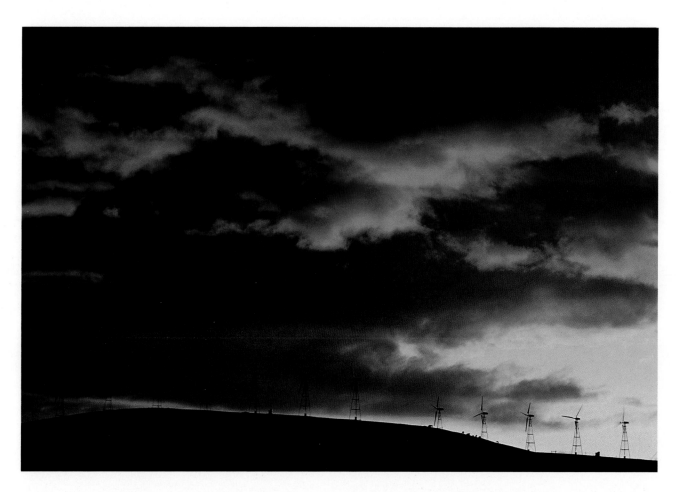

As the sun sets, this storm cloud became a blaze of color. To capture this striking image,
I mounted a Canon FD 80–200mm lens on my Canon F1 and metered on the bright sky
in the bottom right corner. The exposure was f/16 for 1/60 sec. on Kodachrome 64.

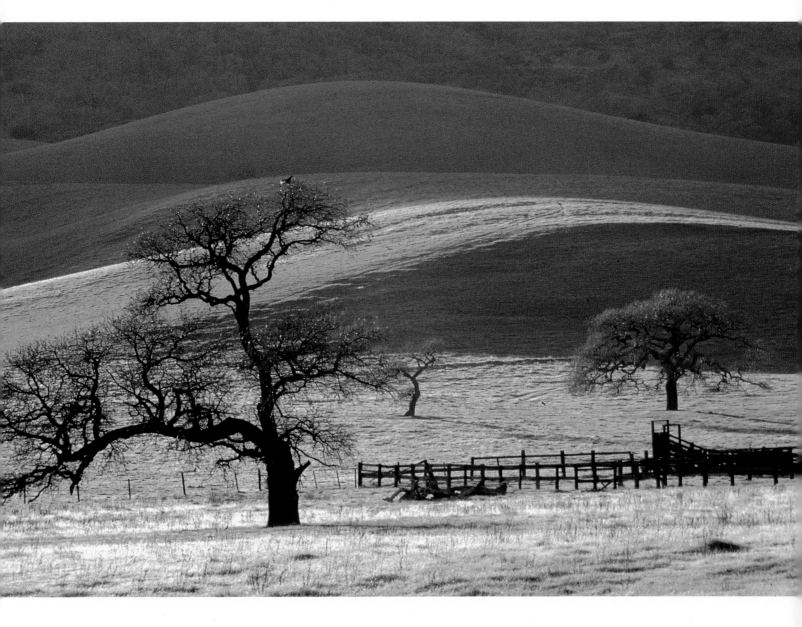

As I drove along Vasco Road north of Livermore, California, on a February afternoon, the contour of the hill caught the light in a dramatic way. I used a Canon FD 80–200mm lens near the long end with my Canon FT; I metered for the ridge in the sun and exposed for ¹⁄₁₅ sec. at f/22 on Kodachrome 64.

The dark trees looming above the pale yellow field in this picture provide contrast. Metering on the plants in the foreground, I exposed at f/32 for ¹⁄₁₅ sec. on Kodachrome 64. I used a Canon FD 300mm lens with my Canon F1.

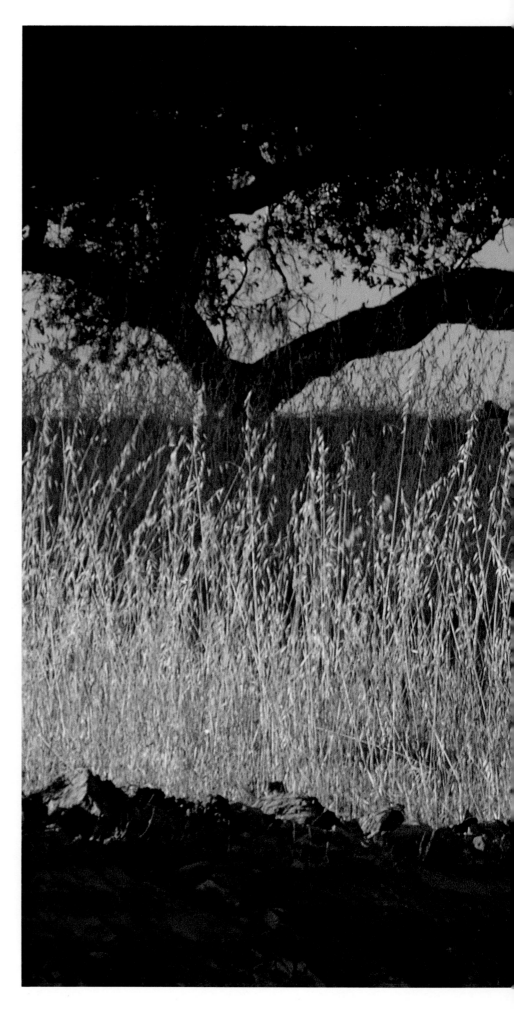

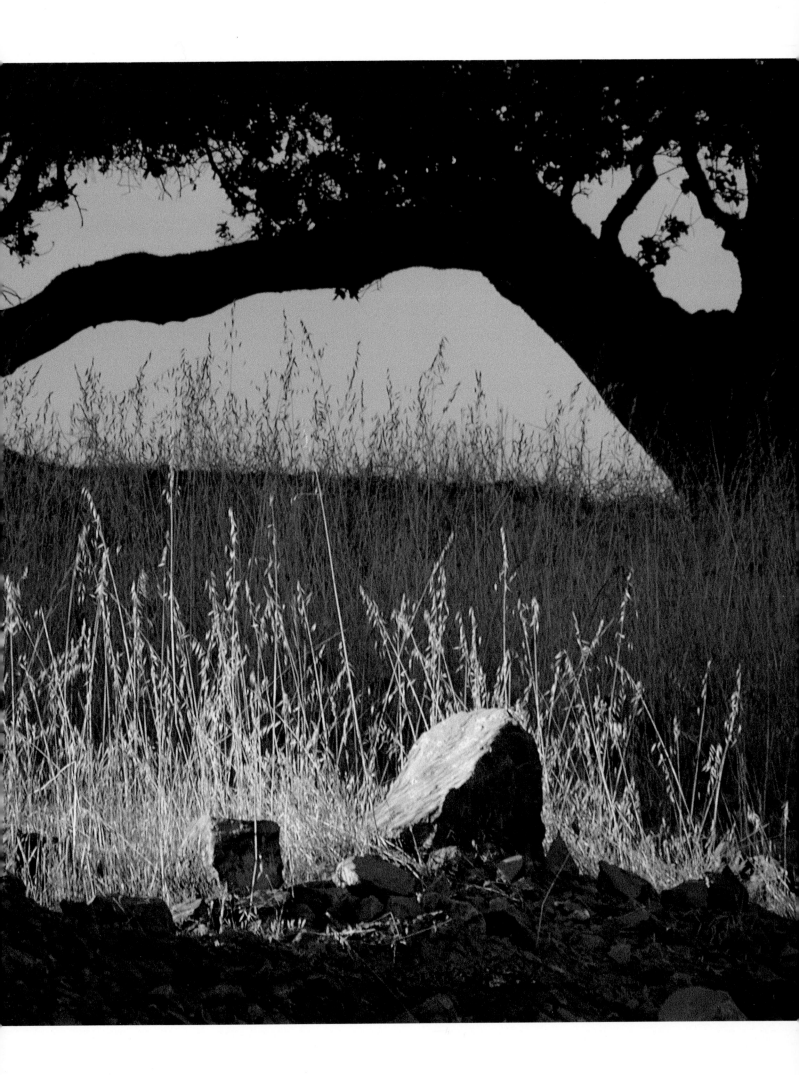

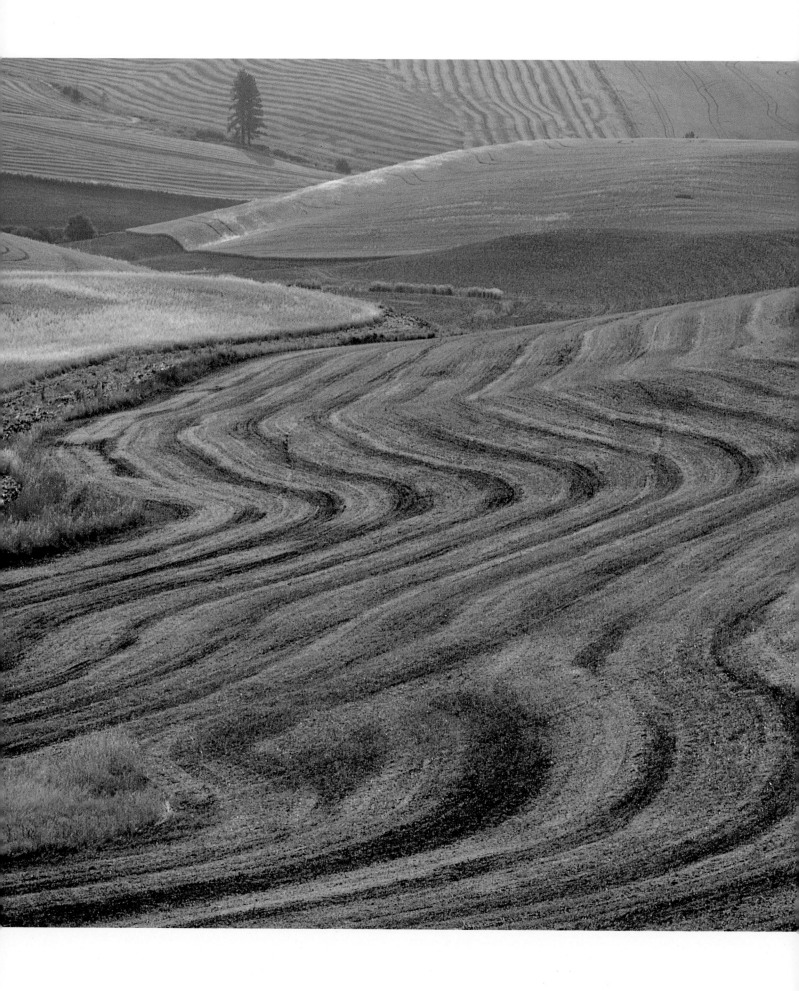

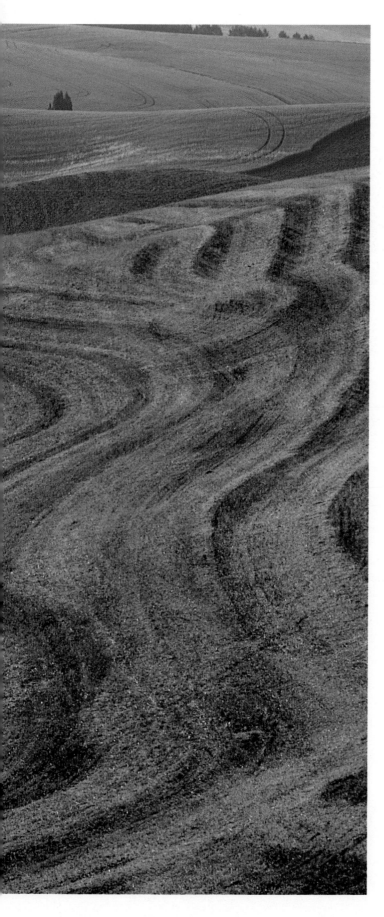

Rhythm

The word "rhythm" is most often associated with music, signifying movement and repetition. In music, rhythm produces a sequential order in time. In photography, time does not exist. But a design pattern in a still image can suggest a progression of time as viewers' eyes follow the pattern.

Such patterns usually consist of repeated lines, forms, or motifs. They provide a structure and establish an order. But, when combined with the element of proportion, the rhythm of the patterns can either enliven or diminish an image. Lines, forms, and motifs at precise intervals might seem rigid and monotonous. Even a slight variation in the pattern can give viewers a sense that they are discovering something new with each recurrence. And recurring patterns that expand or decrease in proportion can also suggest dynamic growth in a still landscape.

The contours and lines of wheat fields in the rolling hills of western Idaho are unforgettable. In this image, the lines created by the wheat harvesters are strewn across the picture space in a rhythmic, almost abstract maze. Only the trees in the distance provide a sense of realism. Photographing with a Canon FD 80–200mm lens on my Canon FT, I exposed at f/16 for 1/30 sec. on Kodachrome 64.

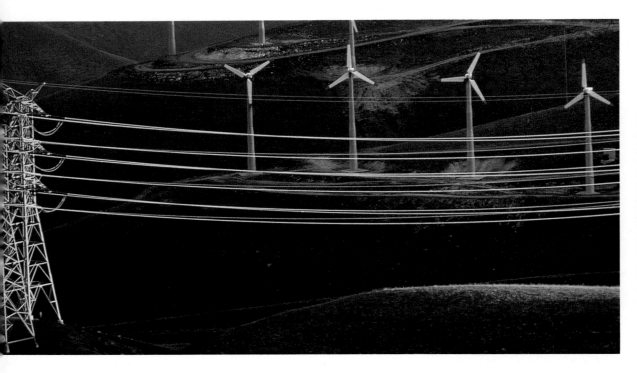

These transmission cables illuminated by the sun look like staff lines on a sheet of music, while the wind generators resemble notes. I mounted a Canon FD 300mm lens on my Canon F1. Metered on the hillside, the exposure was ƒ/22 for ⅛ sec. on Kodachrome 64.

Visual Transition

For most photographs, everything should be integrated to form a unified whole—unless the photographer wants to convey a sense of chaos and disorder. So, visual transitions must be provided throughout the picture space. Subtly or overtly, photographers can "lead" viewers to make the transition from one region to another through the arrangement of lines and forms. But transition is the least tangible principle of composition—despite the many rigid "rules" governing the element, which calls for finesse.

One of these "rules" involves photographs that are considered too busy. This comment implies that the lack of transition prevents the images from being unified. As a result, photographers are often instructed to keep the picture simple and not to include too much in the photograph. But this advice deprives photographers of the opportunity to make sweeping or complex statements through their work.

Another "rule" tells photographers to avoid including an even number, particularly two, of subjects of equal size or importance in a single image. But if the transitions are effective, such subjects can achieve the intended end: harmony or tension.

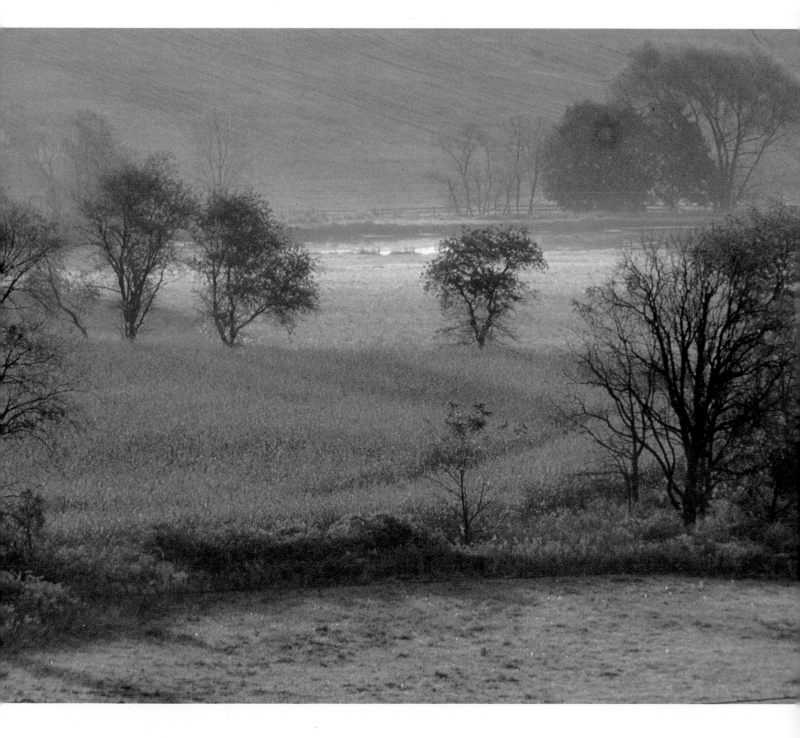

On a spring morning in Oldwick, New Jersey, a light mist softened the landscape, and the sun made the vegetation sparkle. I used a Canon FD 300mm lens on my Canon F1 to achieve the ideal composition: each tree leads the viewer's eye to the next. To capture this aerial view, which is reminiscent of a painting, I exposed for ⅛ sec. at f/22 on Kodachrome 64.

CREATING A SENSE OF MOTION

One of the major difficulties frequently associated with landscape photography is the lack of movement. This refers to both the actual motion captured in and the dynamic quality of an image. Still landscapes seem to be unusual subjects for the photographic medium, which is able to freeze movement and to record something that happens in just a split second, as well as to suggest motion through the technique of panning.

Since changes in the landscape seldom happen rapidly, different weather conditions add an exciting element to landscape photography. But the judicious inclusion of subjects as well as careful composition can enable viewers to be drawn subtly to the various sections of an image.

A sloping or curving line usually suggests movement, while a horizontal line evokes a feeling of calm and equilibrium. I consciously look for the lines, real or suggested, that appear in a scene. For example, a mountain might be massive, imposing, and permanent, while its contours and slopes, along with the shadows they produce, can create a sense of movement.

A different dynamic can be conveyed through the division of the space within a picture. Fields, mountains, rocks, streams, and even trees occupy a large area of an image. And, when they are striking colors or various shades of gray, they can fracture the picture space, turning it into a collage of colors and tones. If the areas are different sizes and are arranged distinctively, the picture gains a sense of movement.

Although lines, forms, and shapes exist in any landscape, they are often too subtle to be discernible. Also, the division of an image through the inclusion of vivid colors is rare in nature. But light and shadow can be used to create tonal distinctions among different parts of a scene or to emphasize lines and contours. The resulting contrasts are often quite powerful and urgent.

One question photographers frequently ask is how to remember the elements of composition in the relatively brief amount of time they have to capture a landscape exactly as they want to. In many situations, previsualization helps. In others, photographers might have to judge the finished image later according to these principles. The more successful pictures are usually those for which the photographer gave some thought to composition. Doing this naturally, and well, comes with practice—which is a large part of the art.

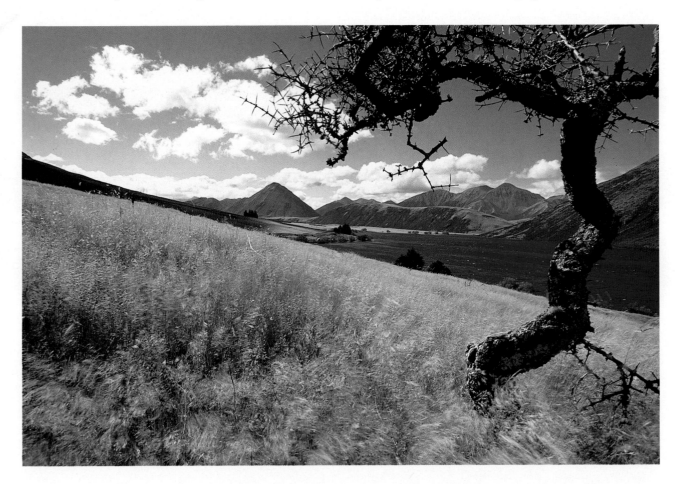

In the horizontal image above, the wide open field of tussock is "stopped" by the small tree, whose size is greatly exaggerated through the use of a Canon FD 20mm lens and a lower camera angle. In the vertical view on the right, the field is not "stopped," but continues to sweep down to the right. The exposure was the same as that of the horizontal picture. Photographing on South Island in New Zealand with my Canon T90, I exposed both images at f/16 for 1/60 sec. on Kodachrome 64.

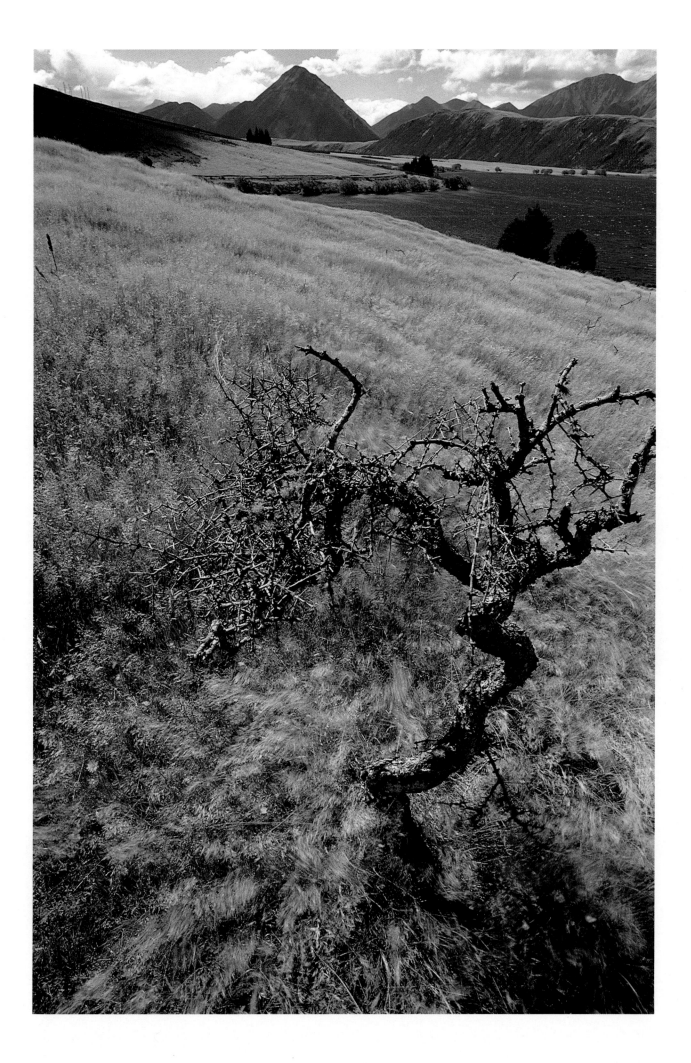

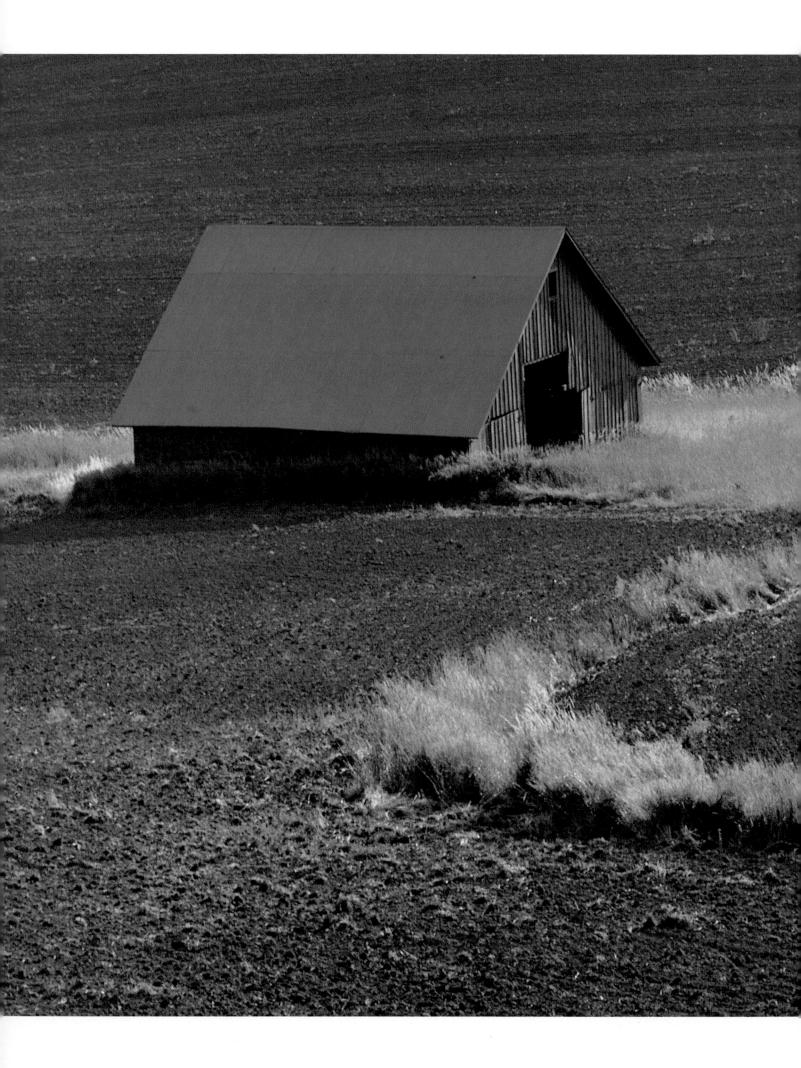

The line snaking through this picture allowed me to present the isolated barn being dwarfed by the tilted field without a static feeling. The line also extends a visual invitation to explore. The blue reflection of the sky on the roof complements both the green grass line and the dark brown field. With a Canon FD 80–200mm lens mounted on my Canon FT, I exposed for ¹⁄₃₀ sec. at ƒ/22 on Kodachrome 64.

Singling out the mountain range, which seems to rest on a foothill, I tried to present a tranquil image of Arthur's Pass on South Island, New Zealand. The illumination of the contour suggests movement. I mounted a Canon FD 300mm lens on my Canon F1 and exposed for ⅟₃₀ sec. at ƒ/16 on Kodachrome 64.

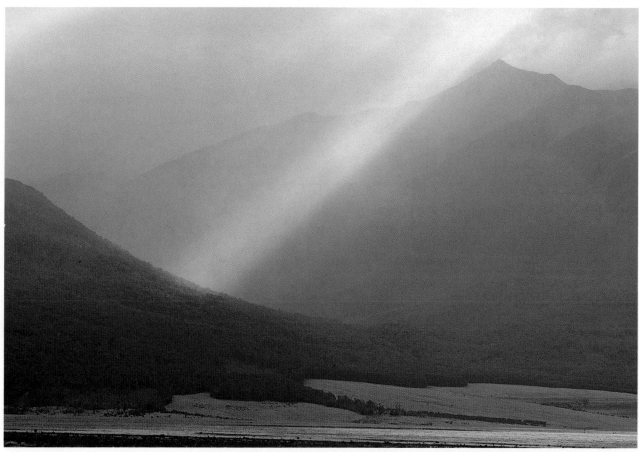

The dominant feature in this picture taken near Arthur's Pass is the interplay of light and shadow. The sunbeam seems to be urgently reaching for the dark hill. I used a Canon FD 80–200mm lens on my Canon T90 for this image. Metered on the haze-filled background, the exposure was ƒ/16 for ⅟₉₀ sec. on Kodachrome 64.

CHAPTER FOUR

THE CONTEMPLATION OF AESTHETICS

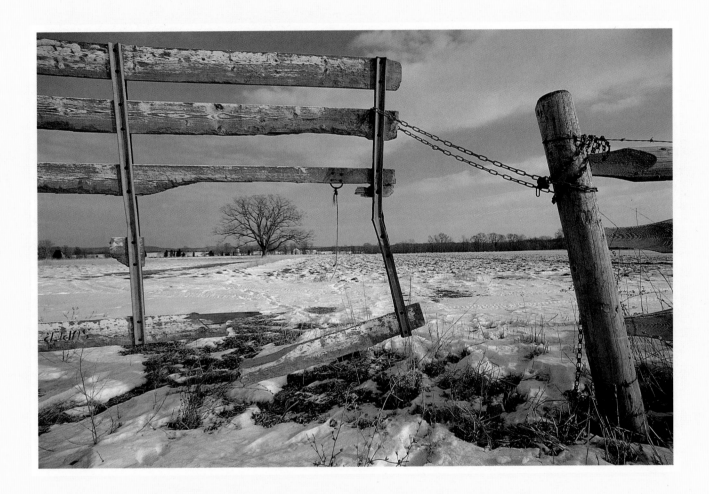

This winter field offered a wide, uncluttered vista. Using a Canon 20mm lens, I hoped to create a visual invitation by allowing the open farm gate to dominate the image. With my Canon FT and Kodachrome 64, I exposed at f/16 for 1/60 sec.

Photography is a visual language that expresses the thinking and the philosophy of the photographer. Like the written word, photographs can be used to tell a story, real or imagined, to advocate a social cause, or to express feelings. Frequently, the power of a picture reaches far beyond "being worth a thousand words." It can arouse emotions, just as drama, poetry, and music can. So, while much can be said about light, color, and composition as well as specific tools, including lenses and film, photography, as an art form, is neither completely methodical nor rational. Simple principles are often difficult to apply. What photographers realize during the lifelong learning process are the potential of the medium and the ways in which it relates to the intellect and emotions.

Aesthetically, a landscape can evoke many different responses. If photographers concentrate on one aspect of it, they might see the landscape as lyrical, powerful, and colorful. Usually—and unfortunately—however, they can convey only one facet well. Including every part of the panorama indiscriminately to create several impressions simultaneously is ineffective and greatly diminishes the impact of the image. Nevertheless, emphasizing one aspect of a scene does not eliminate individual interpretations. Viewers might respond differently to a landscape, particularly if the design juxtaposes seemingly unrelated objects or is somewhat abstract. Ambiguity can make a picture much more interesting and complex. Mastering the descriptive, creative, and interpretive aspects of landscape photography is essential for photographers who wish to broaden its scope, making it a truly visual language. The depth of an image should be appreciated by the photographer and the viewer alike.

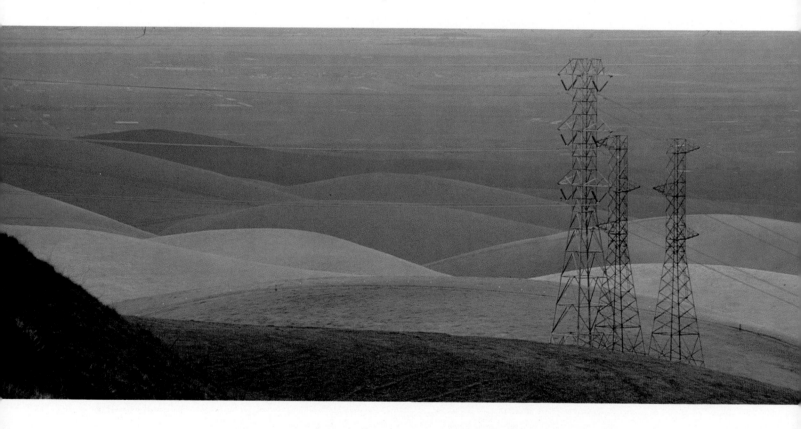

This image was taken near Patterson Pass east of Livermore, California, on a February afternoon several years ago. While I was photographing, sunlight began to pierce the clouds after a brief hailstorm. The color of the hillside was subtle but appealing as the sun and clouds created a tonal gradation toward the upper edge of the picture. I used a Canon FD 80–200mm lens on my Canon A1. The exposure was f/16 for 1/15 sec. on Kodachrome 64.

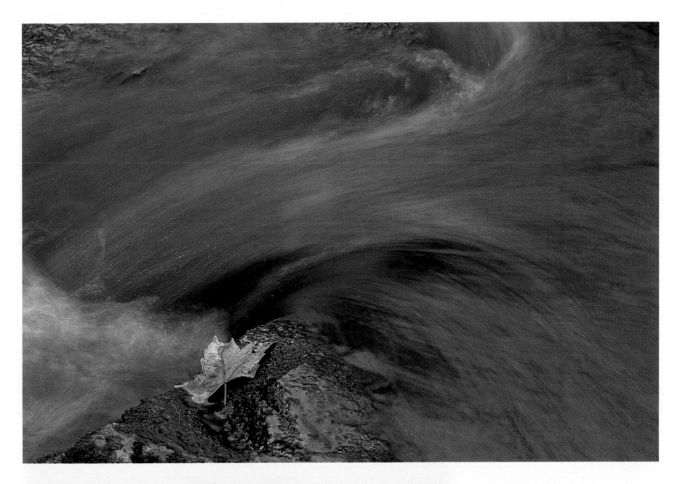

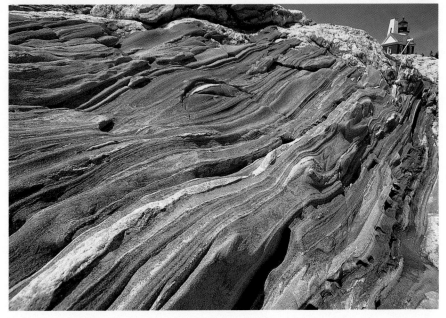

The cascading water above forms lines that seem to have been made with a giant brush stroke. In contrast, the leaf seems to have stopped gliding through the picture space; it looks as delicate as the water looks bold and powerful. I used a Canon FD 135mm lens on my Canon FT and exposed for ⅟₁₅ sec. at ƒ/16 on Kodachrome 64. I found the landscape on the left intriguing also: I was drawn to the erosion of the rock, a result of the pounding of the water. Exaggerated by a Canon 20mm wide-angle lens, the lines carved out by the waves converge toward Maine's Pamaguet Lighthouse. With my Canon FT, I exposed for ⅟₃₀ sec. at ƒ/22 on Kodachrome 64.

These morning fishers in Netcong, New Jersey, look both serene and mysterious. The dark background enabled me to capture detail in the mist rising from the lake. I used a Canon FD 80–200mm lens mounted on my Canon FT. With Kodachrome 64, I metered on the darker portion of the mist and exposed at f/16 for 1/15 sec.

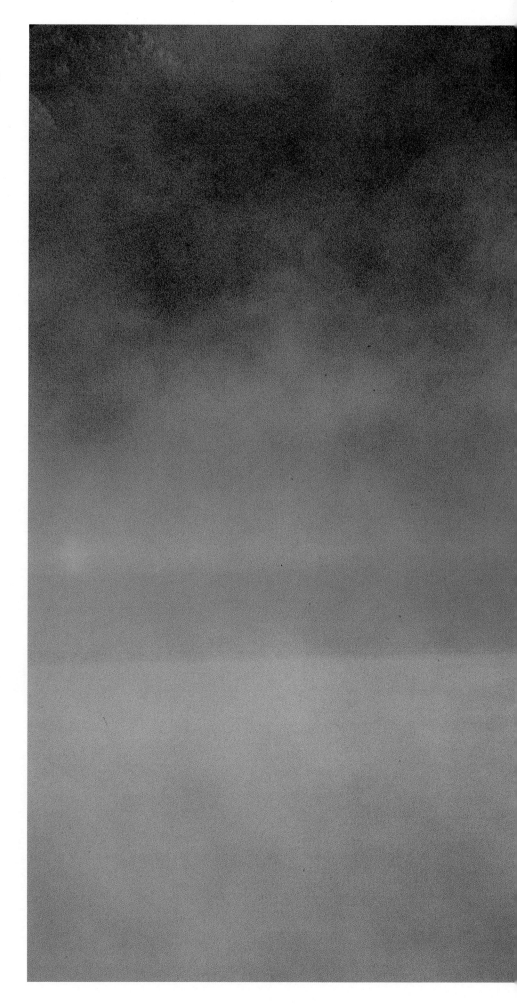

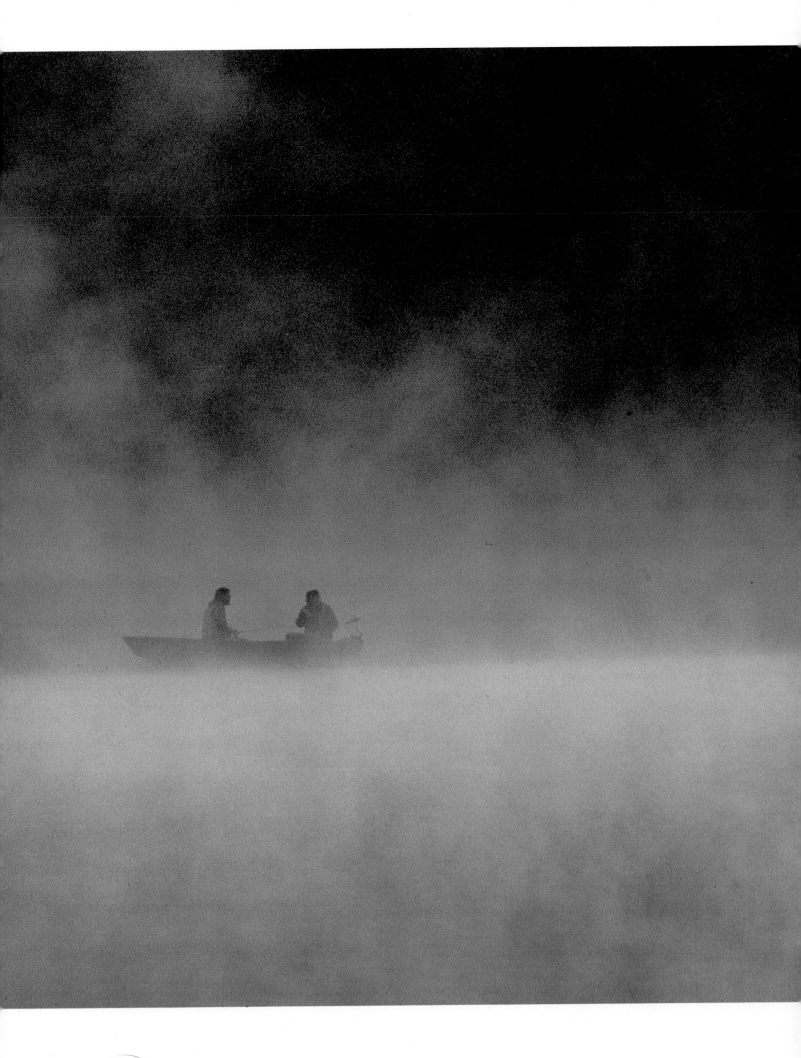

A DESCRIPTIVE APPROACH

Because of photography's mimetic and descriptive powers, it has traditionally been viewed as a tool for recording. Pictures are accepted as evidence in legal cases. Researchers use photographs to document their findings. The very fact that a photographer's editorial control can become an issue in reporting is proof that photography has the ability to provide accurate and credible representations of a scene or an event. In this respect, a photograph is considered to be different from a painting. The "truth" of the image has never been an issue with paintings. But with photographs, viewers frequently wonder if they are being manipulated, in part because they cannot always identify the subject.

Although many descriptive photographs of the landscape can be dismissed as "record shots," their impact should not be overlooked. Yellowstone, for example, was designated as the first national park—thereby establishing the national park system—because of the pictures explorers brought back. Even in this age of visual fatigue, which is a result of the proliferation of graphic images, a highly descriptive picture of Mount Everest at dawn can capture the viewers' imagination. More important, a photograph that has no pretensions of being "artsy" can appeal to viewers in an unbiased way and to allow them to formulate their own opinion about a particular location.

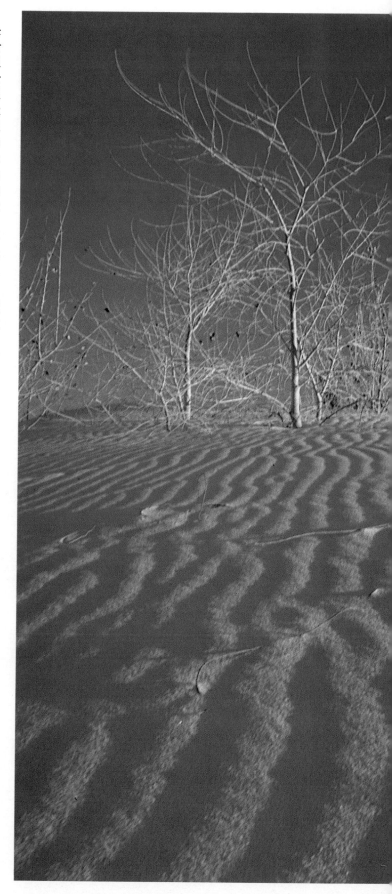

At the White Sands National Monument in New Mexico, the late afternoon sun adds warmth to the landscape and emphasizes the ripples in the sand. By moving in with a Canon 20mm wide-angle lens, I was able to show detail in the ripples. Including the white cloud helped to "close" this descriptive picture as well as to center the bush. Having loaded my Canon F1 with Kodachrome 64, I exposed at f/16 for 1/30 sec.

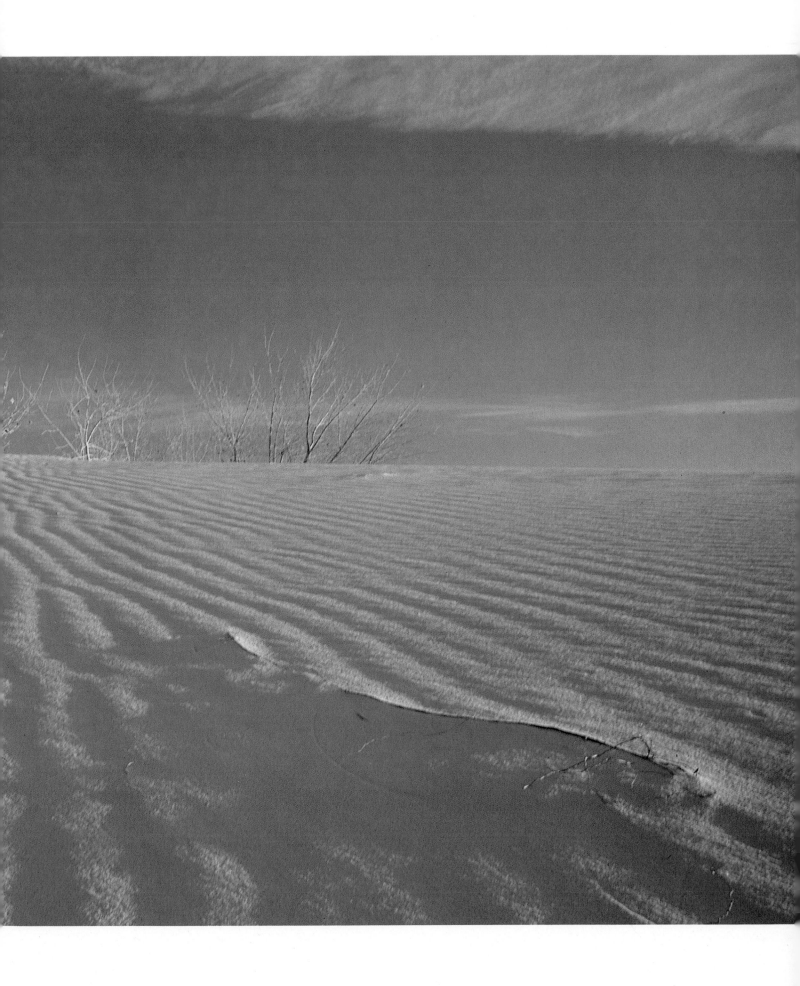

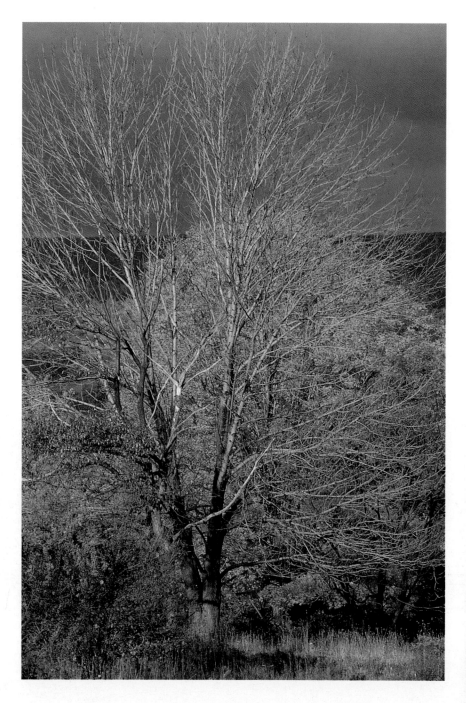

When sunlight penetrates storm clouds, it seems like a giant spotlight that illuminates the subject while it leaves the background relatively dark and unnoticeable. But storms are also characterized by leaves falling from trees. In this image, I wanted to show the contrast between the trees and the sky, as well as the difference among trees that have weathered various numbers of storms. Working with my Canon FT and a Canon FD 80–200mm lens, I metered for the foliage. The exposure was f/22 for ¹⁄₁₅ sec. on Kodachrome 64.

Rainbows are visually appealing and capture the viewer's imagination:
whether pastel or vibrant, they seem to spring forth magically from the land
or sky. For this image, taken in New Zealand, I used a Canon FD 80–200mm
lens on my Canon F1. The exposure was f/22 for ⅟₃₀ sec. on Kodachrome 64.

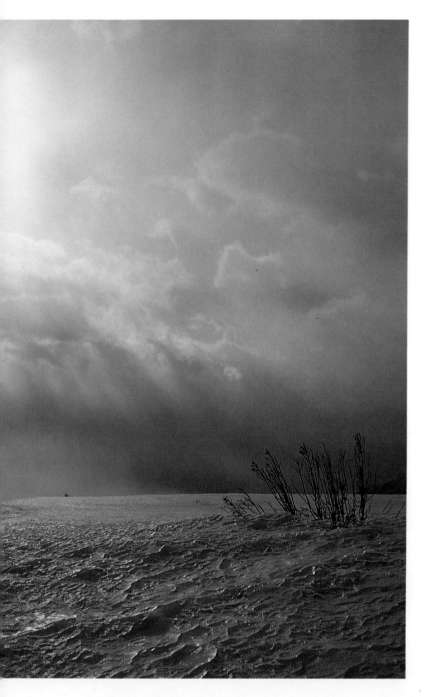

A CREATIVE APPROACH

The elements of color, light, and composition determine, in large part, the final image and affect the way viewers regard the subject. But their influence goes far beyond this. When photographers approach their work in a creative manner, they abandon commonplace perceptions. This poses a challenge to themselves and to their viewers. The resulting image enables and inspires them to see the subject from a different perspective and to attach a new meaning to it. As such, image becomes a means to an end rather than the end itself. The identity of the subject is no longer the primary element.

For my creative work, I prefer to avoid subjects that might overwhelm the design and, thus, the meaning of an image. This is one of the reasons why I try to stay away from landmarks and spectacular scenes. Their physical presence and beauty tend to dominate the viewers' attention and to obscure the message I hope to convey. And, because such subjects are so familiar and extraordinary, understatement and subtlety can be difficult to achieve.

My approach to the creative side of landscape photography is based in part on the art of Chinese calligraphy. The arrangement of the characters and the style in which they are written are far more important than the characters themselves or their meanings. The work is a visual image, and even those who cannot read the characters can understand the calligrapher's emotion. This is conveyed through, for example, the flow of the lines, the amount of ink applied in each section, and the apparent pressure exerted on the brush. The forms and lines of the natural landscape can be isolated and enhanced through the thoughtful use of light, color, and composition. A creative approach allows viewers to appreciate the landscape not only for its physical beauty but also its essence.

In this image of a cloudburst, the small bush seems to greet the sun, while the details on the ice echo the sun's rays and the cloud formation. This creative composition suggests to me a sense of hope. By keeping the sun out of the frame, I was able to stay within the limited latitude of the film, Kodachrome 64. Using a 20mm wide-angle lens enabled me to increase the amount of space occupied by the sky. The exposure was f/16 for 1/125 sec.; the camera was a Canon FT.

I was drawn to the landscape in the picture on the opposite page because the sun shone through the storm clouds. The rays added color to the scene and brightened the river. Approaching this image from a creative standpoint, I wanted to capture the dramatic intensity of the weather and the striking interplay of light and shadow. I exposed for 1/30 sec. at f/22 on Kodachrome 64 and used a Canon FD 80–200mm lens on my Canon F1.

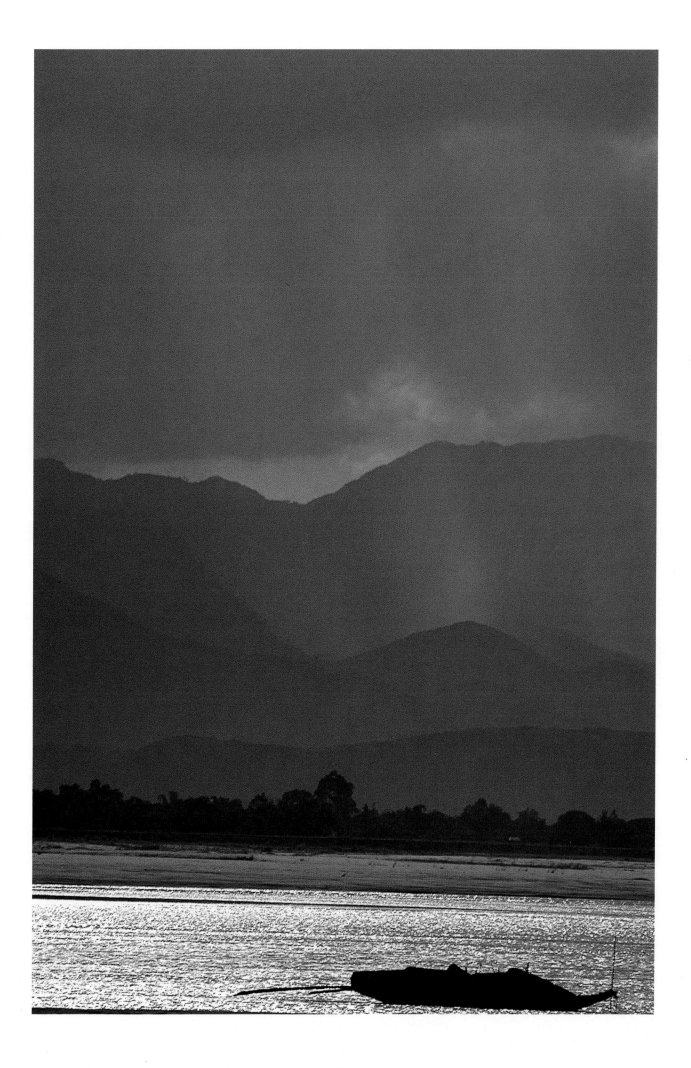

The New Jersey shore can be an exciting subject on a crisp winter afternoon. Snow and sand are undisturbed, and the lower position of the sun adds a warm tone. The dune fence in this picture glowed under the late afternoon sun. But it was the suggested movement of the fence, further exaggerated by a 20mm wide-angle lens, that caught my attention. With my Canon F1, I exposed for ¹⁄₁₅ sec. at ƒ/22 on Kodachrome 64.

AN INTERPRETIVE APPROACH

While much photography is a visual representation of the natural world, a singularly descriptive or creative approach is almost impossible. Usually, photographers begin to make editorial comments the moment they raise their camera to their eye and frame the picture through the viewfinder. However, photographers can explore the interpretive potential of the medium to achieve a universal appeal. Shooting from various vantage points also enables photographers to increase the number of editorial choices available to them.

Through the effective use of light and color and the successful combination of compositional elements to define relationships, photographers can express their views about a landscape. The resulting images can show what the photographers saw and reveal their interpretation of the scene. The camera exposes the relationship between what is in front of it and what is in the mind of the photographer behind it. Again, the image is not dominated by the subject's identity or features; the image is the answer to the question photographers ask themselves: "What do I think about this landscape?"

Juxtaposing contrasting elements in a picture is another interpretive approach. This creates ambiguous connections among the subjects that are worthy of both the photographers' and the viewers' contemplation. When I visited the city of Dunhuang in the western part of China, I was struck by the relationship between the barren landscape and the sign of human interference. To contain the movement of the sand dunes, a row of poplar trees had been planted, extending all the way to the edge of the dunes. As I shot this scene, I wondered: "Was this planting a futile effort by the inhabitants, or a sign of defiance by both the planters and the poplars themselves?" The contours of the sand dunes and the rustling of the leaves suggest the inherent power of the desert wind over this scene.

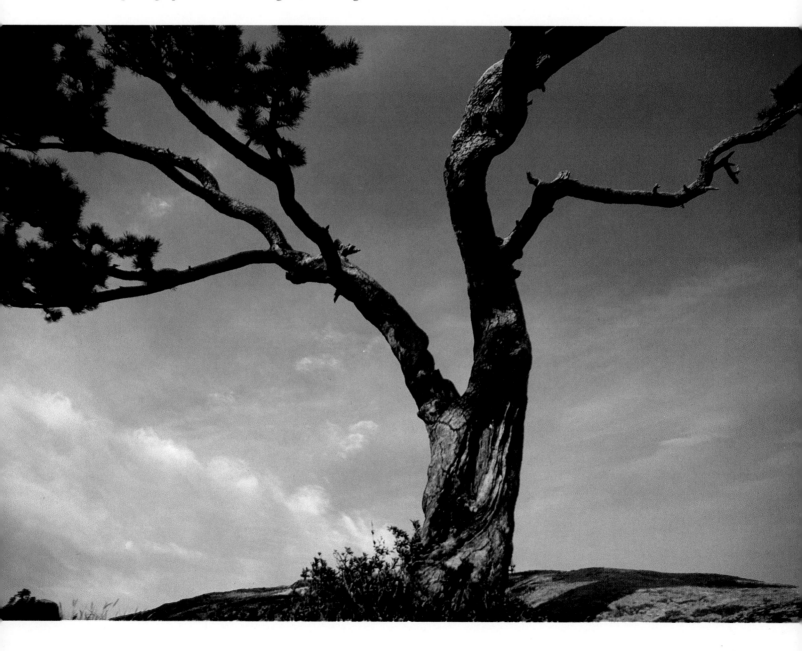

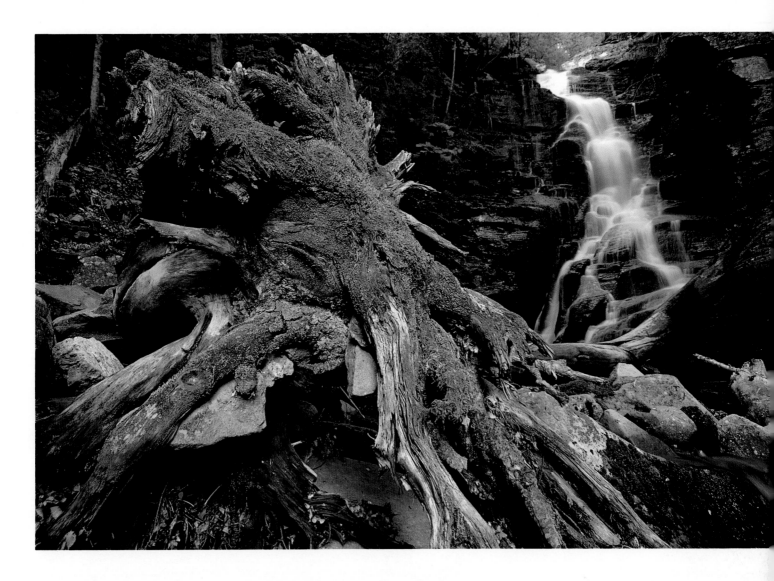

Photographing in a nature preserve in New York's Catskill Mountains during the spring, I decided to emphasize the root of the tree in the picture above. A Canon 20mm wide-angle lens enabled me to render everything insignificant except the root. It reminds me of a dragon, and the waterfall looks like its tail. With my Canon FT, I exposed at f/16 for ¼ sec. on Kodachrome 64.

When I first saw the tree in the photograph at left, I was struck by its awesome presence. From my perspective, the outstretched limbs seemed to have a tremendous—and frightening—power. Working with a Canon FD 20mm lens and my Canon FT, I exposed for ¹⁄₆₀ sec. at f/16 on Kodachrome 64.

*After several attempts at photographing this southwestern landscape, I was finally
satisfied with this composition. The giant saguaro both rivals and enhances the rainbow.
To lower the horizon and to place the cactus directly against the rainbow, I stooped close
to the ground. Having mounted a Canon FD 80–200mm lens on my Canon FT, I
metered on the rainbow. The exposure was f/22 for 1/15 sec. on Kodachrome 64.*

Through the Canon 20mm lens on my Canon FT, this rock looks somewhat precariously balanced. The distortion resulting from the wide-angle lens is effective here. Frequently, however, the camera must be tilted slightly to compensate for obvious distortions, such as sloping horizons. For this picture, taken in Utah, the exposure was f/16 for ⅟₆₀ sec. on Kodachrome 64.

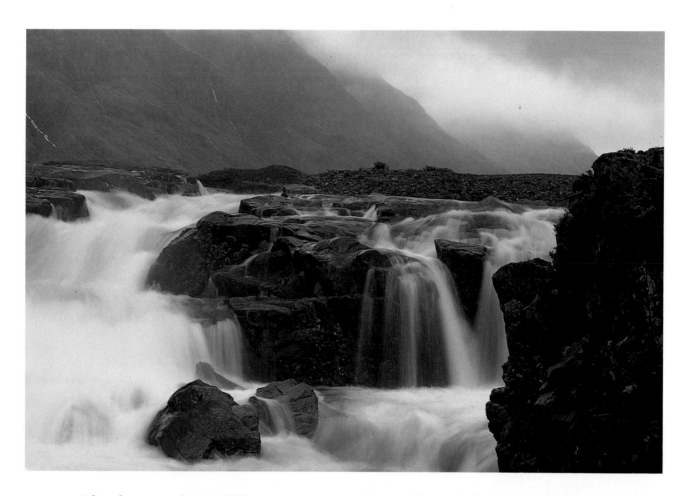

Taking this picture of a waterfall during a storm enabled me to create this "angel hair" effect on the water by using a slow shutter speed. Here, it seems as if the storm caused the water to flow rapidly. I used a Canon FD 80–200mm lens with my Canon A1. I exposed for ⅟₁₅ sec. at ƒ/22 on Kodachrome 64.

Frequently, I regard landscape as a stage set for drama in nature. When landscape photographers adopt this interpretive approach, they create a visual forum in which they can explore their view of the world. The power of the images taken by many Sierra Club photographers, for example, lies in their uninhibited adoration of and concern for nature. Such photographs, conveying a distinct point of view, offer depth and complexity.

While the meaning gleaned from an image depends a great deal on the viewers' mindset, photographers should constantly explore ways to expand the potential of the medium. As a visual language, photography can reach far beyond the power to report. Landscape photography can be a poem about the land; a means through which anyone can establish a bond with the earth; or, simply, a visual abstraction that appeals to viewers on either a sensory, psychological, or emotional level.

THE INSPIRATION OF TRAVEL

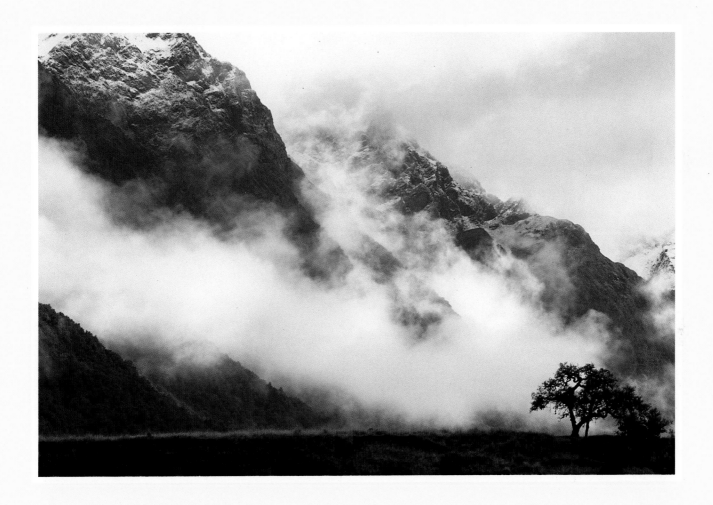

Driving through a narrow valley walled on both sides by snowcapped mountains in New Zealand's Fjordland National Park, I came upon this lone tree. It seemed to me to be a natural stopping point for the receding mountain range. Using a Canon FD 80–200mm lens on my Canon T90, I exposed at f/19 for 1/45 sec. on Kodachrome 64.

For some landscape photographers, travelling to different parts of the world in search of new inspiration is a must. Ironically, this can be paradoxical: in distant lands, photographers tend to take pictures as a way to capture and remember what they have seen. But, quite often, these images are only meaningful as a group of pictures that tell a story about a journey or a region. Individually, they are usually dismissed as "record shots" by serious landscape photographers.

BEYOND "OBLIGATORY" PHOTOGRAPHS
Many landscape photographers feel compelled if not obliged to shoot the scenic wonders in a particular area; this type of picture is often seen in advertisements, promotional materials, and travel brochures. While these photographs can be pleasant reminders of an exhilarating trip, a form of self-expression, as well as extraordinarily beautiful images, they can also seem familiar, repetitive, and uninteresting. I became acutely aware of this problem during a recent trip to New Zealand. I felt obliged to visit that country's landmarks, such as Milford Sound and Mount Cook. After all, I thought, how would I explain to my friends that I did not see any of these famous sites?

Seeing and capturing something unusual about a landmark or a popular area can be almost impossible. The first and often the only way viewers respond to photographs of familiar scenes is to identify the location. So, to present them effectively, photographers have to be resourceful—artistically, physically, and financially. Still, a creative approach might not solve the problem. Many well-known places have been photographed practically from all angles, in every possible way, and under some of the most ideal weather conditions.

Other obstacles to infusing images of familiar panoramas with new vitality and a refreshing sense of originality exist, however. Viewers often have such set notions of what certain scenes look like that, even if a photographer can find a different vantage point, a departure from the norm is usually considered unacceptable. Also, landmarks and scenic wonders are important in terms of cultural heritage. Taking pictures of them is like photographing statues. The images can often seem like mere records of others' creations. There appears to be little that landscape photographers can add to them.

Rather than use excessive visual effects or design elements to embellish landscape pictures, I concentrate on appealing but relatively unexplored vistas and sites—not tourist attractions. Even in national parks, I try to photograph different parts of them instead of their "hallmarks." I enjoy the sense of satisfaction that comes from discovering something meaningful in the commonplace. Being aware of and open to such possibilities can make your landscape images ones of lasting value.

In Stokes State Forest in New Jersey, the diffused light helped to enhance the color saturation. The movement of the foliage seemed to be guided by the dark branches and lines. I used a Canon FD 300mm lens on my Canon F1 and exposed at f/22 for ⅛ sec. on Kodachrome 64.

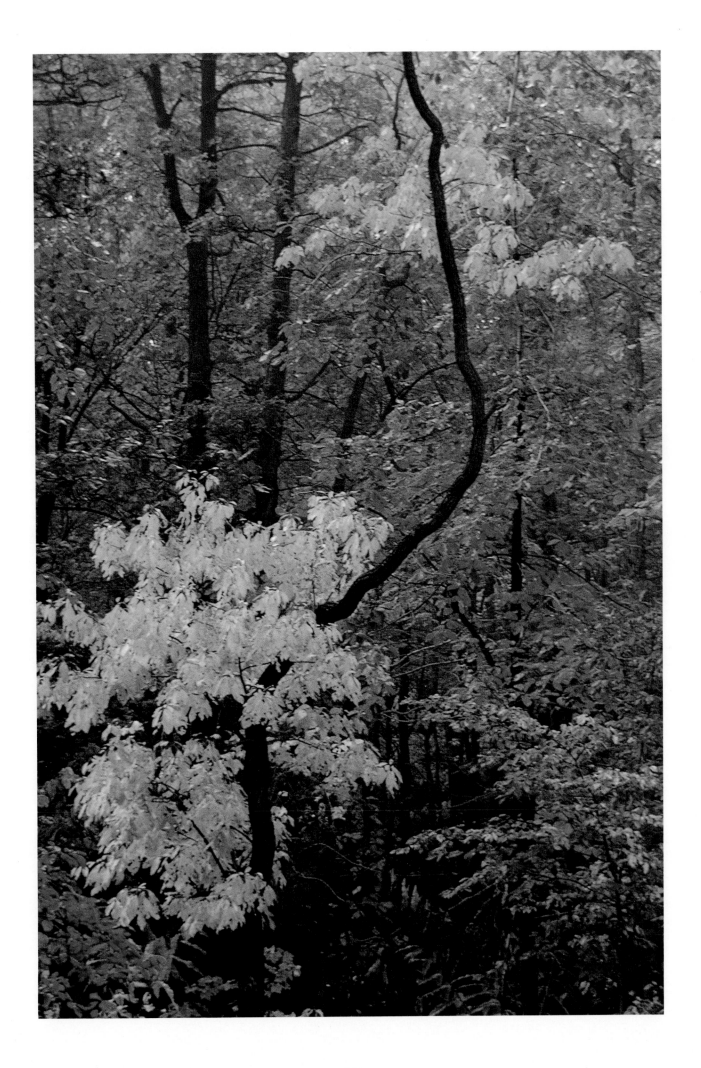

This is the first picture I took after arriving in New Zealand. I was drawn initially to the tree reaching toward the sky: it provided a well-defined structure for the simple separation of gray and green. The faint sunlight touching upon the hillside made the terrain look pastel, which complements the color of the sky. As a result, I was able to present the most familiar New Zealanders, the sheep, in an ethereal manner. I exposed for $\frac{1}{15}$ sec. at $f/22$ using Kodachrome 64, my Canon F1, and a Canon 80–200mm lens.

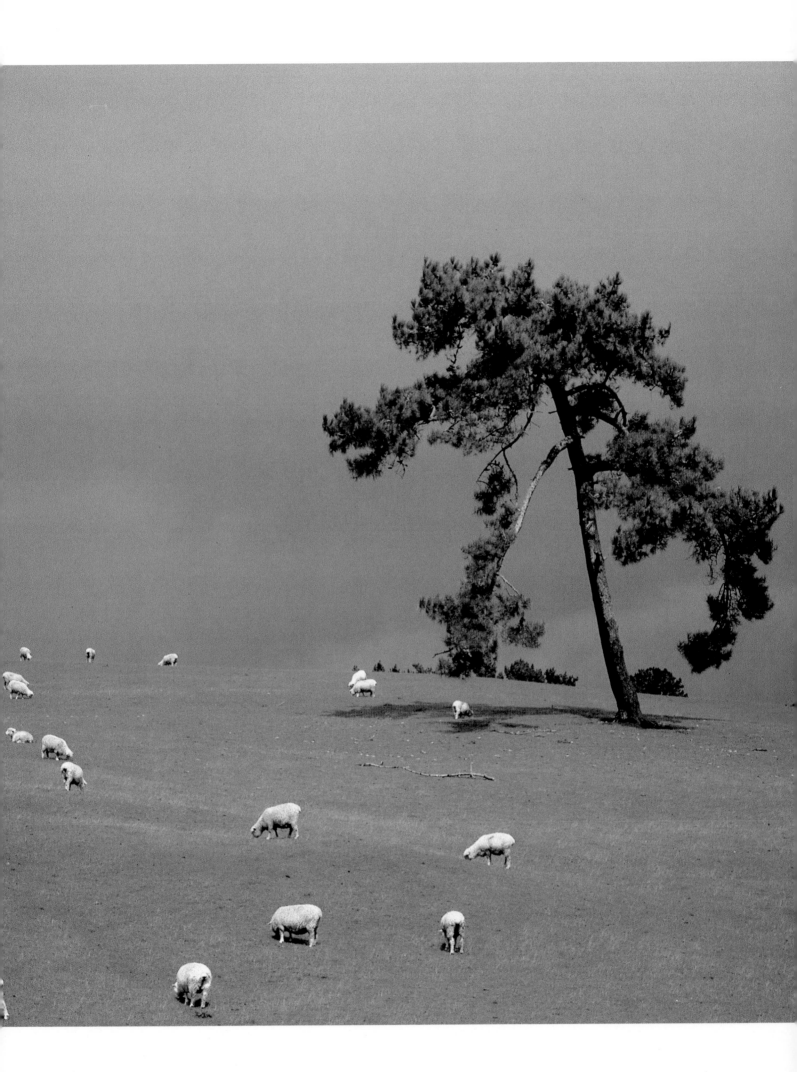

As I came around a turn on the highway near Lake Hawea in New Zealand, a pale rainbow took me by surprise. Everything seemed to come together at this moment to show the rich diversity of the landscape: the snowcapped peak, the palm tree, the glacial lake, the dark mountain, and the rainbow. Working with a Canon FD 80–200mm lens on my Canon T90, I exposed at f/16 for 1/60 sec. on Kodachrome 64.

TAKING THE TIME TO EXPLORE

The most important difference between making travelog pictures and true landscape photographs is the amount of time each requires. I often see cars pulling off a road, the driver or passenger with a camera in hand getting out of the car, snapping the scene, rushing back to the car, and driving off. In less than a minute, an image has been recorded. But landscape photographers who are serious about their photography realize that they must give it their full attention and enough time.

When visiting a region for the first time, I might drive around for an entire day or two without taking any pictures. But once I come across something interesting, I spend as much time as necessary (or as possible) photographing it until I feel that I have captured what I want. I forget about proceeding to my next destination. Later, if I can, I return to the spot. During the first trip, I might have been overwhelmed by the magnificence of the landscape. But subtleties can be appreciated only after the initial excitement has worn off.

PHOTOGRAPHING IN DIFFERENT WEATHER CONDITIONS

Travelling in search of evocative landscapes is also dictated by the weather. Photographers can study a region beforehand and plan their route carefully, even meticulously, but they cannot predict the weather. They can frequently pass through an area without noticing anything extraordinary. But travelling regularly through a region broadens a photographer's knowledge of it, including weather patterns. Photographers can, then, plan future trips to the area when the best weather condition is most likely, either in terms of the time of day or the season.

In fair weather, my travel plans to an area of interest allow me to capture the morning or evening light. First, I scout out an appealing landscape. When I arrive at the spot the next day just before daybreak, I watch how its appearance is transformed under the morning light. If I am able to make satisfactory images within hours after the sunrise, I move on to my next destination according to my planned route. I hope to find another area of interest by three o'clock. If this happens, I get settled and begin to search for the subject that will look best under the evening light. However, if the weather is fair but the blue sky is filled with fluffy clouds, the clouds' shadows can make a place seem spectacular at midday. While this changes my travel plans, I always try to remain flexible and take advantage of the potential for stunning images.

Landscape photographers often find that in adverse weather, some of the most vivid scenes can look dull. Under an overcast sky, only certain subjects, such as a wooded area or vibrant autumn leaves, will produce striking images. If I cannot find such subjects, I continue driving around, searching for new possible subjects or waiting for better weather.

I think that rapidly changing weather patterns are the most exciting and challenging encounters for landscape photographers. A break in the clouds or a "sun shower"

After my initial excitement over seeing a full rainbow in the desert, I began to seek out a different interpretation of spring rain. I wanted the rainbow simply to be a part of rather than to dominate the landscape. For this image, I adjusted a Canon FD 80–200mm lens to the lower range after mounting it on my Canon FT. Then I metered on the sky and exposed at ƒ/22 for ¹⁄₁₅ sec. on Kodachrome 64.

can be quite dramatic by itself; their effect on subjects below can be just as evocative.

Although landscape photographers sometimes congratulate themselves for being "at the right place at the right time," thorough planning is essential. And, photographers must realize that taking truly rewarding photographs of an area often requires several visits; a single trip allows them to only record and document what they have seen, not to present it in the best possible way. As I continue to travel and photograph, I am always rediscovering light and land.

BROADENING HORIZONS THROUGH TRAVEL
I believe that travelling extensively is essential for landscape photographers. Street photographers, on the other hand, might find an area of a city that is teeming with excitement. In fact, they might even run out of film from one corner to the next. For landscape photogra-

phers, that one city street translates into an entire region. The sheer size of the area landscape photographers must cover does limit their productivity and requires physical stamina and endurance. Luckily, the world seems smaller today: modern methods of transportation have made travelling all over the globe much easier and more convenient.

Recently, I rented a mini-camper and toured New Zealand, a place far from my home in the United States. During my stay, I could not help but notice the amount of freedom I had while travelling around the country. I was able to concentrate on my photography rather than being concerned about getting from one city to another. I had the opportunity, literally, to chase after the rainbow. Through this type of travel, landscape photography can be broadened to emphasize the art of seeing as well as to challenge a photographer's ability to communicate and to produce a "new" image.

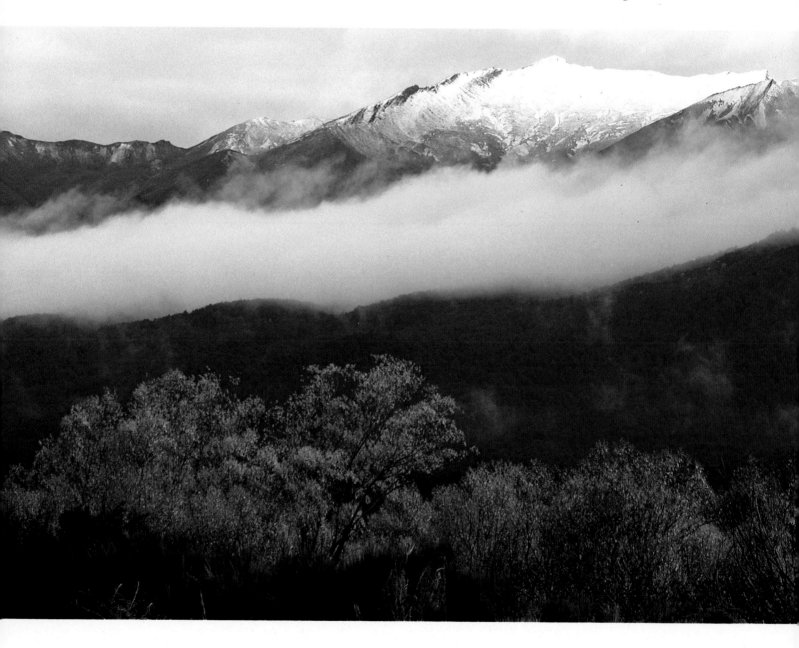

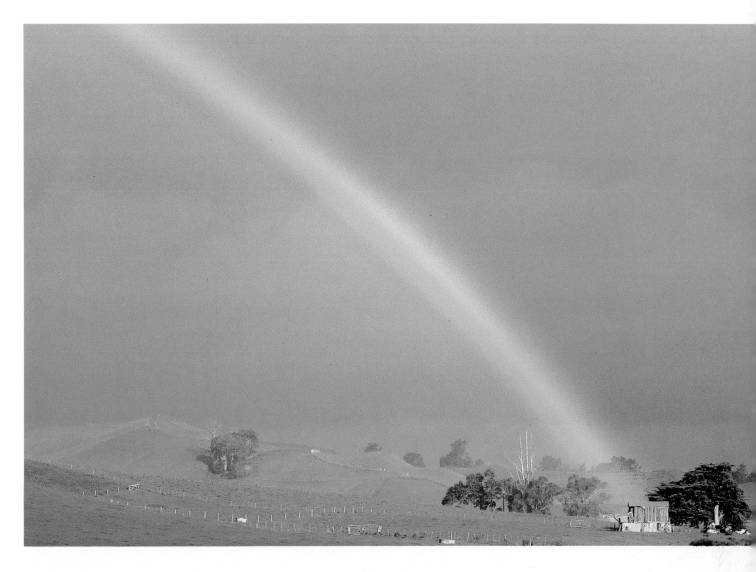

The photograph above, taken in New Zealand, seems quite pastoral and illustrates the commonly held notion about where a rainbow should be seen. Having mounted a Canon FD 80–200mm lens on my Canon F1, I exposed at ƒ/16 for ⅟₆₀ sec. on Kodachrome 64.

As the cloud in the image on the left drifted across the face of the mountain on North Island, New Zealand, it suggested a sense of fluid motion otherwise missing in this still landscape. Here, I used a Canon FD 80–200mm lens on my Canon T90. Aided by the camera's multispot metering system, I exposed at ƒ/19 for ⅟₁₅ sec. on Kodachrome 64.

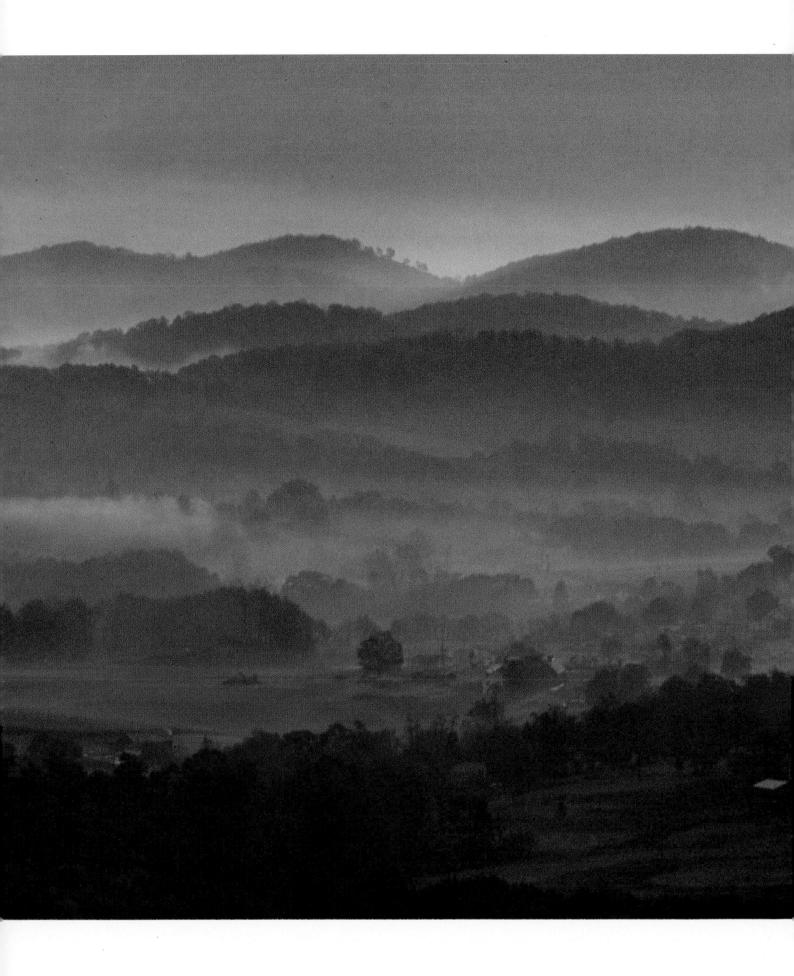

One autumn morning, this field in Oldwick, New Jersey, was engulfed in a thick ground fog. Dark branches in the picture above framed the sunrise and provided contrast, while distant bushes seemed to float in the mist. To capture the beautiful light of this landscape, I metered on the part of the sky far from the sun and underexposed one stop at ƒ/16 for ⅟₆₀ sec. on Kodachrome 64. I used my Canon F1 and a Canon FD 80–200mm lens.

As I was photographing yet again on Sunrise Mountain in New Jersey, the landscape on the left looked surrealistic under the morning mist. I mounted a Canon FD 300mm lens on my Canon F1 for this picture and then metered on the mist. The exposure was ƒ/11 for ⅟₃₀ sec. on Kodachrome 64.

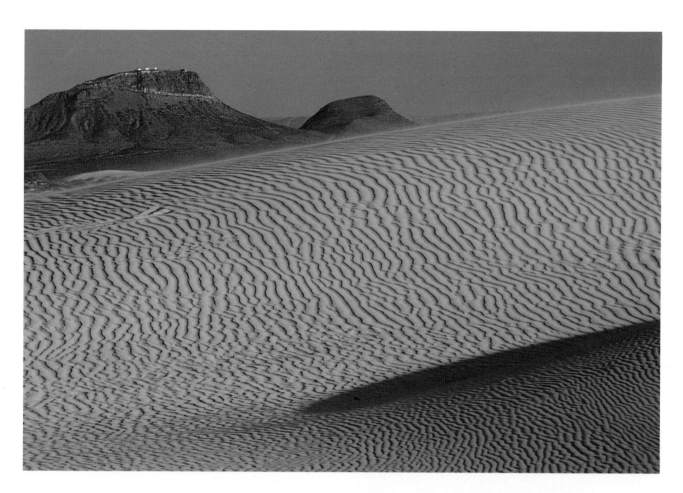

Although this sand dune and hill are actually miles apart, they appear to be close together because they were photographed with a 400mm lens. I stopped down to f/32 for maximum depth of field. I used my Canon F1, Kodachrome 64, and exposed for ⅛ sec.

CREATING THE ULTIMATE EXPRESSION

A few years ago, I attended a camera club meeting in which the members, returning from their summer vacations, presented travelogs ranging from the exotic to the familiar. It was most interesting to discover the personality each photographer's set of images revealed. One member's work reflected his aggressive and forceful personality perfectly: his pictures included closeups of natives that showed little respect for their privacy or the viewers' imaginations as well as landscapes in which light and color seemed to confront rather than to enhance one another. These intrusive, jarring images contrasted sharply with those taken by a retired gentleman during a visit to his ancestral home in Scotland. Throughout the years I have known him, his photography never impressed me. But his portraits of Scotland radiated tenderness and loving affection.

While landscape images can seem impersonal at first glance, they can reflect the thoughts and feelings of the creator behind the camera. When done carefully and conscientiously, landscape photography expresses the photographer's appreciation of the natural world. Landscape photography can speak both for photographers and to viewers. All they need to do is to look and listen.

CHAPTER SIX

THE IMPACT OF CULTURAL INFLUENCES

This photograph was taken at Palisades Interstate Park near Bear Mountain, New York, on a clear autumn morning. The warm moisture from the numerous lakes in the area combined with the cold air to form a golden mist. Here, the mist rising off the lake helps to prevent the sumac tree from blending into the background. I found the suggestion of movement created by the variations in the fog particularly pleasing. I used my Canon F1 and a Canon FD 80–200mm lens and exposed for ⅛ sec. at f/22 on Kodachrome 64.

Photographers and their work are, to some extent, products of a particular culture. Subtly and overtly, they are influenced by society and the events of their time. As such, today's landscape photography can be viewed as a product of social activism, a spirit of adventure, and a utilitarian culture that values function over form. This type of photography is considered more practical than other media. The aesthetics of the images seems less important than the messages and commentary of concerned photographers. The landscape is merely a backdrop for buildings and other structures or a passive participant in the exploration of social issues, such as industrial pollution.

Some cultures, however, view the landscape differently. Regarding humanity as part of rather than master of the universe, many cultures believe that understanding the landscape enriches one's character. In other cultures, nature is an awesome presence spiritually; in yet others, its physical presence is powerful. In all of these cultures, respect for and appreciation of the landscape itself are foremost.

THE LANDSCAPE IN ORIENTAL LITERATURE

Wang Wei, the poet of the Tang dynasty, wrote, "The river flows beyond the edge of land and sky. The mountain, vague and almost nonexisting, adds a touch of color. Villages float on the near shore, while the tide pushes toward the sky." By using exalted language and an elegant tone to describe a natural setting, Wang not only adds a sense of dynamism to the scene but also expresses his exhilaration, a feeling generated by the evocative and seemingly eternal landscape. Also underlying Wang's choice of words is the concept of a landscape's organic and transcendent nature.

For learned scholars in the Confucius tradition, the landscape has traditionally been a source of spiritual enrichment and a guide to self-improvement. Nature is replete with life and the struggle for survival. In particular, Chinese painters view the landscape as a means of self-expression; they focus on the seemingly insignificant to symbolize larger issues that are closer to human experiences, much the same way Minor White, inspired by both Zen and Eastern philosophy, approached photography. To Oriental writers, nature is an important part of the human experience. Nature is personified and, in the form of a teacher, imparts invaluable wisdom.

ORIENTAL APPROACHES AND TECHNIQUES

While embracing the ideas of another culture is difficult if not impossible and the need to do so is questionable, different cultural values can elicit new approaches toward the visual medium of landscape photographers. Several techniques used by Oriental visual artists are worth exploring.

Idealism or Realism

Unlike commercial art, Oriental painting and calligraphy are intended to be tools through which artists can educate or express themselves. Objectivity is not important, nor is beauty. What is presented in these art forms is either a highly subjective rendition of a subject or event, or an idealistic one. When this approach is applied to landscape photography, it can produce what I call "stylized realism." Here, a realistic view merges with the photographer's vision. Some stylistically real images represent ironical human experiences. Other pictures reflect a world that the photographer is most comfortable with. As Wang's poem suggests, the scene "moves" and the photographer's thoughts begin to flow.

Vertical or Horizontal Arrangements

Before my visit to China in 1980, I never thought that a vertically oriented image—of, for example, jagged, cloud-shrouded mountain peaks—could be a realistic rendition of the landscape photograph. In my mind, this arrangement has always been an allegorical representation of elevating oneself to moral high ground. A vertical image can also suggest an artist's desire to rise above the mundane and to reach what one poet describes as "somewhere deep in the cloud but hard to locate"; this is where Taoists hope to enjoy immortality. In order to achieve a vertical arrangement, I stand either on high ground from which the land unfolds toward the horizon and the foreground is in the bottom part of the image, or at the foot of a hill with the peak rising vertically in the frame.

Such approaches to landscapes and vistas pose a sharp contrast to those of most Western photographers and painters. These artists usually extend the borders of the landscape horizontally to suggest expansiveness. Arranging the picture space with stacked horizontal strips can also offer an alternative way to present a multifaceted observation and to add complexity to a picture in an orderly fashion.

During a trip to China, I photographed Hwangshan, which is hailed as the country's most scenic mountain. Under an overcast sky, the peak looked like one often found in a storybook. Working with my Canon FT and a Canon FD 80–200mm lens, I exposed at f/16 for 1/15 sec. on Kodachrome 64.

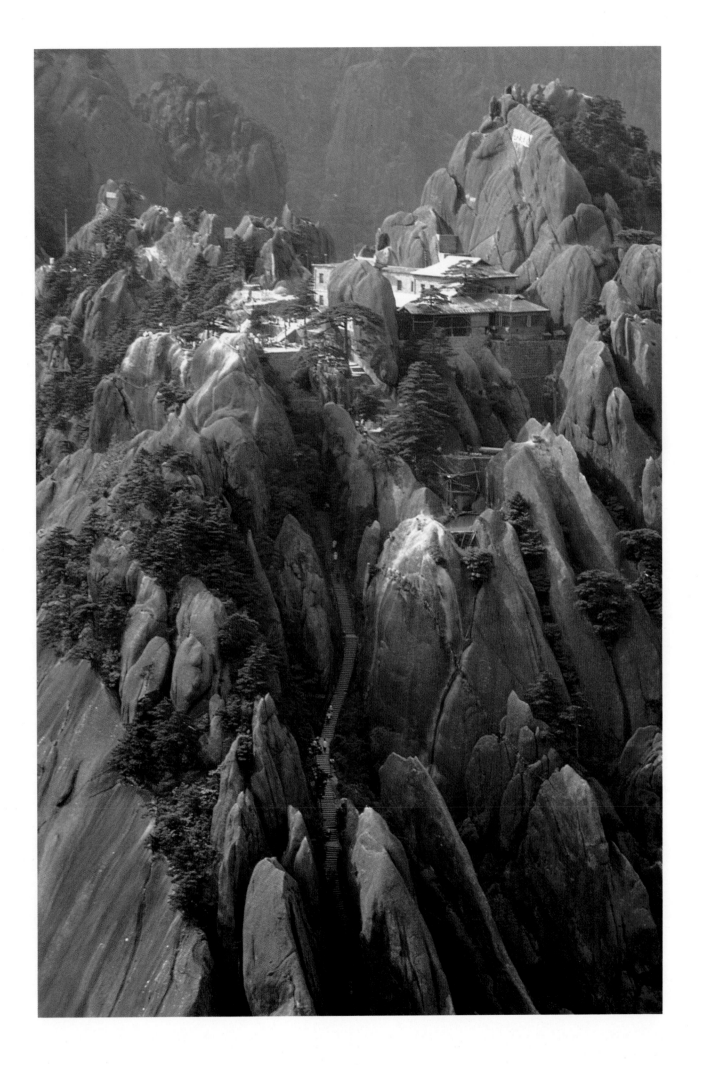

This horizontal image of a lake wrapped in fog does not seem empty because of the position and reflection of the plant, as well as the warm morning sun. Using a Canon FD 300mm lens with my Canon F1, I metered on the lake and exposed for ⅛ sec. at ƒ/22 on Kodachrome 64.

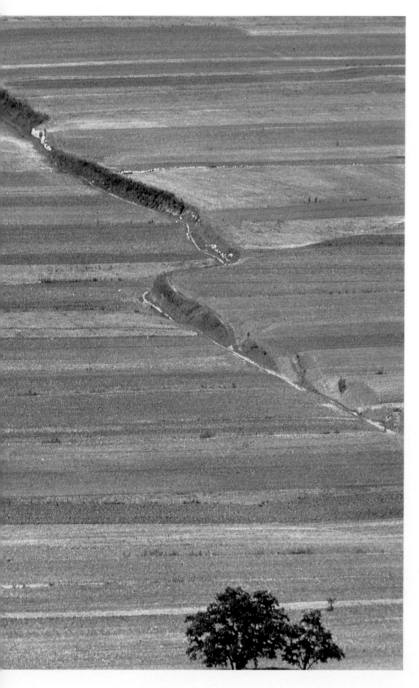

The view from Wutai Mountain, which is part of the Qinling mountain range located to the south of Xian, China, is spectacular. In the above photograph of this vast plain, a sense of expansive space is created. The trees frame the edge of the picture; the field, whose spring wheat has just been harvested, fills the center. Using my Canon F1 and a Canon FD 300mm lens, I metered on the field. The exposure was f/22 for ⅟₁₅ sec. on Kodachrome 64.

Lines or Forms

Perhaps because of the type of brush Oriental painters use and their training in calligraphy, they give greater emphasis to lines rather than forms (see Chapter 3). In addition, holding the brush allows the painters to create lines that have different implications. Lines can suggest movement or strength, increase the picture's appeal, and unify the image. A full awareness of lines can help evoke emotions and inspire viewers. Although roads, trees, and ridges are the most obvious lines, light and shadow can also create lines. A sharp, careful eye enables photographers to discover an abundance of lines, real or suggested, in nature. While Oriental photographers are not the sole practitioners of using lines effectively, they most certainly have mastered it.

Juxtaposition

In classic Chinese poetry, two verses usually are devoted to a description of a scene. These are followed by the poet's interpretation of and feelings about the view. In this way, the landscape inspires the poet and becomes a reflection of human thought and emotion.

Describing a scene effectively requires the poet to choose words carefully. The language must be succinct but clear in order to convey the essence of the landscape and the meaning the poet attaches to it. However, the words must also allow readers to use their imagination to resolve ambiguities and to respond to the scene in their own way.

Relating this approach to landscape photography necessitates the juxtaposition of seemingly unrelated subjects. This reduces an image to its bare but essential elements. As in Oriental poetry, less is more. Uncluttering the picture space reduces distractions. The stark presence of any subject, then, acts as a catalyst and allows viewers to discover their own reactions.

Negative Space

The concept of using empty space effectively is familiar to artists everywhere (see Chapter 3). For Oriental artists who use brush and ink, it is particularly important. The ink fills the picture space with different shades of gray, very much like those in a black-and-white photograph. But in most ink illustrations, only the contours of the subjects are sketched; the forms are left white, with just a few brush strokes added to suggest the depth and three-dimensional quality of the subjects. For example, a stream winding through mountain slopes might look like a twisting, curving strip of blank space. Similarly, when a rock juts out at midstream, it might be the only, or the primary, subject that captures the viewers' attention. The rock is prominent because of the negative space surrounding it.

Landscape photographers frequently encounter empty space in the sky or in shadow. How they approach the negative space within the picture frame can produce a well-defined structure or a glaring void.

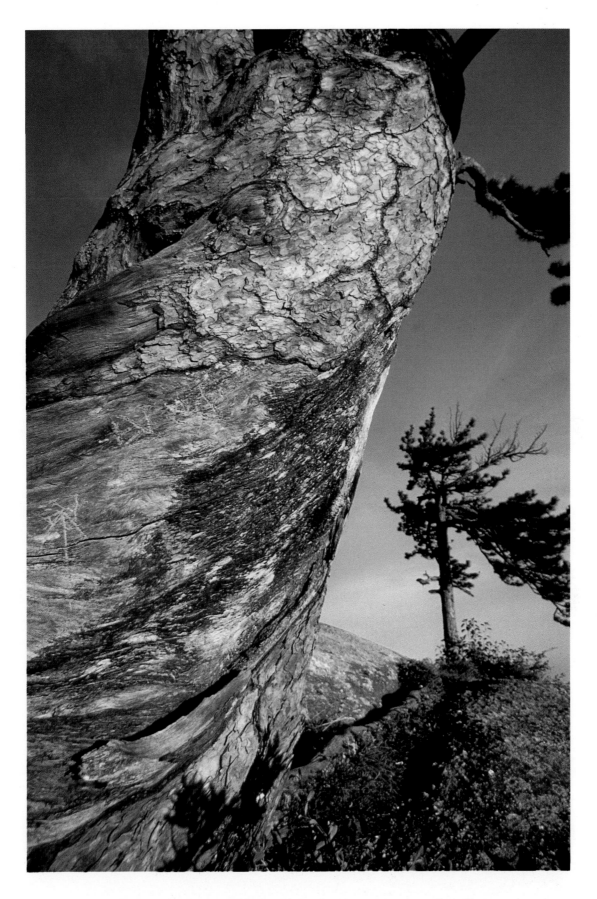

*Growing on rocky cliffs on Hwashan, which is a mountain in western China, the pine
trees in the picture on the opposite page are regarded by painters in the classic Chinese
tradition as ideal subjects through which they can display their mastery of brush strokes.
The limbs suggest power and motion. I used a Canon FD 20mm lens on my Canon FT to
accentuate this sense of movement. I exposed for ⅓₀ sec. at f/22 on Kodachrome 64.*

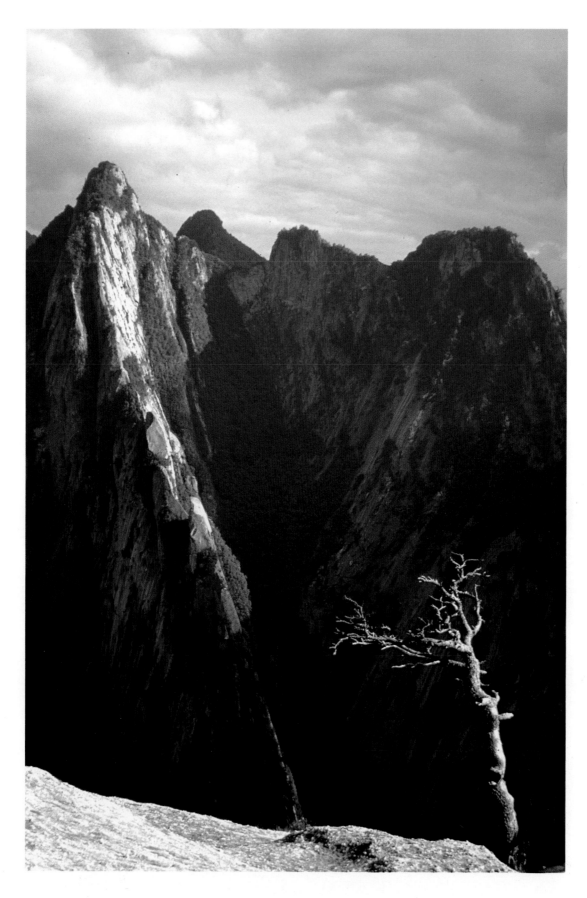

Hwashan is an inaccessible mountain in China: it is characterized by jagged peaks and is frequently shrouded in clouds. Still, I was intrigued by the twisted, gnarled tree in the picture on the opposite page. I was determined to photograph it. I mounted a Canon 80–200mm lens on my Canon FT and adjusted it to mid-range. Metering on the ledge but allowing for half a stop overexposure in order to capture detail in the mountain, I exposed at f/16 for ⅟₁₅ sec. on Kodachrome 64.

Refinement or Innovation

Chinese landscape artists regard copying the classic works of early masters as an important part of their education. They believe that it is only through such practice that they can learn to appreciate some of the nuances their predecessors developed. Building on this foundation, they can then create original work of their own. At its best, this custom allows for evolution rather than a break with the past. But to less confident artists, the tradition can provide an excuse to avoid innovation.

In the world of photography, making an impact on viewers frequently means a complete departure from what has been done before. Because of the seemingly unchanging nature of the land, however, landscape photographers find it difficult to present subjects in fresh, new ways. To create effective landscape images, photographers must recognize that refinements are as essential to the interpretation of a scene as technical innovations are. Capturing the nuances of a familiar subject can enliven it and make it more complex.

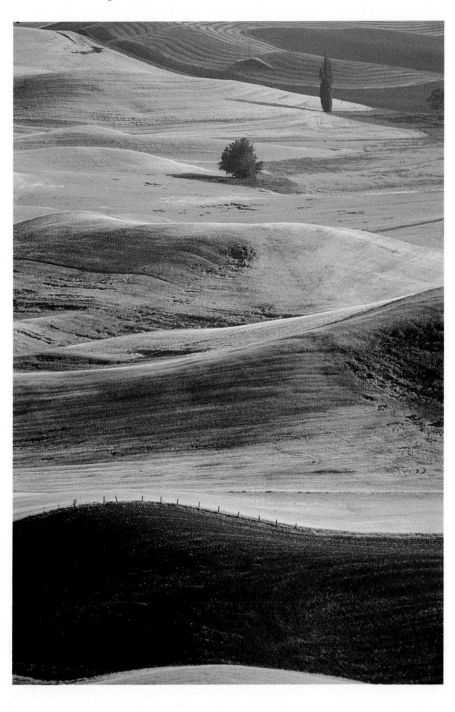

Steptoe State Park near Pullman, Washington, offers an unobstructed view of the surrounding wheat fields. Because their many curves and layers can create a number of designs, isolating a subject and composing can be difficult. Here, I tried to use the dark strip as the base of the image on the left and to stack the layers of the field below the tree. With a Canon FD 300mm lens mounted on my Canon A1, I metered on the brighter strips. The exposure was f/22 for ⅛ sec. on Kodachrome 64.

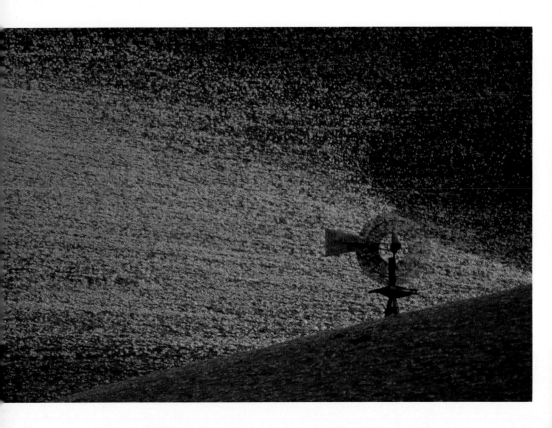

The plowed California hillside in the picture above serves as a backdrop for the design created by the contour of the rolling hill and the interplay of light and shadow. A Canon FL 200mm lens flattened the view, so it is difficult to imagine that there is a road between the dark foreground and the hillside. I used a magenta filter to give the image a more graphic look. With my Canon FT, I exposed for ⅛ sec. at ƒ/22 on Kodachrome 25.

The railroad tracks in the photograph on the right run along the Hudson River in upstate New York. Shadows increase as the sun sets behind the mountain across the river. The irregular shape of the hillside contrasts with the straight lines of the poles and tracks. For this image, I used a Canon FD 80–200mm lens with my Canon F1. I metered on the light on the hill; the exposure was ƒ/22 for ⅛ sec. on Kodachrome 64.

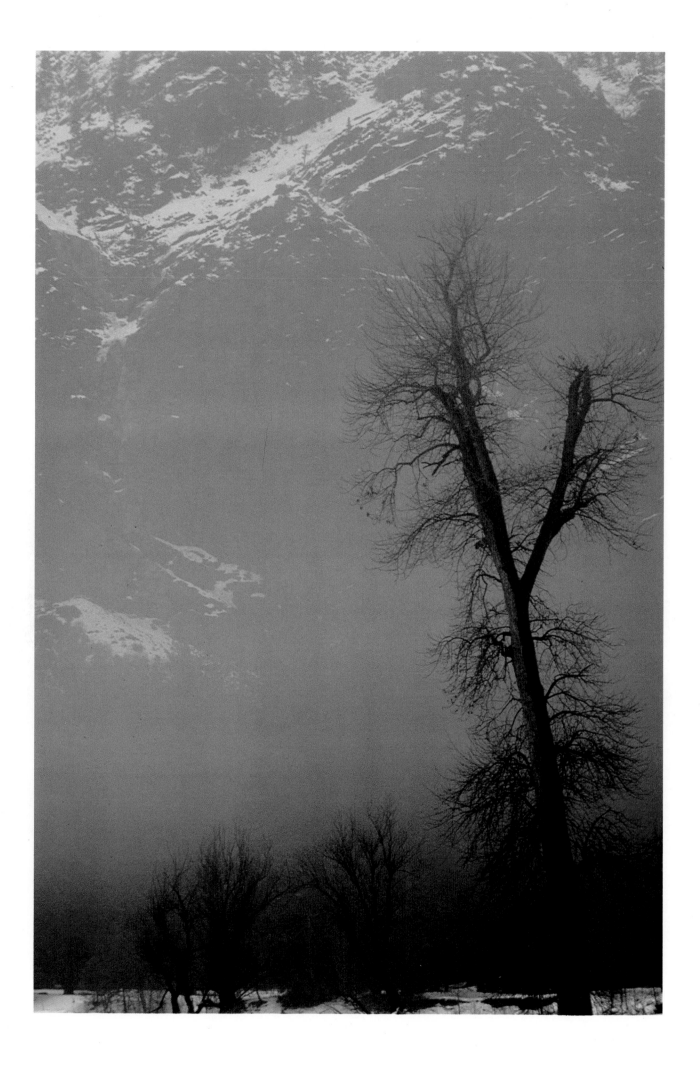

Understatement or Exaggeration

To give a picture impact, many photographers favor exaggeration. But, while it is true that images are successful only if they grab the viewers' attention immediately, their ability to endure is also important. This permanence can come from understatement, which Chinese writers employ. Through this, they allow readers to contemplate the subject further.

Understatement can also be instrumental in the creation of effective landscape images. A picture that leaves little to the imagination is basically incompatible with a landscape that inspires visitors to return over and over again. Also, those who seek respite in natural surroundings might find a forceful, highly personalized image too intense and too confrontational. While any work of art bears its maker's imprint, a more subtle and understated approach can move viewers without making them consciously aware of the presence of the creator.

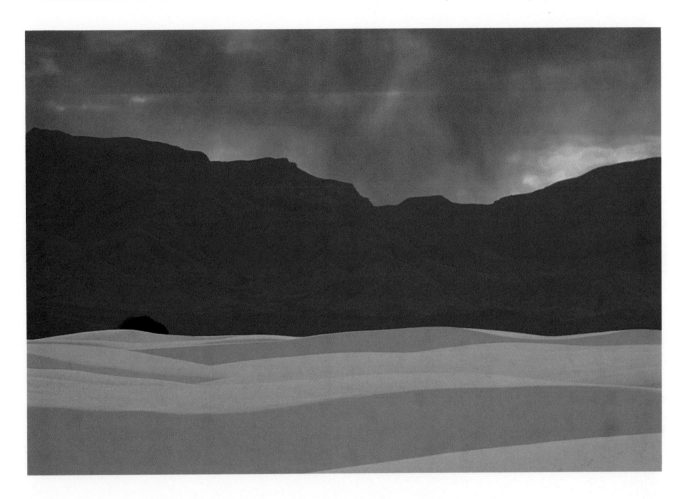

The thunderhead in the photograph above creates vertical streaks that stand out against the horizontal arrangement of the mountain range and sand dunes. The late afternoon sun graces the dark landscape with subtle color. Using a Canon FD 80–200mm lens on my Canon F1, I exposed for ⅛ sec. at f/16 on Kodachrome 64.

Because the bottom of Yosemite Valley is much warmer than the surrounding cliffs, it is frequently covered by a ground mist in the winter. In the picture on the left, a tree is prominent: the mist softens and de-emphasizes the background. The uplifting feeling created by the tree line and the snow on the cliff helps to minimize the monotony sometimes associated with simple, understated designs. Having mounted a Canon FD 80–200mm lens on my Canon A1, I metered on the mist. The exposure was f/16 for 1/15 sec. on Kodachrome 64.

An Ideal Format

Many photographers prefer to use full negatives for their work. Others are forced to use the format dictated by a publisher or advertising agent. But photographers should explore the various options available to them. Although 35mm film produces the rectangular format commonly used in book and magazine reproduction and for most paintings, other shapes and sizes exist and can be quite dramatic. Oriental scrolls are often either narrow, vertical strips or long, horizontal panels.

In addition, the new formats Japanese camera manufacturers began developing recently, such as 6 × 8 and 6 × 9, can be most effective in landscape photography. The vertical format is perfect for a series of subjects that stack one on top of the other. Conversely, with a flat terrain, neither the sky nor the foreground might be strong enough to warrant the standard rectangular format. The interesting subjects might simply occupy a thin strip at the edge of the horizon. To control composition and to avoid including any wasted space, photographers must choose a format judiciously.

No format is truly ideal. This is one reason why I try to stay away from the square format when photographing the landscape. Not only do I find this format static, I believe that it is an unsuccessful compromise between the horizontal nature of most vistas and the isolation of specific subjects, many of which are vertical. In the end, the square format does justice to neither.

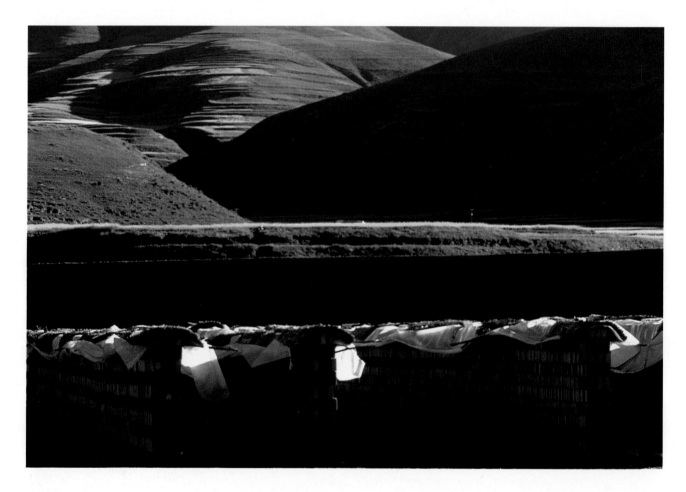

Near Xiahe in China, the irregularly shaped green hills in the picture above contrast the carefully stacked brown bricks. As a result, the image is divided in half and works best in a horizontal, rectangular format. The red tent, which is barely noticeable, connects the halves; it also provides additional contrast between the nomadic lifestyle and the permanent one of the new settlers. For this image, I used a Canon FD 80–200mm lens mounted on my Canon F1 and metered on the sunlit hill. The exposure was f/32, to ensure maximum depth of field, for ¼ sec. on Kodachrome 64.

Often unnoticeable at first, lines and the sense of motion they suggest can be found in many natural surroundings. In the photograph on the right, the piles of leaves, which had been shaped by the stream, curved and turned. They establish a rhythm in the image. Another appealing element is the reflection of the foliage and the sky: it turns the water a golden color with a hint of blue. To best capture this landscape, I composed vertically and used a Canon FD 300mm lens on my Canon F1. The exposure was f/22 for ¼ sec. on Kodachrome 64.

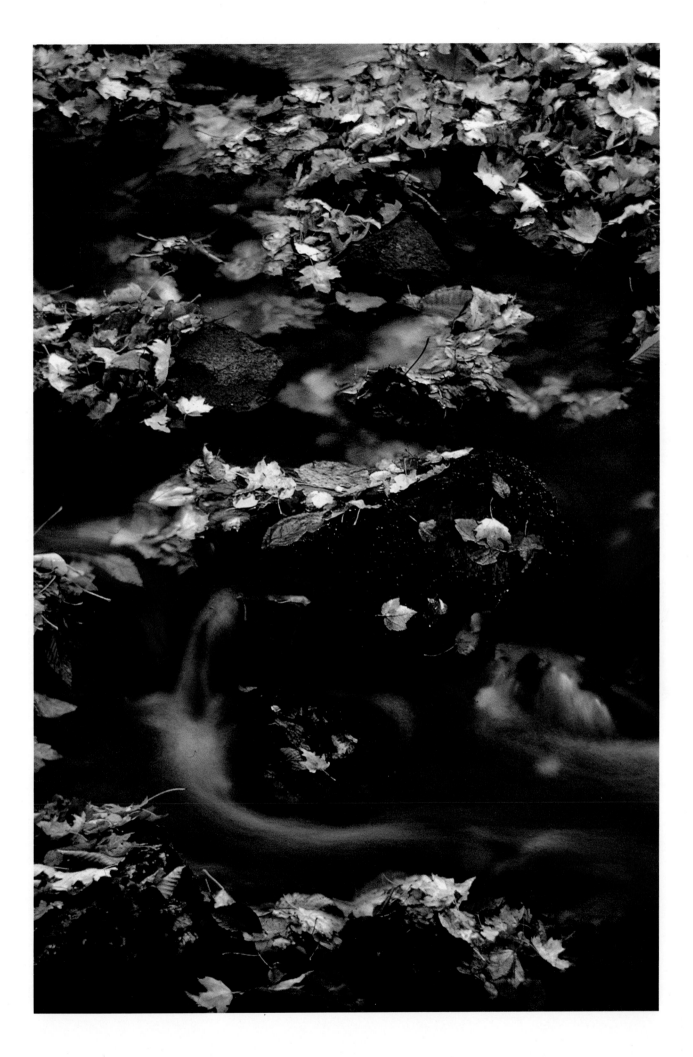

At sunrise, the mist in Zhang Jiajie, China, created a vast area of negative space in this photograph. The peak balances the cliff and makes the composition airy but not empty. With a Canon FD 300mm lens mounted on my Canon F1, I metered for the mist. The exposure was f/16 for ⅓₀ sec. on Kodachrome 64.

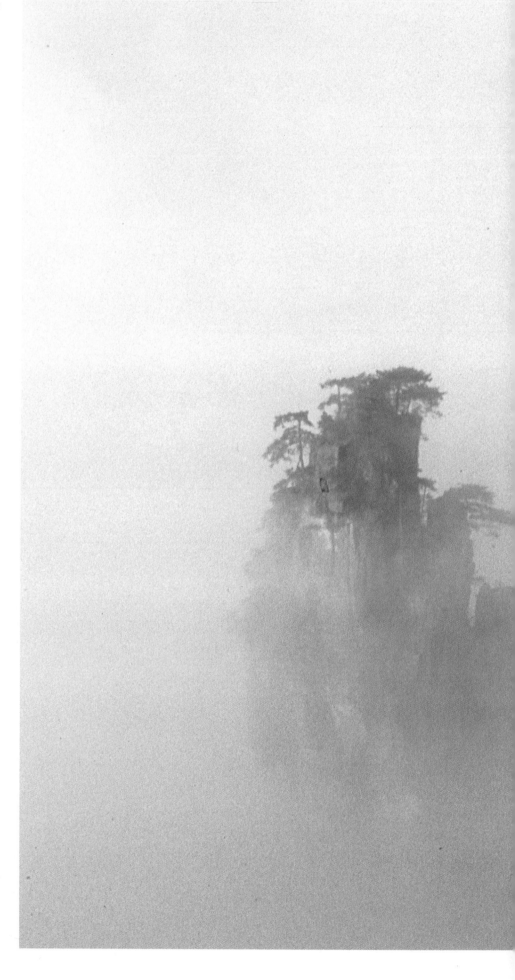

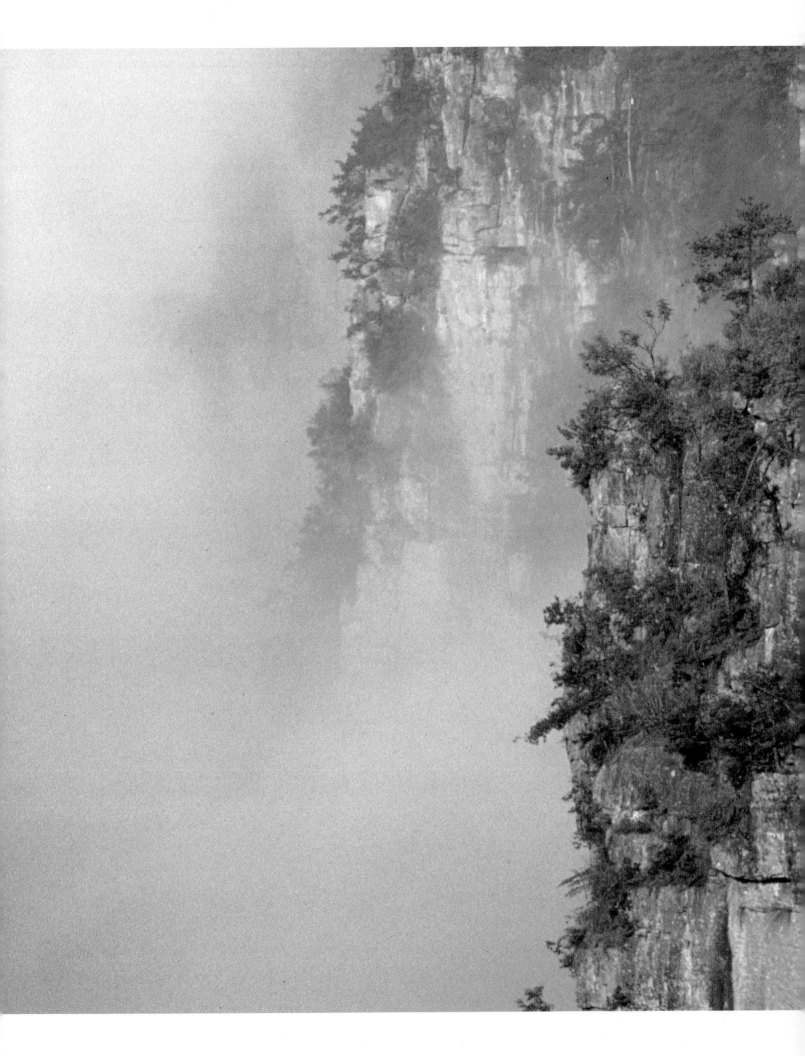

THE UNIVERSALITY OF
LANDSCAPE PHOTOGRAPHY

Through the use of symbols and metaphors, landscape photography can confront viewers with more than a record of a place or a backdrop for human activity. It can convey a message, provoke a thought, and exhilarate photographer and viewers alike. I have always been fascinated by the strength of tree limbs during the winter months. To me, the branches suggest a spirited nature, optimism, and resilience, and, at the same time, the struggle for survival. I also regard natural surroundings as full of ambiguities and ironies, just as the social environment is. I think of the landscape as a metaphor for human experience.

The culture gap and the value system in different societies notwithstanding, a strong visual design based on the commonly existing elements in the landscape is universally acceptable. An awareness of their meaning in different cultures should expand a photographer's ability to handle the basics of light, color, and composition, and to capture the essence of an image.

As an art form, photography can be more than just functional and utilitarian. The medium explores and defines the relationship between landscape photographers and their subjects, both of which are products of a particular culture.

Looking up through autumn trees can be dazzling. Against the blue sky, the translucent leaves are quite vivid. I tried to "anchor" this picture by including a small tree in the foreground in the bottom of the frame. Working with a Canon FD 20mm lens on my Canon F1, I exposed at f/22 for ⅟₆₀ sec. on Kodachrome 64.

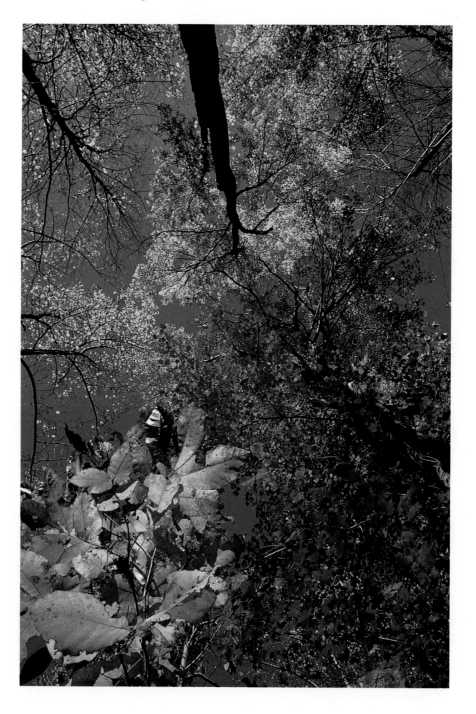

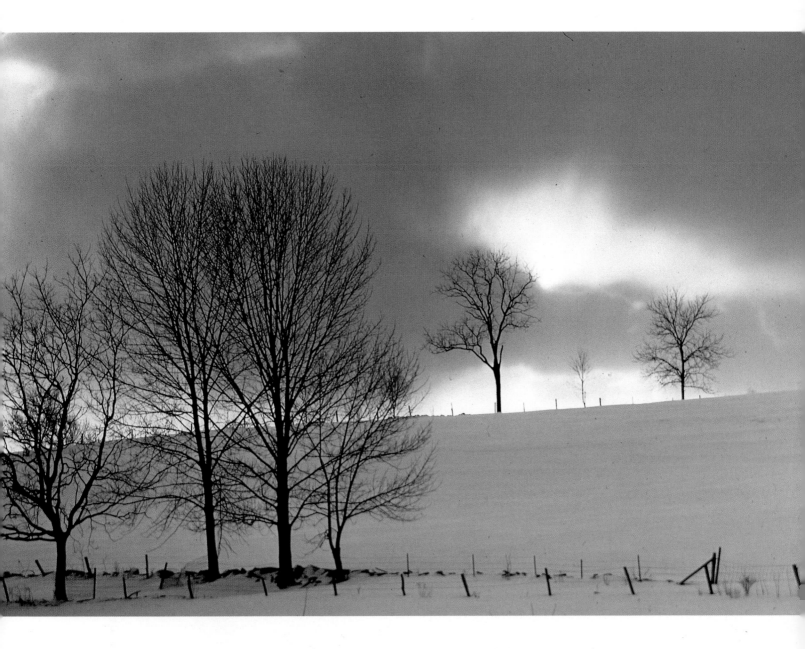

In this subtle rural scene, the pale cloudburst is accentuated by the dark trees. Because of the snow-covered ground, the picture resembles a simple sketch on a white canvas. Photographing with my Canon FT and a Canon FD 80–200mm lens, I exposed at ƒ/16 for 1/125 sec. on Kodachrome 64.

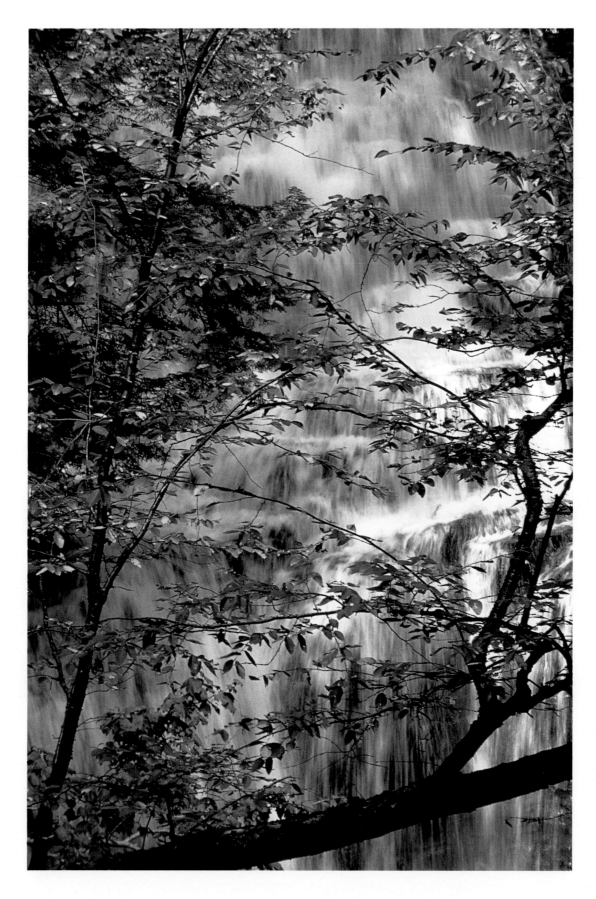

Trees and waterfalls have a special appeal to many people: they suggest the enduring beauty and power of nature. As the muted sun broke through this cloud at Ricketts Glen State Park in Pennsylvania, I decided to unite this tree and waterfall in a single image. I also wanted to capture detail in both. I photographed this landscape with a Canon FD 80–200mm lens and my Canon F1. Metered on the waterfall, the exposure was f/22 for ⅟₁₅ sec. on Kodachrome 64.

THE FUNDAMENTALS OF EQUIPMENT

*My cousin, Dong Yafan, took this picture of me photographing on the top of Hwashan, in
the Qinlin Range in China. As seen from the summit, at an elevation of 2000 meters,
other peaks in the range appear to float in a sea of mist created by a light summer rain.
My cousin caught me completely engrossed in my work.*

As a product of the Industrial Revolution, photography synthesizes artistic vision and technology. Cameras, lenses, tripods, and films become the artist's tools, enabling a photographer to explore and to create. The photographer can change perspectives, rearrange the relationship among subjects, and attach new meanings to a scene.

CAMERAS

Because landscape photographs are frequently used for calendars and posters, working with a view camera might seem ideal. Also, the sharpness of the resulting images is quite impressive. But a view camera is expensive both to purchase initially and to operate later. Other problems are its bulky size and the weight of just a few plates. Unless used for professional work, the camera system frequently limits a photographer's options to experiment and demands great stamina.

A 35mm SLR camera, on the other hand, is mobile and less expensive. In addition, the convenience of roll film, which allows the photographer to experiment without being overly concerned about wasting film, an accurate through-the-lens (TTL) metering system, and a full range of supplemental lenses make the 35mm SLR camera quite versatile. But, because of the small size of the film, enlargements that exceed 16 × 20 usually are not as sharp as the photographer would like.

In contrast, a 35mm rangefinder camera, with its less complicated operating mechanism, generally produces sharper images than those produced by a 35mm SLR camera under the same condition. But most rangefinder cameras are equipped with a fixed lens, which restricts the photographer's ability to compose pictures properly.

The medium format SLR camera with its larger-sized film and interchangeable lens system is an excellent compromise. However, I find that the standard size of the picture (6 × 6mm or 6 × 7mm) makes cropping necessary for almost every landscape image for my taste. I prefer the more rectangular dimensions used in the 645 back.

LENSES

The difference between a painter and a photographer is commonly said to be the way each handles a particular scene. Starting with a clean canvas, a painter adds items of interest until an ideal design appears. A photographer, on the other hand, is usually presented with a full canvas and must eliminate distractions as well as any elements that are inconsistent with the design. The picture must give the impression that the photographer was in full control of the creation, just as a painting should. Using different lenses helps photographers to compose selectively.

Lenses are ordinarily divided into three categories according to their focal length: wide angle, standard, and telephoto. Placing a lens in one of these groups according to its focal length, however, is not entirely accurate. The limits of each category can change, depending on the film size used. While a 50mm lens is usually called a standard lens on cameras requiring 35mm film, it is a wide-angle lens on cameras with larger formats.

A more precise way to distinguish lenses involves the visual angles they extend in front of the camera. This angle defines a wedge-shaped area within which a scene is captured on film. However, because most film is rectangular, distortion results. With standard lenses, distant objects are compressed at the top of the frame in comparison to those nearby in the foreground. As a result, objects in the background of the image appear smaller than those in the foreground. Viewers accept such distortion because human eyes act like standard lenses.

The distortion that occurs varies according to the type of lens used. Wide-angle lenses make objects in the background appear smaller and more distant than standard lenses do. Telephoto lenses, on the other hand, especially those with a very long focal length, produce such small visual angles that the wedge-shaped areas they form are practically rectangular. As a result, faraway subjects appear to be about the same size as closer subjects, the sense of distance is diminished, and every object seems to be on the same plane.

Associated with the focal length of lens is the depth of field with which a sharp image can be obtained. In general, the longer the focal length of the lens, the more limited its depth of field is. (Some adjustment in depth of field can, however, be made by opening the diaphragm. The smaller the diaphragm opening is, the greater is the depth of field.)

By switching lenses, a photographer can control not only the area included in the picture, but also, to some extent, depth of field and the amount of distortion. It is because of these creative options that I think of lenses as a photographer's paintbrushes.

Telephoto Lenses

Because of their reduced visual angle, telephoto lenses are ideal when a landscape photographer wishes to concentrate on one specific aspect of a scene. The limited depth of field of telephoto lenses eliminates non-essentials simply by blurring them.

The most important effect of using telephoto lenses cannot be duplicated by a photographer's merely moving closer to a subject when using a standard lens. With the standard lens, approaching the subject can alter the relationships among the objects within a picture frame. Consider this example: a photographer is standing in a field where nothing interesting is in the foreground. Rows of trees are near the horizon, and a distant mountain range looms in the background. If the photographer decides to move closer to the trees to eliminate the foreground, the mountain range might be blocked by the tall, dense trees. Even if the mountain range is still fully visible, the size differences between the trees and the mountain range would not be the same. From a

distance, telephoto lenses can appear to bring the mountain range closer, making it seem more powerful than the trees. In a picture taken with a standard lens near the trees, they will dwarf the mountain range and become the center of the attention.

Wide-Angle Lenses

Unlike telephoto lenses, with which photographers can handle distant objects effectively by either bringing them closer or blurring them, wide-angle lenses enable photographers to emphasize foregrounds. With their extended fields of view, wide-angle lenses greatly exaggerate the size of objects in the foreground and, at the same time, increase the apparent distance between the foreground and the background.

This effect can, however, pose a problem: creating a proper composition can be difficult for photographers. The large visual angles of these lenses frequently allow irrelevant objects to enter the frame, producing chaotic, cluttered images.

Photographers can eliminate unnecessary elements for an image taken with a wide-angle lens by drawing attention to the foreground. When photographers move closer to an interesting subject, they can create a "portrait" of it, making the background seem even more distant. But this does not mean that the background can be disregarded. Because wide-angle lenses have greater depth of field than telephoto lenses, the background cannot be blurred. As a result, the relationship between the foreground and background must be well defined if a unified composition is intended. In addition, through the reduction in size of distant objects, they can play supporting roles, bringing out the subtle contrasts or harmonies in the photograph.

The distortion caused by wide-angle lenses can be another problem. Rather than producing sweeping panoramas, as would be expected, wide-angle lenses tip tall structures, bend trees, and curve horizons. Viewers often find such distortions unsettling. Photographers can minimize linear distortion by including a line that cuts through the middle of the picture or by making it parallel to the film plane. Frequently, I prefer to use the distortion to transform some linear elements into sweeping curves, visually projecting a sense of exhilaration and power. As such, I find wide-angle lenses more fun to use because they allow me to create, not merely to reproduce. But finding a subject or motif that benefits from this type of distortion can be a challenge.

LENSES IN THE FIELD

Aware that lenses are a photographer's "paintbrushes", most camera manufacturers support their cameras with an extensive line of lenses, ranging from the fisheye to the ultra telephoto. So, even if affording all of the lenses isn't a problem, a photographer must carefully and intelligently decide which ones to take into the field. Carrying excessive weight is both an unnecessary burden and, even more important, a sure way to make taking pictures unpleasant.

My standard outfit consists of a 20mm wide-angle lens, a 50mm macro lens that also serves as a standard lens, an 80–200mm lens, and a 300mm telephoto lens, along with two camera bodies. (For one-day trips during which I don't anticipate taking any closeups, I might carry only one camera body and leave my 50mm macro behind.) The one lens conspicuously missing from my gear bag is a mid-range zoom lens, such as a 35–85mm lens. An ideal lens for street photography and taking other candid shots of people, this lens does not allow me to concentrate on the essentials of the landscape—which the 80–200mm lens and the 300mm lens do. And, unlike the 20mm lens, it doesn't offer the amount of distortion I need for the stylized realism I try to create. Of the lenses I carry, I use the 80–200mm lens most frequently, although I am becoming more fascinated by the results I achieve with the 300mm lens. If I were able to carry just one lens, I would bring along this zoom lens for its creative possibilities.

TRIPODS

Photographers shy away from using tripods for all kinds of reasons. They are bulky and conspicuous, and photographers usually have to fight with them when composing pictures: tripods never seem to tilt or turn the way photographers want them to. While many photographers think tripods are a nuisance, others maintain that tripods are meant to be used with heavy equipment, such as view cameras. Furthermore, one of the main advantages of 35mm cameras is their mobility, which using a tripod restricts. Still other photographers believe that they have steady hands and need not worry about camera shake.

I find that working with a tripod not only reduces vibration, but also enables me to compose images more thoughtfully. Because most landscape subjects do not move, photographers often (but not always) have the time to set up a tripod and carefully consider the elements of a picture. Using a tripod forces me to slow down and to think. I am also compelled to pay more attention to the details near the edge of the frame or at the corners rather than concentrate on the part of the image that interests me most.

Another advantage to using a tripod is no longer having to worry about the aperture setting lowering the shutter speed. Also, the sharp images produced with a steady camera can eliminate the need for a large-format camera when enlargements might be wanted. However, steadying the camera can be difficult if its center post is raised. The vibration created by the complicated mechanism of SLR cameras—which closes the diaphragm, raises the mirror, and releases the shutter—is frequently magnified when the post is in this position.

Photographers also complain about another aggravation caused by using a tripod in the field: turning the knobs on the tripod in order to adjust the camera. I find that replacing the standard head on a tripod with a ball-

and-socket type can be helpful. As a result, the tripod tilts and turns in a single movement, and I am able to concentrate on composing the image, not struggling with knobs.

FILMS

To produce evocative color landscape images, photographers must consider the most important issues relating to films: proper exposure and color rendition.

Controlling Color

The rich diversity of natural colors can be a nightmare for film manufacturers as well as for some photographers who seek total control of color. By and large, all color films can produce acceptable color images, particularly under bright, sunny conditions. It is the subtle differences under adverse light conditions that distinguish color films. Each brand of film responds differently to color. Furthermore, even rolls of film made by the same manufacturers that bear different emulsion numbers might offer minor variations in color response. To complicate matters even more, color shifts can take place during the shelf life of the film, and different quality standards exist among professional laboratories.

Anticipating color reproduction can often be a gamble, and choosing a particular brand of film is only a first step in reducing the odds. In recent years, I have been trying to stay with one type of film and one particular processing laboratory. While this practice by no means eliminates surprises, I have developed a feeling for how a given scene will likely be reproduced on color film in color. My choice of film is also dictated by the subject as well as by the type of color I have come to prefer: warmer, richer, deeper, and occasionally a bit muddier.

INDEX